OVER THE MOON:

ILLUMINATING THE JOURNEY

OVER THE MOON: ILLUMINATING THE JOURNEY
ISBN: 9781789096514

Published by
Titan Books
A division of Titan Publishing Group Ltd
144 Southwark St
London
SE1 0UP

www.titanbooks.com

First edition: November 2020
1 3 5 7 9 10 8 6 4 2

Did you enjoy this book? We love to hear from our readers.
Please e-mail us at: readerfeedback@titanemail.com or
write to Reader Feedback at the above address.

To receive advance information, news, competitions, and exclusive
offers online, please sign up for the Titan newsletter on our website:
www.titanbooks.com

A CIP catalogue record for this title is available
from the British Library.

Printed in Canada.

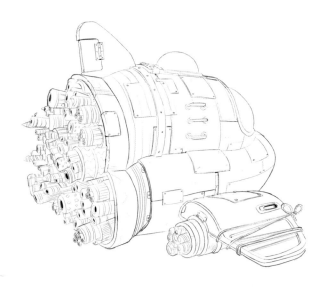

OVER THE MOON:

ILLUMINATING THE JOURNEY

LEONARD MALTIN

FOREWORD BY JANET YANG

TITAN BOOKS

CONTENTS

FOREWORD .. 06

NO BARRIERS.. 10

THE LEGEND OF CHANG'E......................... 18

HOME... 26

THE MID-AUTUMN FESTIVAL 64

ROCKET TO THE MOON............................. 74

WELCOME TO LUNARIA 94

MOONSCAPE... 134

HOUYI REUNION 156

RE-ENTRY... 178

ACKNOWLEDGMENTS............................... 196

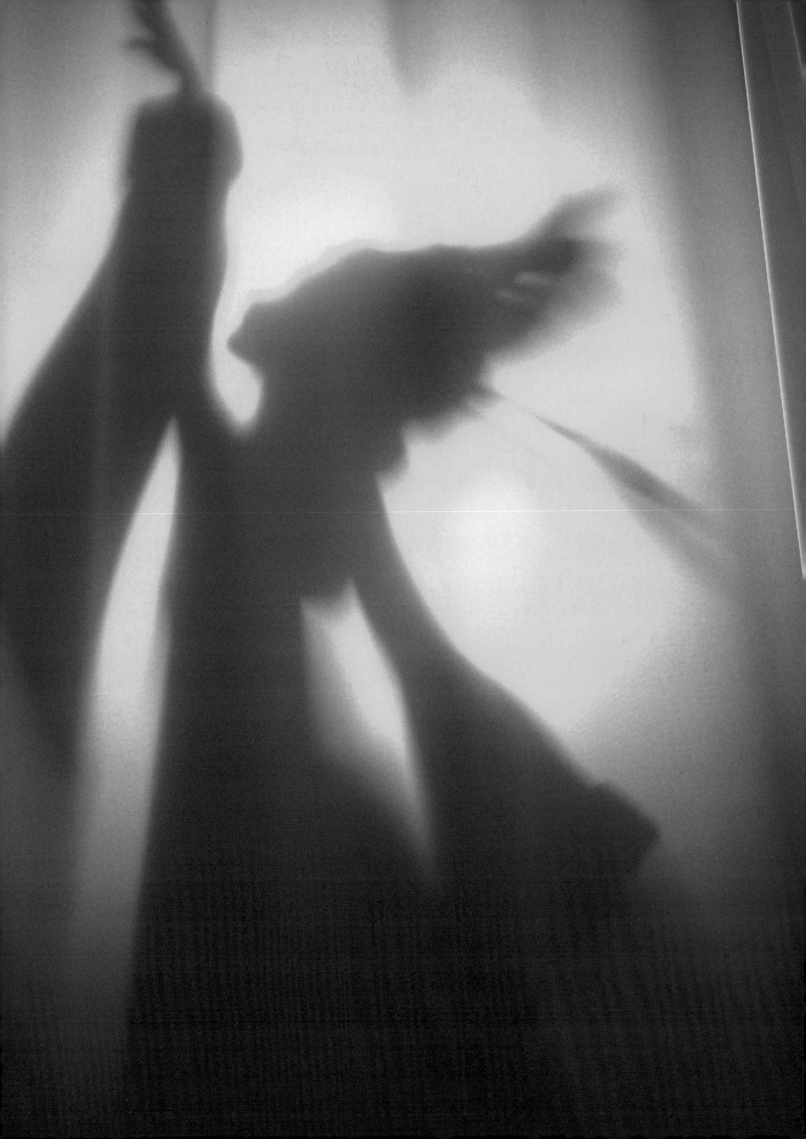

FOREWORD

JANET YANG
EXECUTIVE PRODUCER

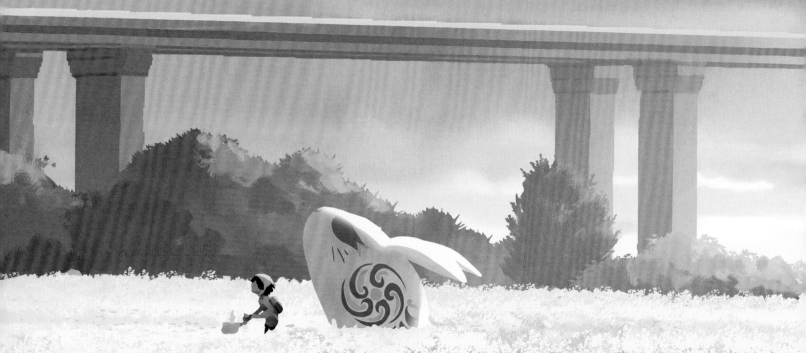

The making of any movie involves an element of, for lack of a better word, magic. With *Over the Moon*, the magic was palpable.

The magic started in December 2015 in Shanghai. I had been invited by Peilin Chou, then head of Oriental DreamWorks Animation (ODW), to attend its first ever "Brain Trust." ODW was already a promising outlier, as a joint venture formed by famed Hollywood mogul, Jeffrey Katzenberg, and one of China's biggest media figures, Li Ruigang. LA-based DreamWorks had already made the hugely successful *Kung-Fu Panda* films. It successfully merged two iconic Chinese symbols—an indigenous martial art, and its most beloved animal—to create an international sensation. The company seemed like a natural fit with China, especially during a time when the entertainment sectors of the two countries were enjoying robust conversations.

Shanghai is not only my father's birthplace, it was also where I launched my career. In the mid-1980s,

I was fortunate to be asked to join the production of Steven Spielberg's *Empire of the Sun* (1987). Despite my lack of production experience, I had spent many years working with China's film industry in both the import and export of films, and could therefore effectively serve as a liaison between the two countries for this giant production. After months of preparation, I stood by Steven's side on the first day of shooting while 5,000 extras in period costume filled Shanghai's historic riverside Bund. I could have died and gone to heaven right then.

Years later, Shanghai's Bund was again a location for scenes in a film I executive produced, *The Joy Luck Club* (1993), and, later still, I produced two movies shot entirely on location in Shanghai—Disney's *High School Musical: China* (2010), and *Shanghai Calling* (2012). Having gotten to know it fairly intimately, I declared Shanghai my favorite city in the world.

So yes, any opportunity to return to Shanghai was always welcome.

The Brain Trust included journalist Jeff Yang and screenwriters Rita Hsiao, Leo Chu, and Eric Garcia. While I had known each of them individually, this project provided a special bonding experience. Most of us, including Peilin and several of her staff such as Justinian Huang are Americans of Chinese descent. We were born to immigrant parents, but raised and educated in the States. That gives us a very unique, sometimes awkward, position in both America and China. Whether or not we speak Chinese or have actually lived in China (as I did), being Chinese-American usually means that we are influenced, in ways large and small, by the values, the stories, and the customs of our ancestors. We often struggle to find ways to choose among, and be authentic to, these traditions while living in America.

Peilin asked us to pitch relevant stories, mining myths from deep layers of Chinese civilization. I already had one legend in mind before we met, and during the course of my time in Shanghai, developed the story further.

The Chang'e goddess is well-known in China. Like many myths, there is definitely some vagueness about the exact origins and even the meaning of this legend. But it holds an eternal and powerful place in the Chinese imagination.

Thousands of years ago, Chang'e was madly in love with the dashing stud, Houyi. She took immortality pills in hopes that their love would last forever. Well, this made her persona non grata in the eyes of the gods, and she was banished to the moon. She has been residing there all this time! But fortunately, she is not entirely alone—she has a rabbit companion. (No, this is not her male lover, despite what some may surmise!) If you look closely enough at the moon, and really believe, you can see the little bunny nestled in there with Chang'e.

The affection for Chang'e persists and seems to grow even stronger each year. Does this represent a longing to believe in true love at all costs? (Even with such a long-distance relationship?!) She is celebrated each year during the Mid-Autumn Festival, which falls on the lunar calendar

in September or October, always under a full moon. If you happen to be in China during this festival, watch out, because you might get hit in the head with something that feels like a meteor and turns out to be a mooncake. Just kidding; however, you will notice an explosion of mooncakes throughout the country. You definitely could get caught in the frenzy of massive deliveries by car, bike, and foot, and if you're lucky, you might be gifted with some of them. You might get a large, beautifully wrapped cardboard box with some very fancy designs and ribbons on it. It will be quite heavy for its size. Inside will be a grid of further individually-wrapped mooncakes, each carefully cushioned and measuring three to six inches in diameter. They might be round or square, with smooth or scalloped edges. You will pick one up, unwrap it, and feel the weight in your hands as you examine the elaborate

design on the pastry crust. And, most of all, there will be tremendous anticipation for what's inside—will it be salty duck egg yolk, or lotus paste, or black sesame paste, or wintermelon paste? You just don't know. There are no clues from the outside, no little labels. Ah, the mystery. You just have to take a chance. In the new, ever richer China, you might even find gold.

Of all the traditional Chinese festivals, the Mid-Autumn Festival asks so little of us. It does not require that we dutifully return home to family, as during Chinese New Year; or sweep the graves of our ancestors, as during the Qing Ming Festival in spring; it simply asks that we think of the goddess and her rabbit, and perhaps muse on love, while debating which mooncake filling is our favorite...

Why does the legend of Chang'e persist after all these years? It's hard to say, but the fact that the Chinese government decided to name its entire space program after her is just one indication of its ongoing importance.

And so, out of these fundamental elements, I fashioned a story. A goddess, a rabbit, a mooncake-making tradition, a festival. Add to this what I am always drawn to—Asian girl power. Animation gives us the freedom to create a world and situations that are not entirely real—in fact, it demands it. So how about... a girl named Fei Fei (which means "to fly," and is a homonym for a common Chinese name) from a mooncake-making family, who has heard about the moon goddess all her life. She wants to meet the mythical goddess. She figures out how to build her own rocket ship. She brings along her own rabbit. She has an annoying brother, because annoying brothers are always good fodder.

Thus was the beginning of the story I pitched in our group session. I saw Peilin make a note after I pitched it. I think she likes it. We talk about it some more. She wants to develop it.

Then the real magic starts: Screenwriter Audrey Wells is brought on to write the screenplay. We did not initially know that she was living out the last months of her life as she was writing, and that his project represented a gift to her daughter. The following year, Peilin reconnects with the iconic Glen Keane at the Annecy International Animation Film Festival after twenty years. He reads the script and signs on. Woo-hoo! Production begins under the supervision of Glen and his producer, Gennie Rim.

In the meantime, DreamWorks Animation is purchased by Comcast and folded in with Universal. ODW is fully acquired by its Chinese shareholders, led by Li Ruigang.

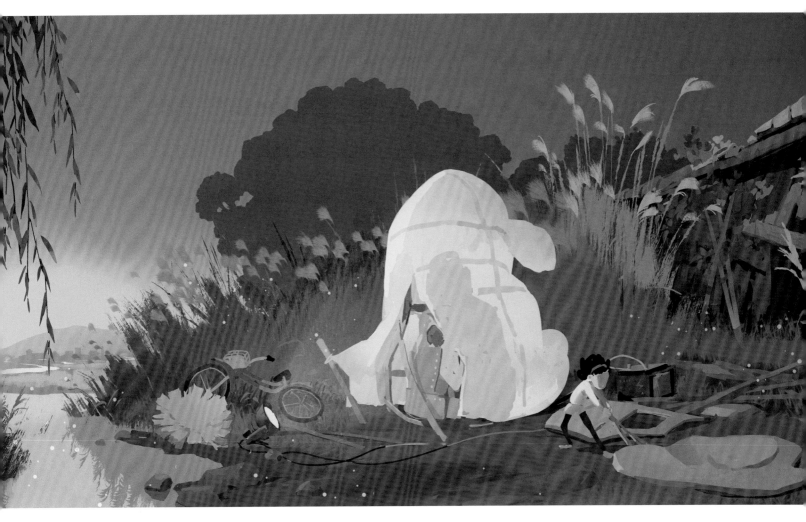

PREVIOUS SPREAD: Artwork by Tian Yuan.
ABOVE: Artwork by Tian Yuan.

Former ODW executive, Melissa Cobb, who also has a personal connection to the story, is hired by Netflix to run family films. *Over the Moon* is now a Netflix film!

An army of people is brought on to execute Glen's vision. I watch with fascination as his drawings of Fei Fei come to life. The initial drawings already have everything in her face—her delight in the presence of her parents, her anguish with the new family dynamics, her annoyance at her bratty younger brother, her determination to get to the moon.

Eventually, she walks, runs, bikes, and talks. And then all the other characters start coming into relief, as do the animals and mythical creatures. Voices from a cast of people I adore, who are part of our ever-growing and influential Asian American entertainment community, bring this population further to life.

Songs and lyrics, in the meantime, are exquisitely created by Christopher Curtis, Marjorie Duffield, and Helen Park to blend perfectly with the visuals. They are entirely memorable, singable songs that end up ringing in my head for weeks after each screening. Add Steven Price's lyrical compositions and the movie starts floating above ground.

Later, the beautiful scenery of Fei Fei's hometown—the famed water towns near Shanghai—are watercolored in, and I am lifted into space. And then the unique, eye-popping Lunaria universe is fleshed out and we have ascended to yet another celestial plane!

And so the magic continues and continues, over three years, with each drawing, each recording, each frame of animation until we are veritably... over the moon.

To take this long journey into space over the course of the past five years after I first pitched the original story is nothing short of transcendent. Hundreds of talented and devoted individuals contributed to this magical journey, and I am so grateful to each and every one.

I thank them all for reaffirming my belief in magic, and in love. I hope that this movie does the same for you.

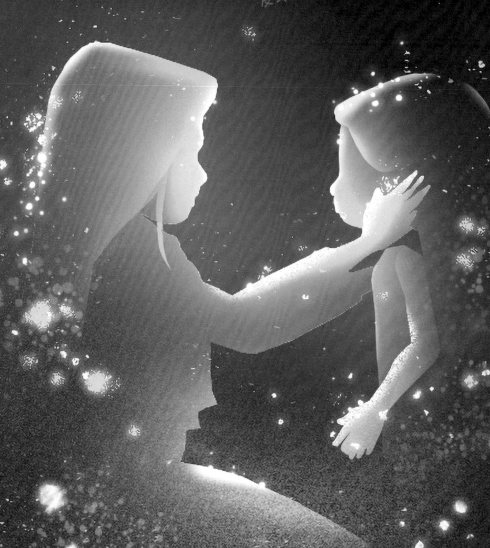

AUDREY WELLS

SCREENWRITER
1960-2018

■ Screenwriter Audrey Wells is known for her powerful and multifaceted female protagonists, having penned films such as *The Hate U Give* (2018) and *Under the Tuscan Sun* (2003). Wells, who tragically died shortly after finishing the script for *Over the Moon*, wrote the film partially as a tribute to her daughter.

PREVIOUS SPREAD: Artwork by Marion Louw.
BELOW: Glen Keane, Audrey Wells, Cathy Ang, and Gennie Rim.

ABOVE: Screenwriter Audrey Wells in conversation with director Glen Keane.

BELOW: Sketch of Fei Fei and Bungee by Glen Keane.

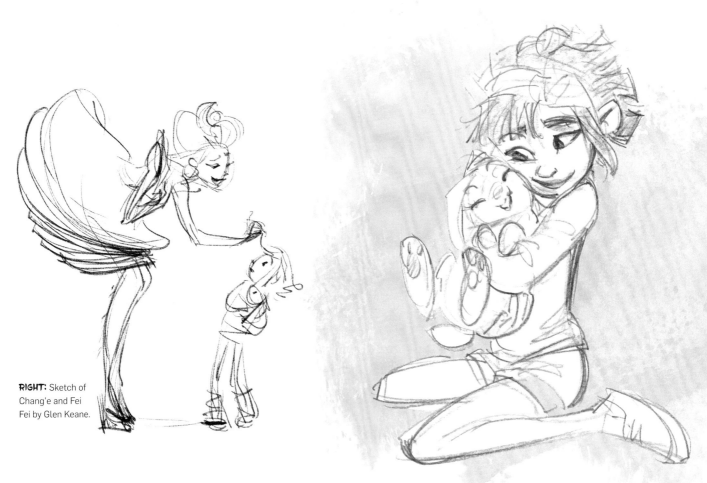

RIGHT: Sketch of Chang'e and Fei Fei by Glen Keane.

ANIMATING FROM THE POINT OF DISCOVERY

■In creating a movie like *Over the Moon*, director Glen Keane knew that he would have to step out of his comfort zone. As part of this exploration, he and the production team took a research trip to China, visiting Shanghai and its surrounding water towns, to immerse themselves in the culture.

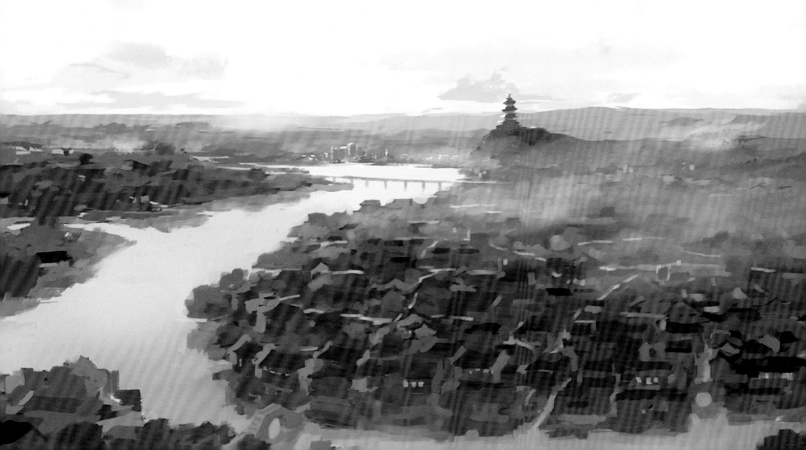

ABOVE: Glen Keane painting during a research trip to Shanghai, China.

BELOW: Drawing from Glen Keane's sketchbook.

BELOW: Glen Keane during a research trip to Shanghai, China.

OPPOSITE: Artwork of Fei Fei's water town home, by Wang Rui.

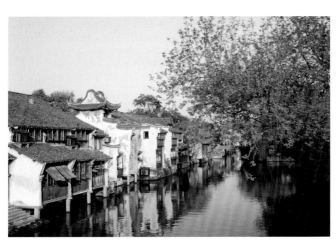

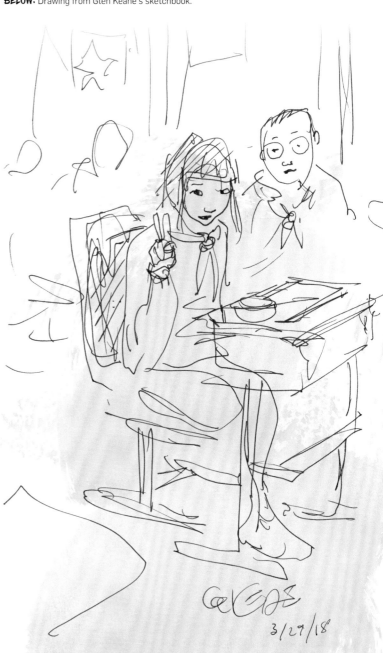

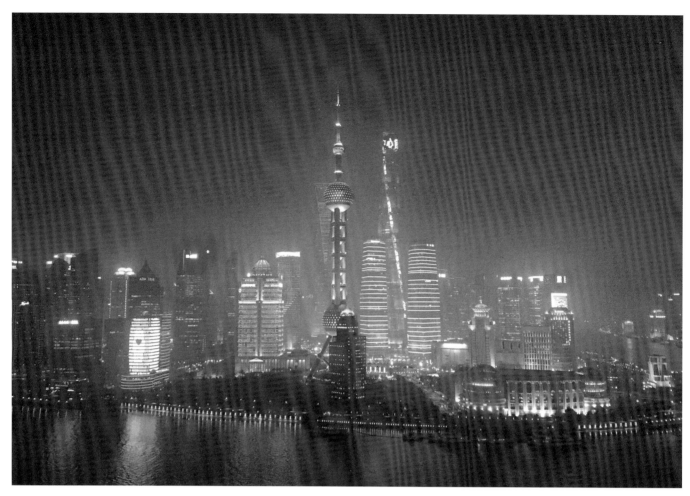

ABOVE: The Chinese city of Shanghai.

BELOW: In the photo, starting from bottom and going clockwise: Lisa Poole, Laure Miard, Angelique Yen, Pellin Chou, Glen Keane, Steven Macleod, Linda Keane, Lulu Wang, Gennie Rim, Céline Desrumaux. Photographed by Alessio Avezzano.

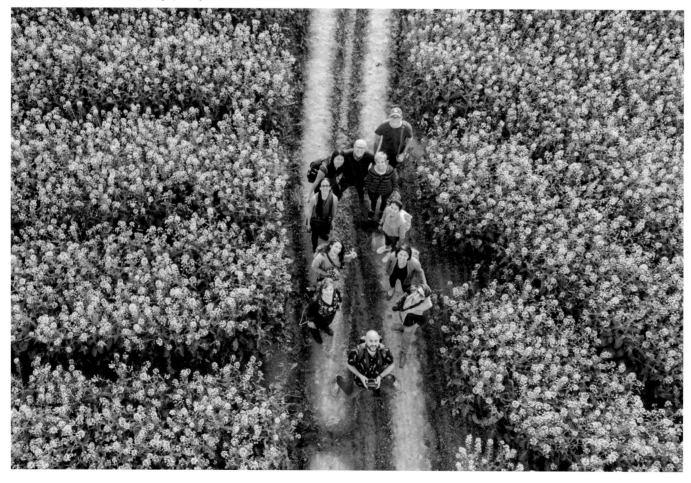

OVER THE MOON: THE ART OF THE MOVIE

"WE WERE ALL VERY DEEPLY INVESTED IN MAKING SURE THAT THE FILM FULFILLS ITS POTENTIAL OF THE TYPE OF STORYTELLING THAT WE SET OUT TO DO, THE LEVEL OF QUALITY THAT WE WANTED TO ACHIEVE."

GENNIE RIM
PRODUCER

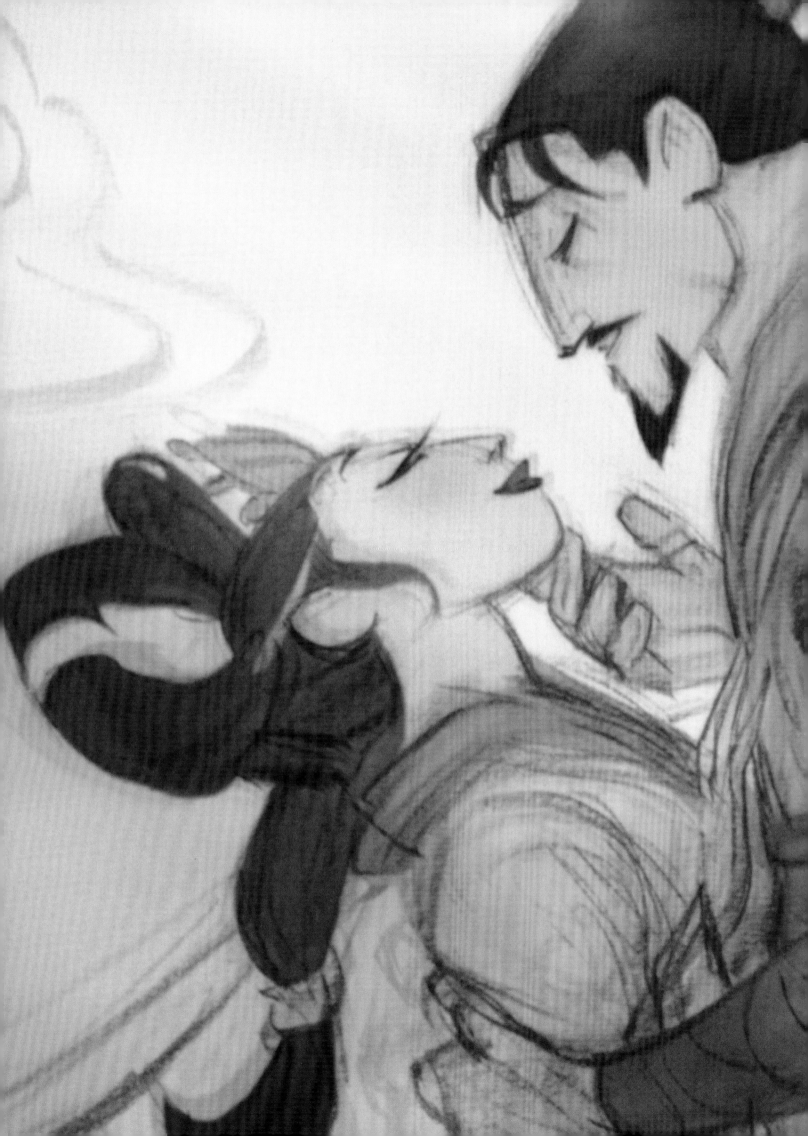

THE LEGEND
OF CHANGE

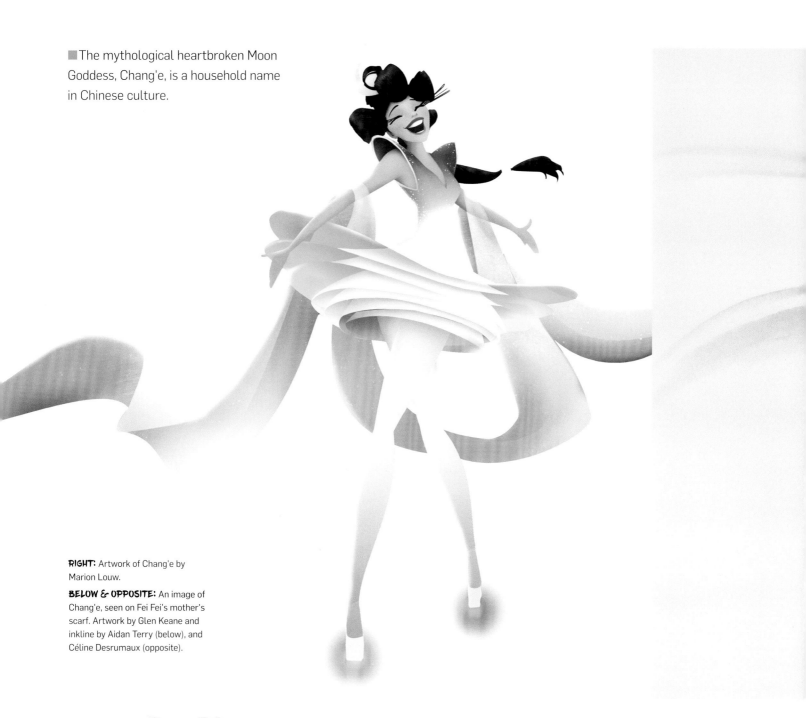

■ The mythological heartbroken Moon Goddess, Chang'e, is a household name in Chinese culture.

RIGHT: Artwork of Chang'e by Marion Louw.

BELOW & OPPOSITE: An image of Chang'e, seen on Fei Fei's mother's scarf. Artwork by Glen Keane and inkline by Aidan Terry (below), and Céline Desrumaux (opposite).

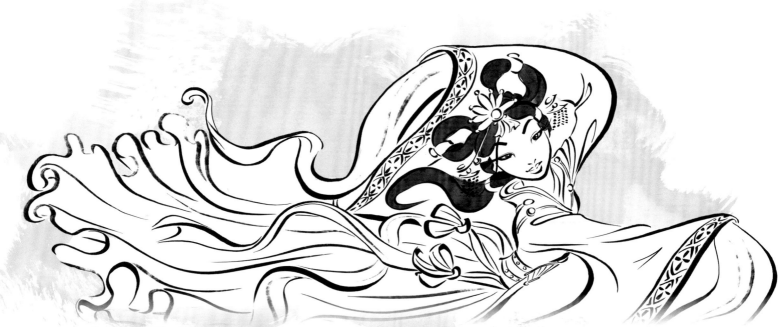

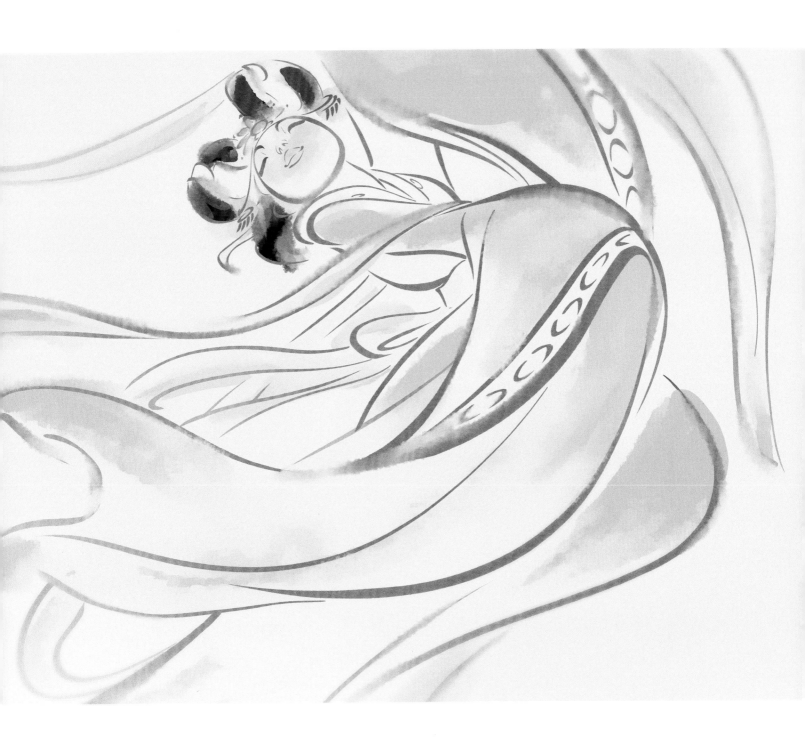

Making a film requires a great deal of work and some degree of luck. The achievement is even greater for an animated feature, especially if your crew is separated by oceans and continents. Yet even a global pandemic couldn't deter the creators of *Over the Moon* from finishing their movie, in part because it was more than a just another job: it was a passion project.

The undeniable power and boundless imagination of *Over the Moon*'s story attracted its collaborators one by one, including one of the greatest animators of our time.

Glen Keane may not be a household name unless your household is animation-savvy, in which case he is a veritable giant. This is the man who gave life to Ariel in *The Little Mermaid* (1989), the Beast in *Beauty and the Beast* (1991), Pocahontas, Tarzan, and Rapunzel in *Tangled* (2010), to name just a few. He grew up in a nurturing, creative environment; his father Bil Keane, created the still-popular daily cartoon panel 'The Family Circus,' which his brother Jeff carries on to this day. He studied at Cal Arts (California Institute of the Arts), then joined Disney as part of a master apprentice program where he learned his art, craft, and work ethic from Walt Disney's celebrated Nine Old Men (including Eric Larson, Frank Thomas, and Ollie Johnston), and spent thirty-eight years working there before striking out on his own. His collaboration with the late Kobe Bryant called *Dear Basketball* (2017) won an Oscar® for Best Animated Short Film. This was overdue public recognition for an elite "team player" whose name was primarily known to animation aficionados.

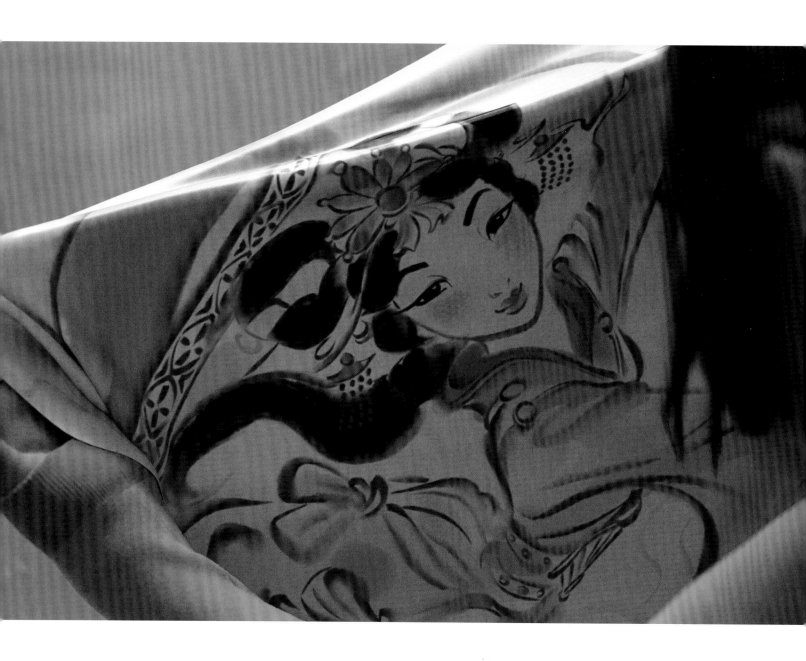

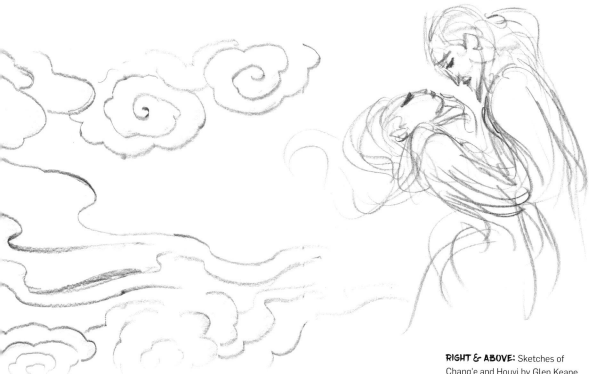

RIGHT & ABOVE: Sketches of
Chang'e and Houyi by Glen Keane.

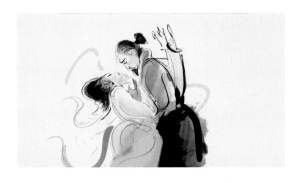
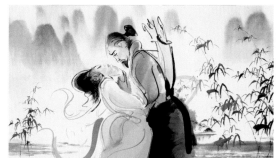
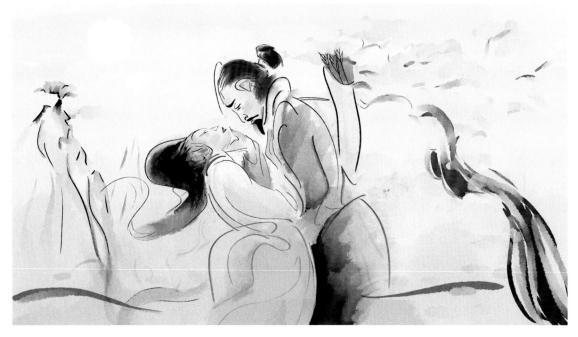

ABOVE: The Legend of Chang'e and Houyi, seen above in artwork by Céline Desrumaux, is shown on Fei Fei's mother's scarf, and on a freize in Chang'e's palace.

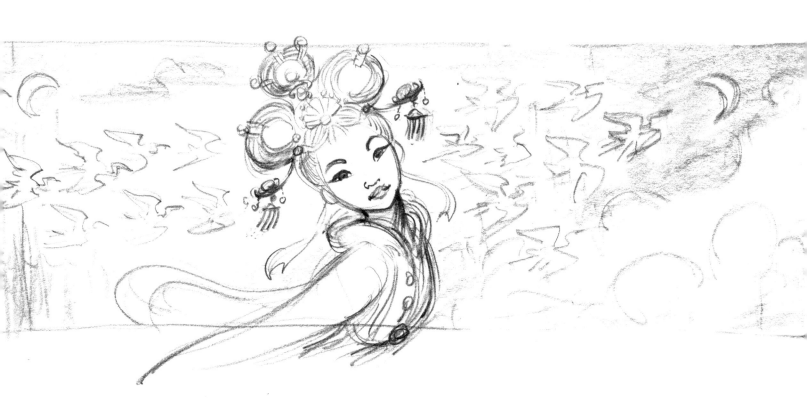

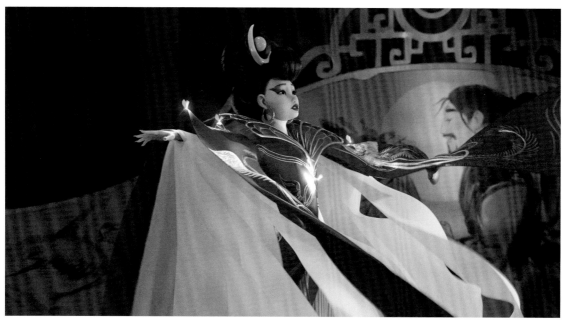

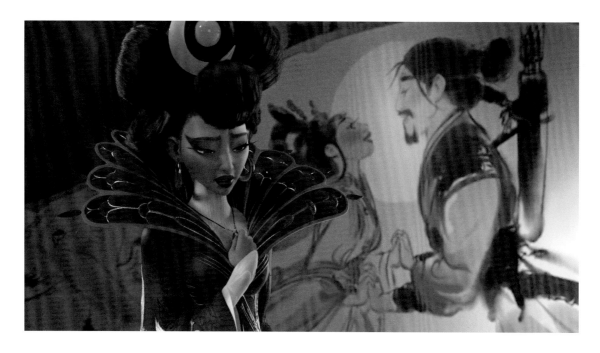

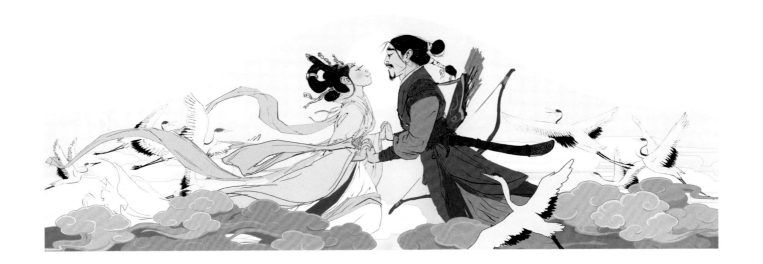

许你生生世世
无绝期的爱
任它千年万载
仍长留我心

*"ALWAYS AND FOREVER
IN THIS HEART OF MINE."*

CHANG'E

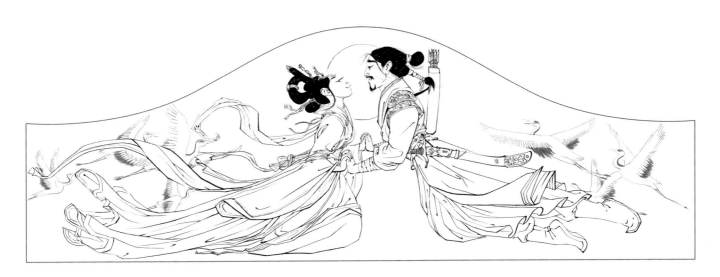

THIS SPREAD: The freize in Chang'e's palace, shown at different stages in design. Artwork by Céline Desrumaux (opposite), Wang Rui (top), and Aidan Terry (above).

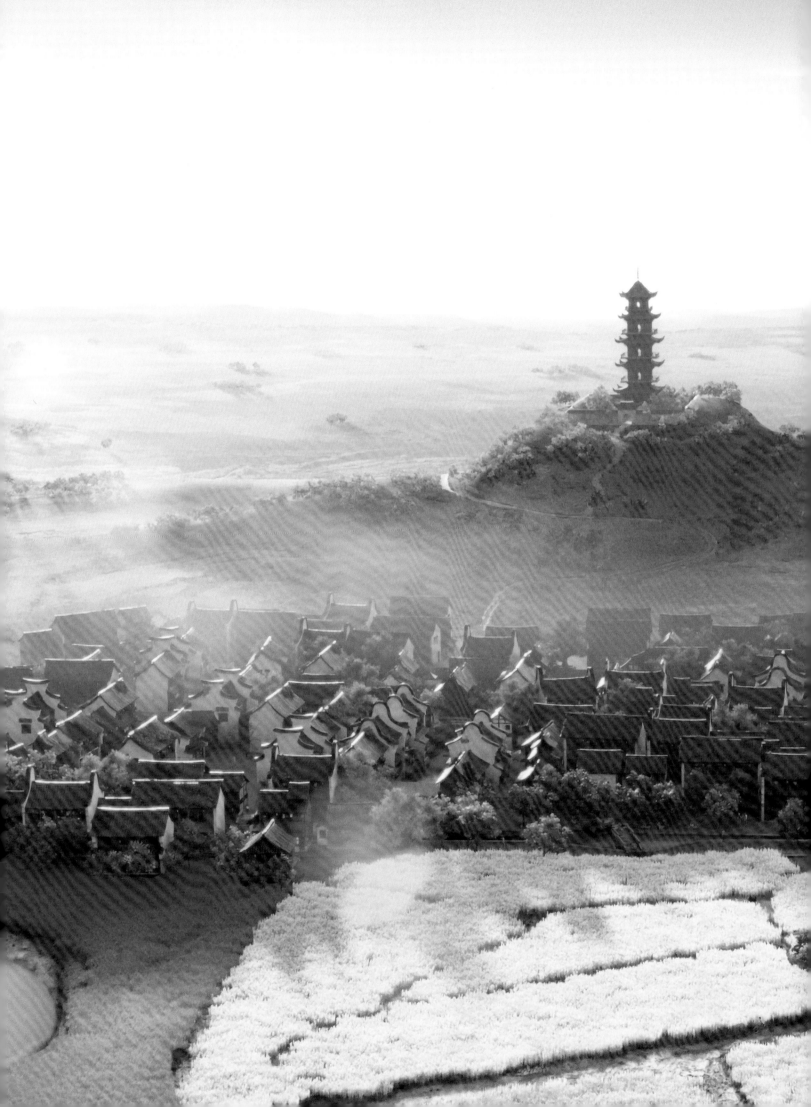

FEI FEI

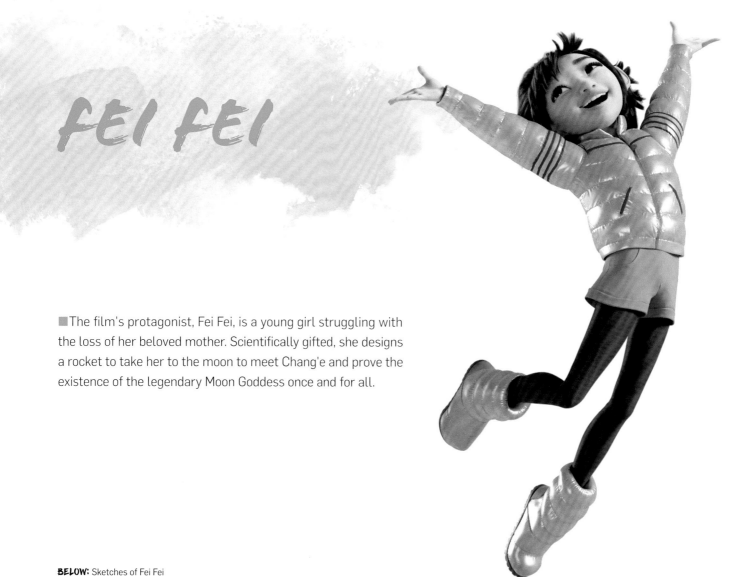

■The film's protagonist, Fei Fei, is a young girl struggling with the loss of her beloved mother. Scientifically gifted, she designs a rocket to take her to the moon to meet Chang'e and prove the existence of the legendary Moon Goddess once and for all.

BELOW: Sketches of Fei Fei by Jin Kim.

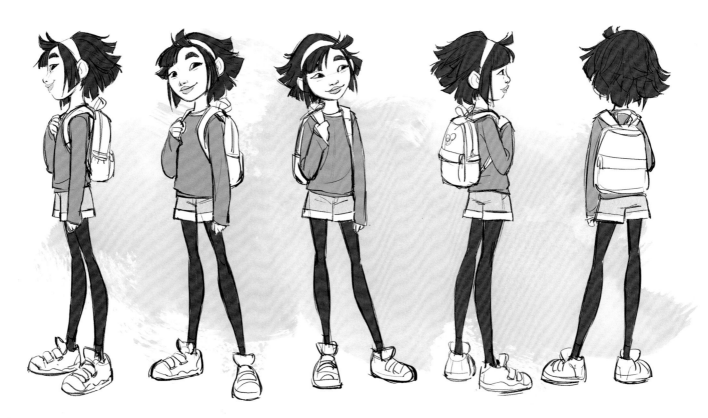

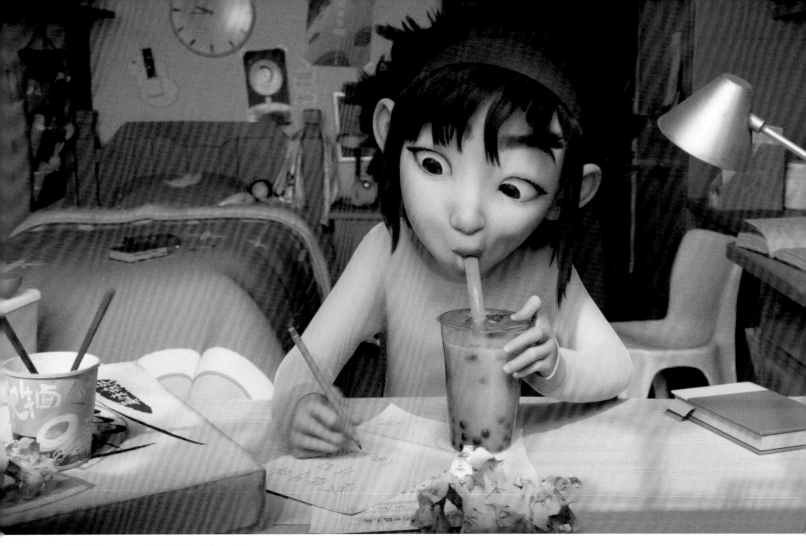

BELOW: Early artwork of Fei Fei by Brittany Myers.

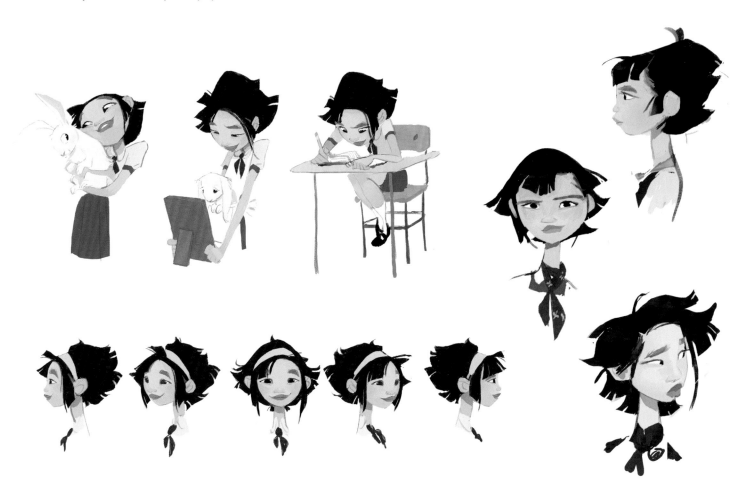

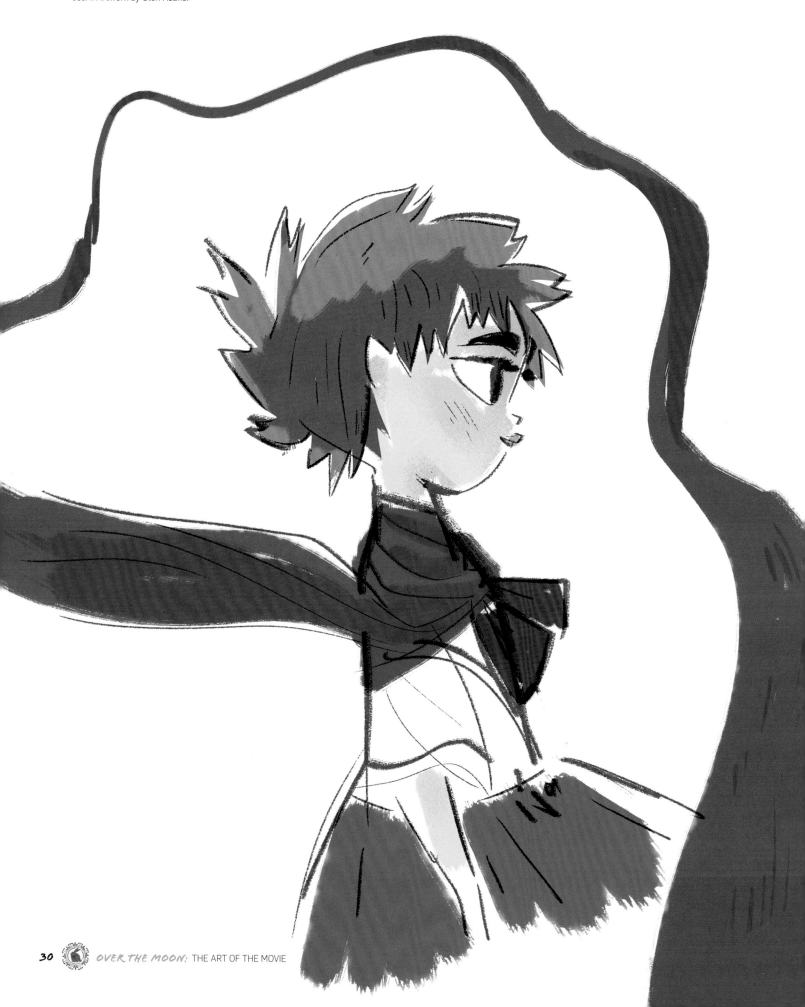

BELOW: Sketch of Fei Fei by Joe Moshier.

OPPOSITE TOP: A young Fei Fei cutting her own hair. Artwork by Brittany Myers.

OPPOSITE BOTTOM: Fei Fei sitting at the Special Place with her mother's scarf. Artwork by Glen Keane.

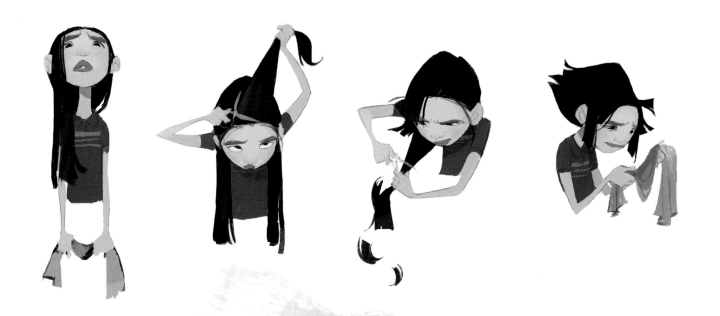

"ONCE YOU LOSE THE PERSON
YOU LOVE THE MOST,
IT CHANGES YOU."

FEI FEI

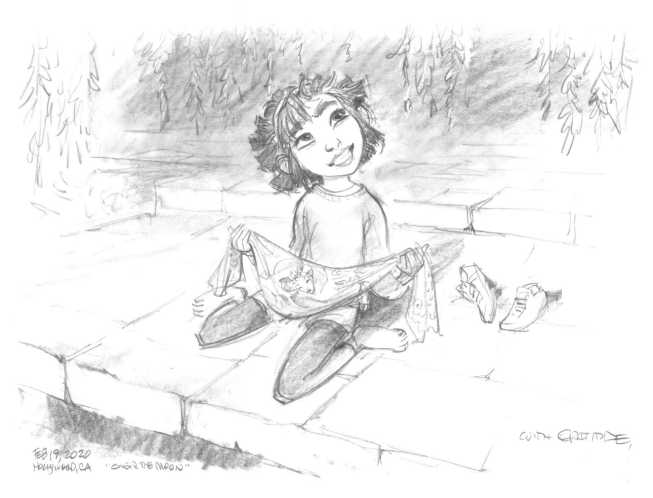

FEB 19, 2020
HOLLYWOOD, CA "OVER THE MOON"

WITH GRATITUDE,

Meanwhile, every child in China knows about the Moon Goddess called Chang'e. She has inspired many legends, mostly dealing with her lost lover Houyi, whom she hopes will return some day. Producer Janet Yang, who shepherded *The Joy Luck Club* (1993) to the screen, believed that the time was right to dramatize the story of Chang'e. She shared her idea with Peilin Chou, who, like Yang, grew up in America in an immigrant family. Chou remembers Chang'e well. "I grew up believing she was up there with her rabbit. I think the way the moon markings are, it kind of looks like two ears that are upside down."

As the erstwhile Chief Creative Officer of Pearl Studio in Shanghai, Chou and her team developed an outline and then sought out a writer to take it to the next level. Audrey Wells had been in talks with Pearl for a project once before and Chou was a fan. As a writer and director, Wells built a reputation for smart, female-centric films such as *Guinevere* (1999), *Under the Tuscan Sun* (2003), and, alongside director George Tillman, Jr., *The Hate U Give* (2018). "I felt like she would be an amazing person to

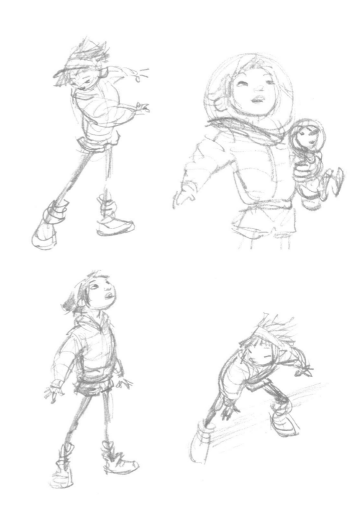

RIGHT: Sketches of Fei Fei by Glen Keane.

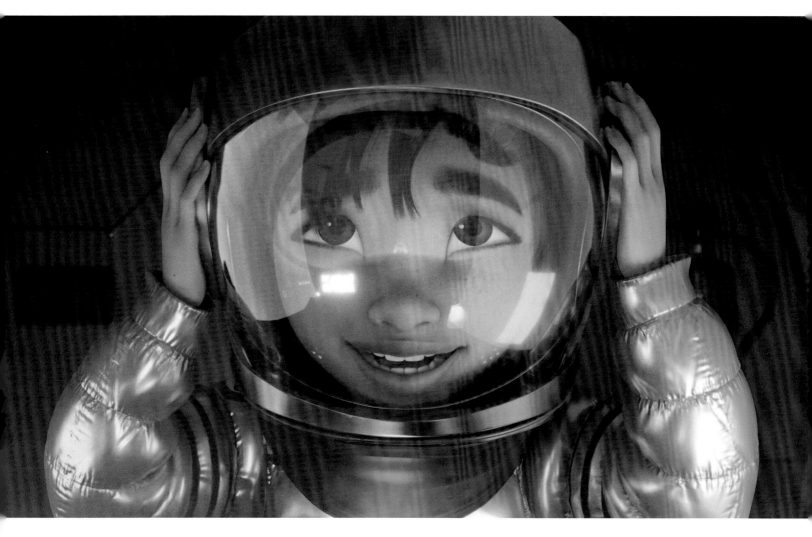

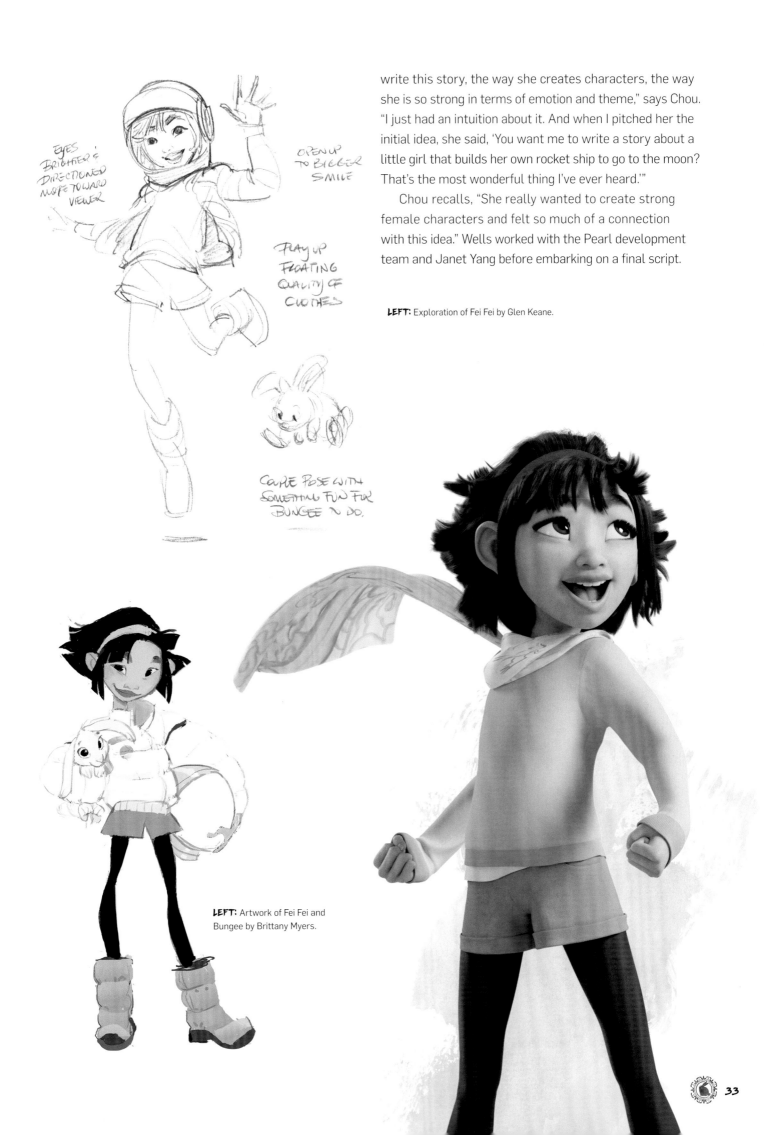

EYES BRIGHTER & DIRECTIONED MORE TOWARD VIEWER

OPEN UP TO BIGGER SMILE

PLAY UP FLOATING QUALITY OF CLOTHES

COUPLE POSE WITH SOMETHING FUN FOR BUNGEE TO DO.

write this story, the way she creates characters, the way she is so strong in terms of emotion and theme," says Chou. "I just had an intuition about it. And when I pitched her the initial idea, she said, 'You want me to write a story about a little girl that builds her own rocket ship to go to the moon? That's the most wonderful thing I've ever heard.'"

Chou recalls, "She really wanted to create strong female characters and felt so much of a connection with this idea." Wells worked with the Pearl development team and Janet Yang before embarking on a final script.

LEFT: Exploration of Fei Fei by Glen Keane.

LEFT: Artwork of Fei Fei and Bungee by Brittany Myers.

THE MUSIC

■ Over the Moon's stunning soundtrack was written by composers Chris Curtis, Marje Duffield, and Helen Park, who worked closely with director Glen Keane and screenwriter Audrey Wells.

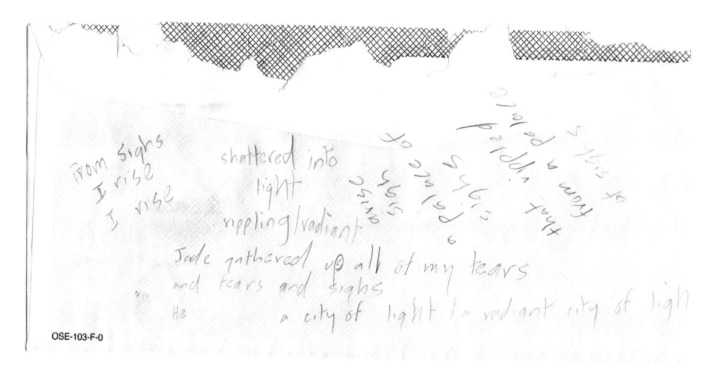

OSE-103-F-0

"It took Audrey longer than is usual for a first draft, almost nine months," says Chou. "It came in and I read it and I wept; this was the best first draft of a script I've ever read. Ever. And I've been doing this, like, twenty-something years. It really, really blew me away. You could tell her heart and soul were in it."

There was just one problem. In the midst of a thriving career, Wells learned she had cancer and was living on borrowed time. She took on the screenplay of *Over the Moon* because it spoke to her. Her husband, Brian Larky, is unabashedly proud of the result and says his wife wrote "a love letter to her husband and daughter to enable them to move on with their lives after she was gone... [giving them] permission to love again." She told Brian, "Love isn't immortal but love is eternal."

At this point, crafting *Over the Moon* wasn't just another assignment: it represented the legacy of its author. Everyone involved felt a special responsibility to honor her screenplay.

Some people believe in serendipity; others call it fate. Chou had met animator extraordinaire Glen Keane when

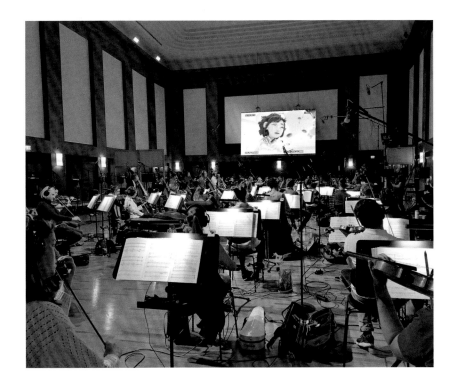

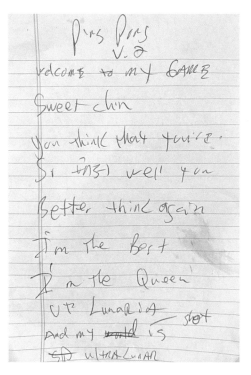

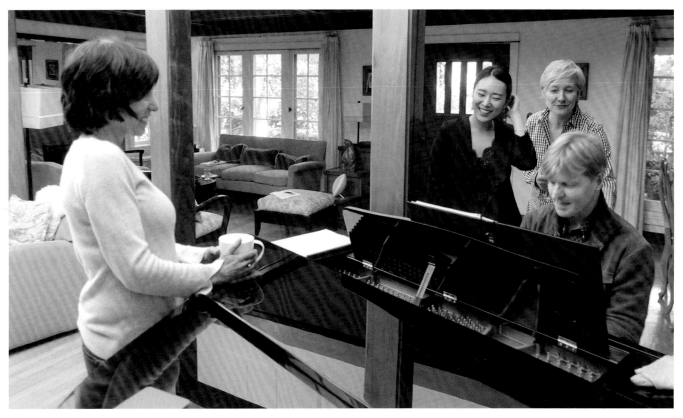

she was a development executive at the Disney studio, but the two hadn't spoken in twenty years. She followed an impulse to attend the Annecy Animation Festival in France in 2017 and, with fellow executive Melissa Cobb (now the Vice President of Original Animation for Netflix), attended a lecture Keane was delivering called 'Thinking Like a Child,' which summed up everything he believes about animation.

Keane picks up the story, "During the talk, she leaned over to Melissa and said, 'That's the guy that needs to direct *Over the Moon,*' and Melissa Cobb said, 'Yes! We've

got to get him.' I think it was something to do with the fact that believing the impossible is possible was the theme of that talk. Afterward, she got in touch with [Keane's producing partner] Gennie Rim and me and said, 'We have a script that we think you should really direct.' I was reading it and at first I wasn't sure if I really believed the story; you know, Walt Disney was always talking about the plausible impossible. I thought, *A girl building a rocket to the moon... thirteen years old... I don't know, am I going to believe this thing?*"

He becomes more animated (pun intended) as he recounts his experience. "As I'm reading it, I got to the page where her rocket launches and then it runs out of power and starts falling back, like they're going to die, and I was like, *Yes! Now I believe it! Now you've got to save them somehow!* I was suddenly invested in wanting to believe, which is such an important thing. You've got to get the audience to want to believe, and I did. Then this beam of light comes down and starts pulling her up to the moon. It was at that point that I thought, *Wow, Audrey knows how to grab the audience to get them to commit to something that they would never have committed to otherwise.* I was really impressed with her writing and the heart of the story. It wasn't long into it that I realized I really wanted to do this movie. I feel like I was *called* to do this movie."

It isn't hard to see what stirred that feeling in Keane. Every story needs a protagonist that the audience can relate to and root for. In *Over the Moon*, it's Fei Fei. An impish thirteen-year-old girl, she happily participates in the family business, baking and selling mooncakes. Her mother sings to her about the immortal moon goddess known as Chang'e, and Fei Fei takes her to heart... all the more so as her mother becomes ill and passes away. Now there is a shrine to her in the family home, and a void that can never be filled.

ABOVE: A lyric sheet of 'Rocket to the Moon' with handwritten notes and changes by Marjorie Duffield.

LEFT: Additional songwriting thoughts and ideas by Marjorie Duffield.

"THE SONGWRITING PROCESS ITSELF WAS SO JOYOUS; IT WAS JUST KIND OF MAGICAL HOW IT ALL WORKED OUT."

HELEN PARK
SONGWRITER

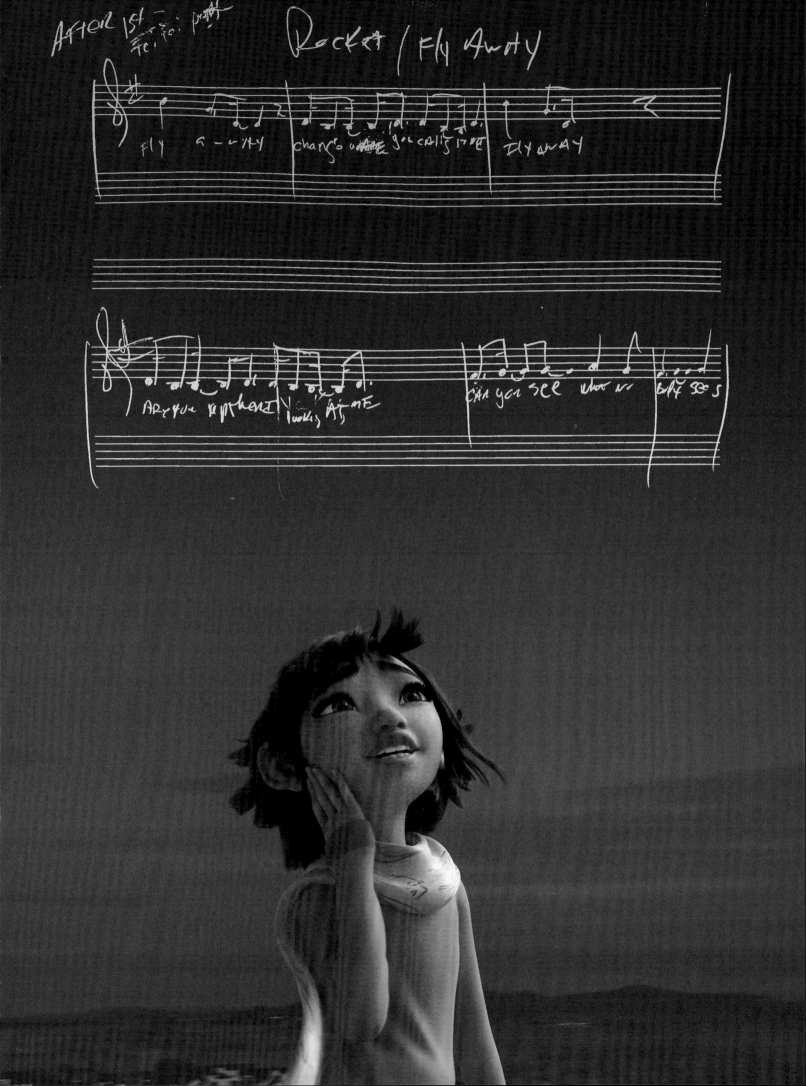

THE TOWN

■ Fei Fei's beautiful home is based on Chinese water towns. Glen Keane and his creative team took a research trip to these towns so they could fill the film with as many beautiful details as possible.

ABOVE: A sketch from the research trip by Glen Keane.

BELOW: A design of the exterior of Fei Fei's house in situ, by Wang Rui.

OPPOSITE: Artworks of the town by Wang Rui.

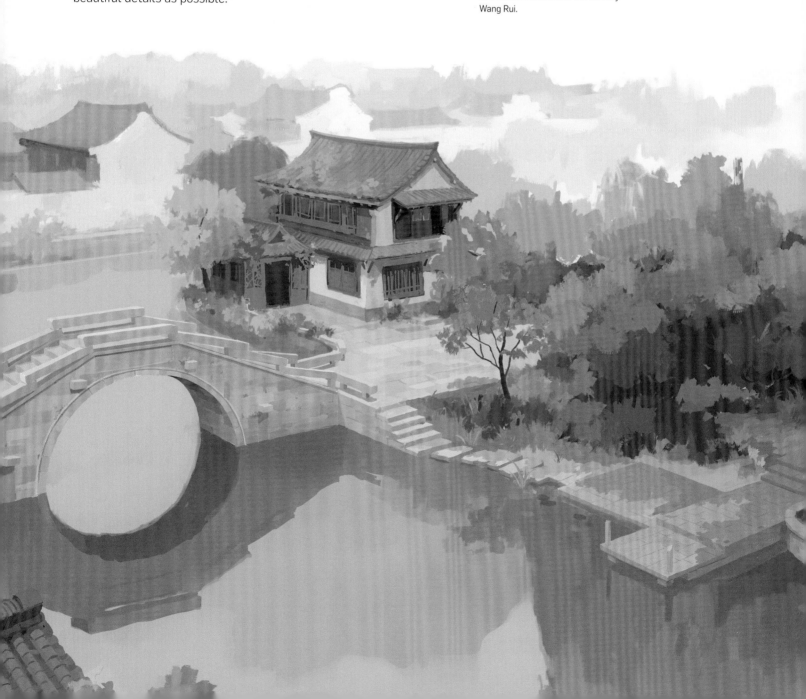

"WE ALL BROUGHT OUR
A-GAME BECAUSE WE
KNEW THIS WAS A VERY
SPECIAL PROJECT."

KEN JEONG
GOBI

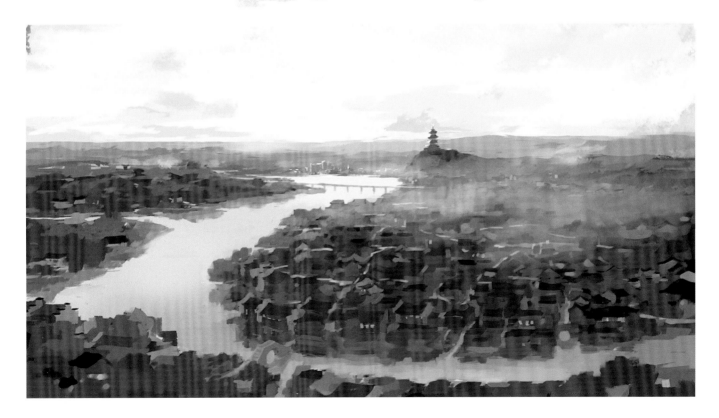

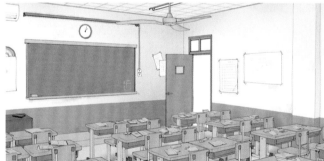

ABOVE: Design of Fei Fei's classroom by Elle Shi.

At the next family dinner, there are two unwelcome newcomers: a nice woman named Mrs. Zhong, whom Fei Fei shuns, and her hyperactive son, Chin, who believes he can crash through walls and plays leapfrog with an actual pet frog. Family chatter that evening convinces Fei Fei that she and her pet rabbit, Bungee, are the last true believers in the mythical Chang'e. This cements her plan to build a rocket ship that will take her and her devoted rabbit to the moon to meet the legendary Moon Goddess. (Here, she sings what is sometimes referred to as the "I want" song, 'Rocket to the Moon.')

Sure enough, Fei Fei and Bungee make their way to the moon, where they meet the goddess on her home turf, called Lunaria. Chang'e is a majestic figure, dressed in the height of fashion, but aloof, imperious, and far from welcoming—as mercurial as the Queen of Hearts in Lewis Carroll's *Alice in Wonderland*. Lunaria is populated with creatures created by her tears. All she seems to care about is an elusive gift that she has been promised. Fei Fei embarks on a series of adventures while searching for that gift and meets an array of strange and wonderful characters.

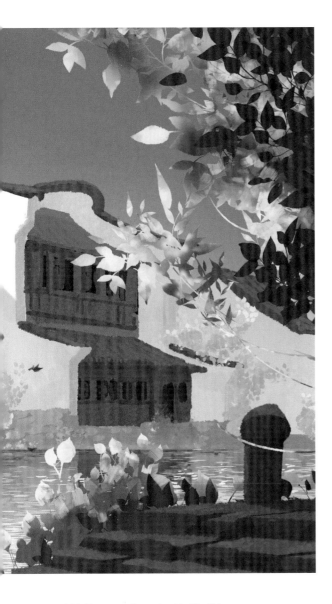

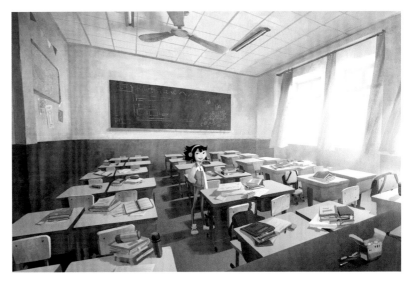

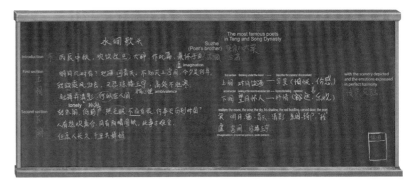

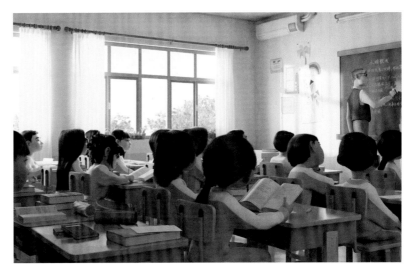

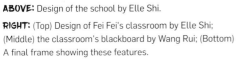

ABOVE: Design of the school by Elle Shi.

RIGHT: (Top) Design of Fei Fei's classroom by Elle Shi; (Middle) the classroom's blackboard by Wang Rui; (Bottom) A final frame showing these features.

For Keane, connecting to this story marked a turning point in the development of *Over the Moon*. "To me, the through-line is always through the main character," he declares. "I would not have wanted to do this movie if it was just about Chang'e. It had to be about this kid that had a drive that came from somewhere deep inside and she couldn't resist it. Everything I've done starts with that kind of character. I really connected with Audrey and her way of writing, which is very visceral, though she's also a really super, super-smart lady. At a certain point, I said, 'So, Audrey, obviously this is a dream for Fei Fei,' and she

said, 'It is?' 'I mean, Dorothy didn't go to Oz.' 'Of course she did!' And [I was] like 'No! No!' and she said, 'Yes! You don't believe that?' I said, 'No!' She was sitting on a couch and I'm sitting on the other side of the couch. We actually have a picture, this is probably several months before she died, and we're both just looking at each other. I love the fact that between the both of us, there is the movie, and it has to exist on this razor's edge that the audience could choose to believe one way or the other."

The next vital step was taken by Keane's producing partner, Gennie Rim. Keane says, "Gennie has a knack

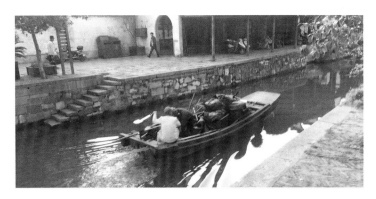

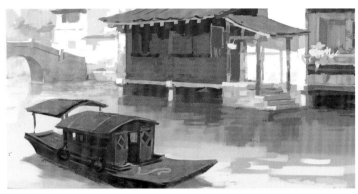

THIS SPREAD: Designs of the town by Wang Rui and references photos from the trip to China.

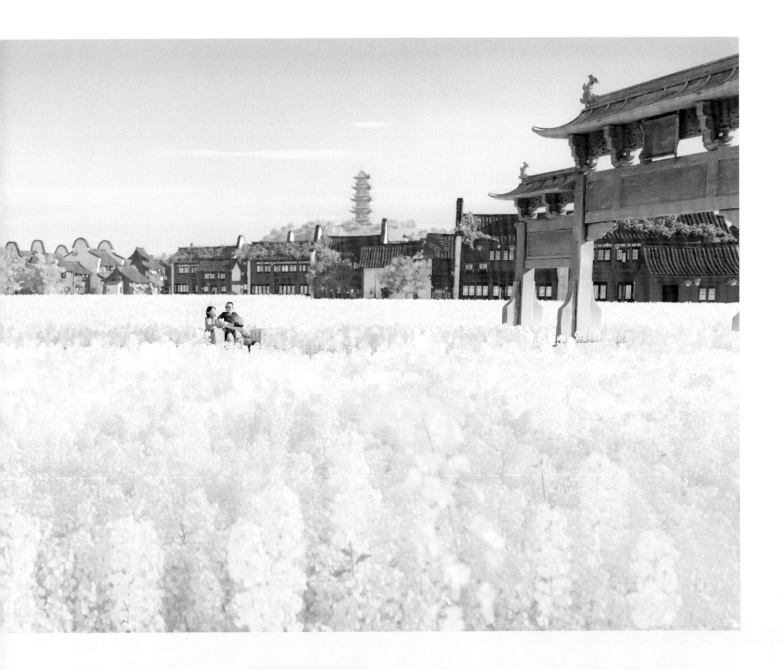

of finding the right people to bring together, but she does it in a very natural way. She won't tell me, 'I think I know the perfect production designer for this movie.' Instead, we were in Montreal visiting different studios as a possibility to do the film and she said, 'I'm going to go have a drink with a friend; do you want to join me?' and I was like, 'Oh man, I'm kind of tired. I don't think so.' And then I'm walking back toward the hotel and I'm like, 'Okay, maybe—yeah, all right. I'll come.' And it was Céline Desrumaux. So we walk in and there's Céline in a cafe.

"And what struck me was that Céline had a shovel with her. She had just bought a shovel for shoveling snow. I took a picture of her with her shovel. And now when I think about Céline and how the everyday things in life are so important, that was so appropriate. We sat down and started to talk about this movie and art and color and design. I felt, *I like the way this girl pushes me out of what is normal into something new. I really hope we get a chance to work together*, though I didn't know that that was all in Gennie's little devious mind. And she agreed to come on and be our production designer."

LEFT: A house design by Mehrdad Isvandi.

BELOW: Design of Fei Fei and her mother selling mooncakes on a busy street, by Wang Rui.

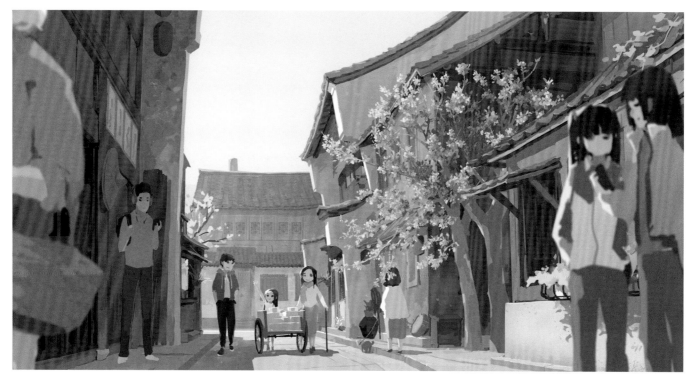

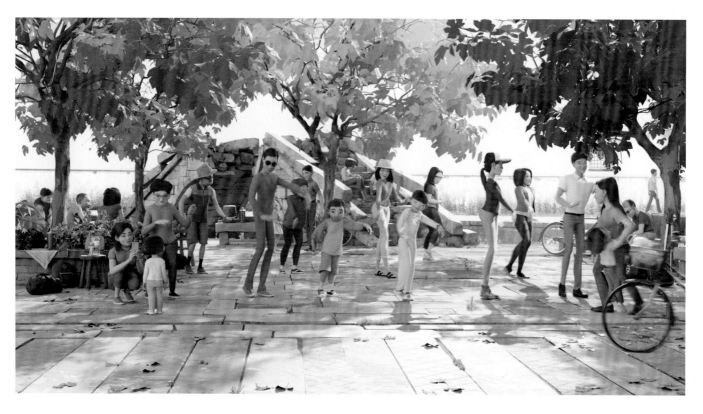

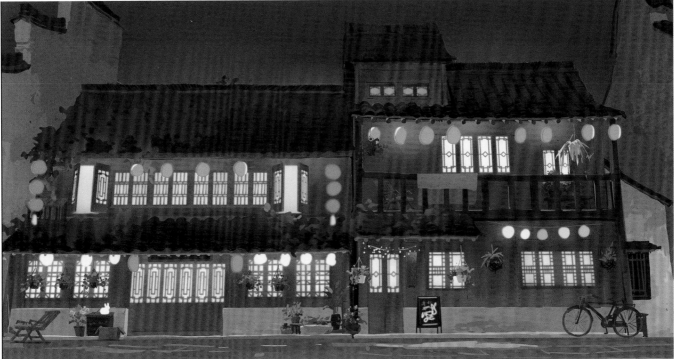

ABOVE: Design of a building by Wang Rui.

TOP: Design of the "White Wall" by Céline Desrumaux.

RIGHT: A photograph taken on the crew's trip to Shanghai.

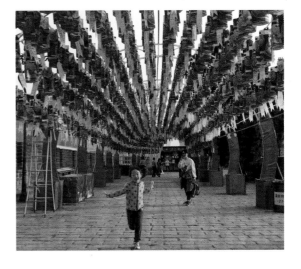

FEI FEI'S FATHER

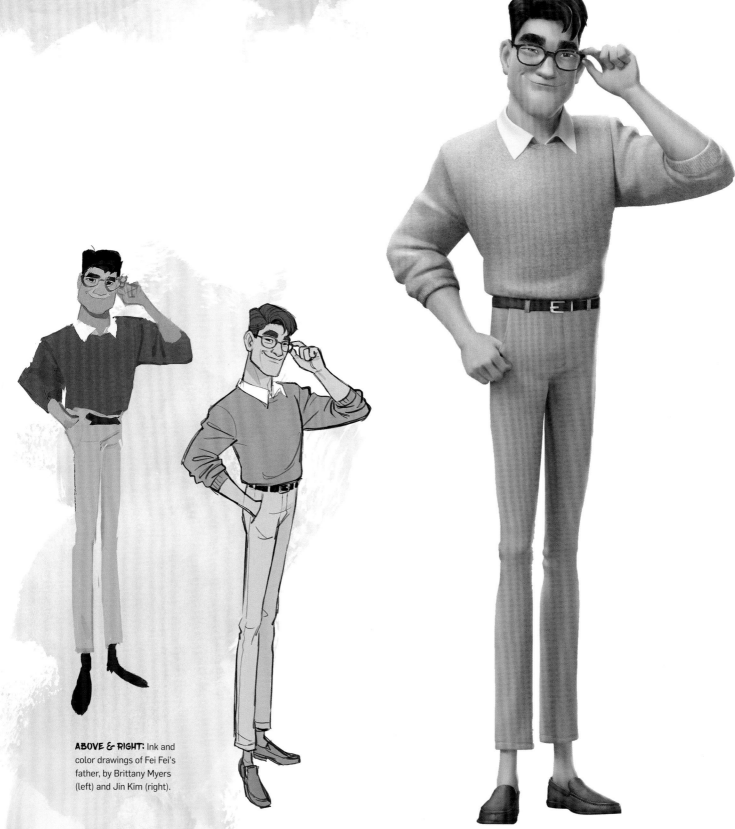

ABOVE & RIGHT: Ink and color drawings of Fei Fei's father, by Brittany Myers (left) and Jin Kim (right).

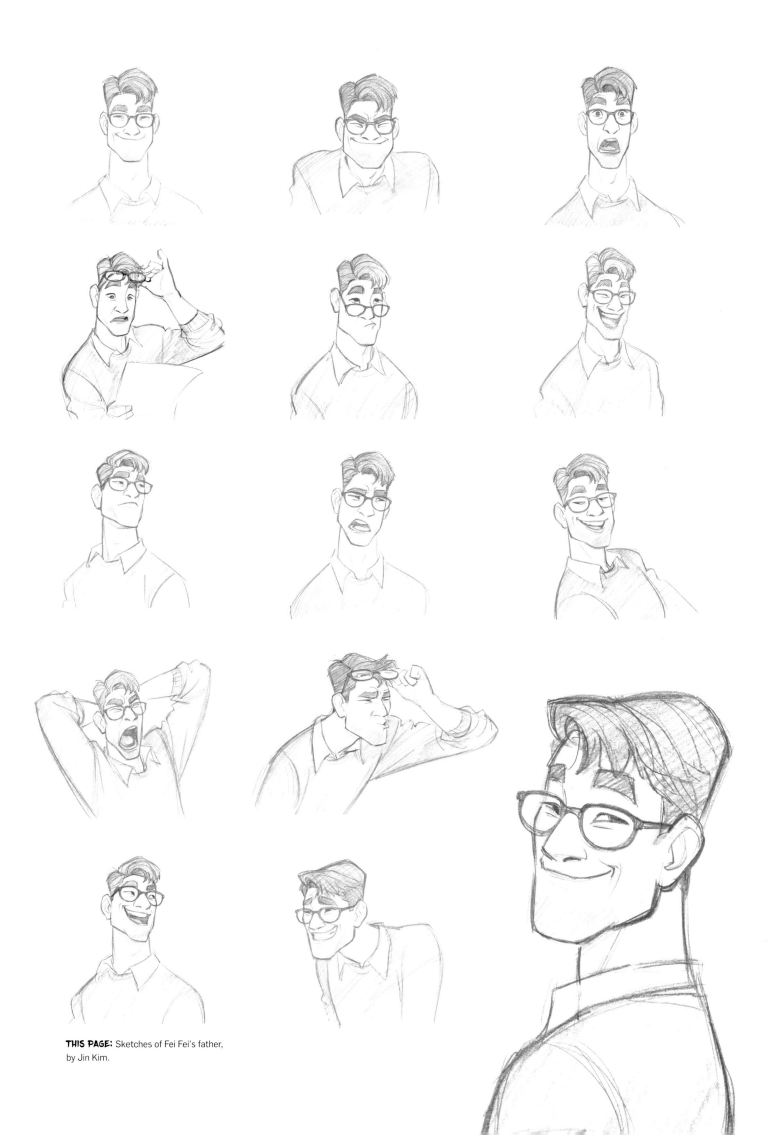

THIS PAGE: Sketches of Fei Fei's father, by Jin Kim.

FEI FEI'S MOTHER

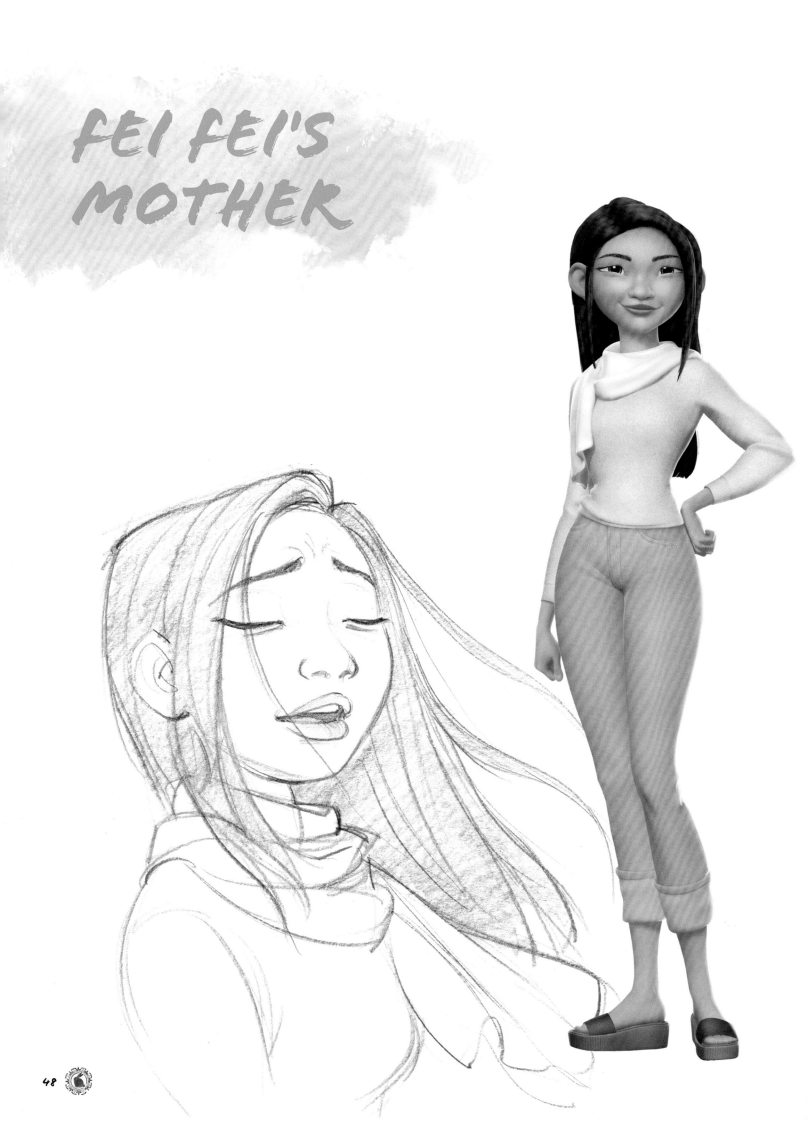

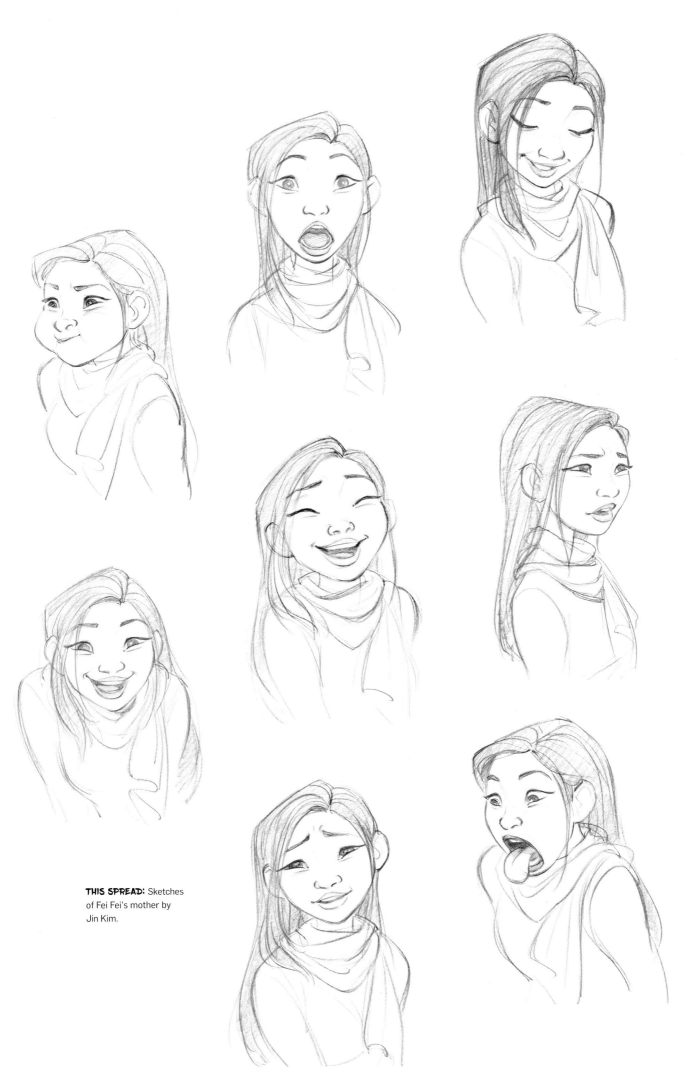

THIS SPREAD: Sketches of Fei Fei's mother by Jin Kim.

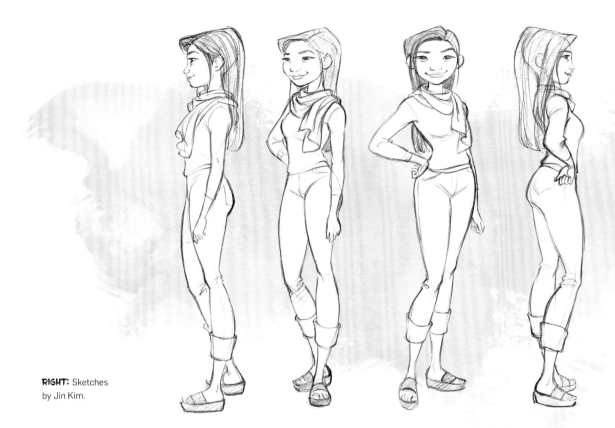

RIGHT: Sketches
by Jin Kim.

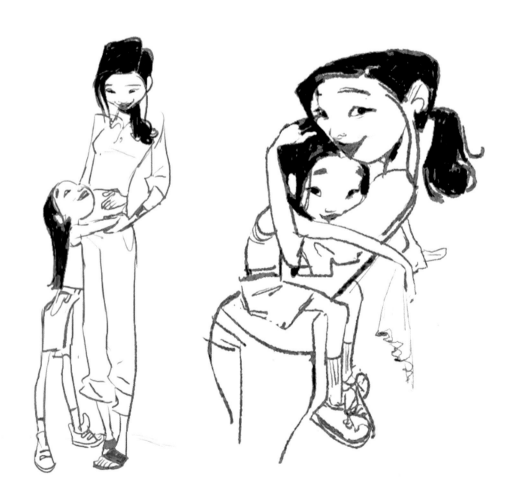

RIGHT: Sketches
by Brittany Myers.

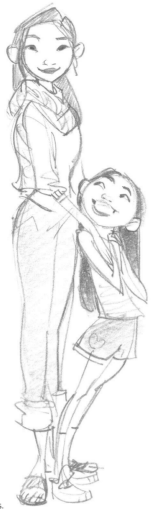

RIGHT: Sketch by Glen Keane.
BELOW: Artwork by Brittany Myers.

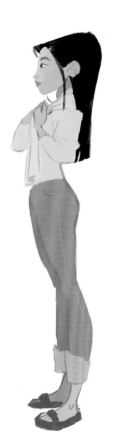

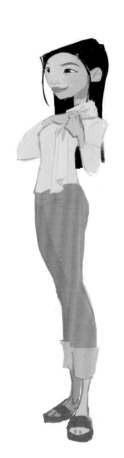

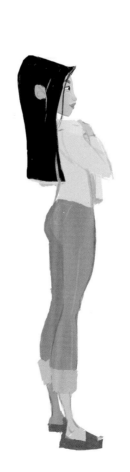

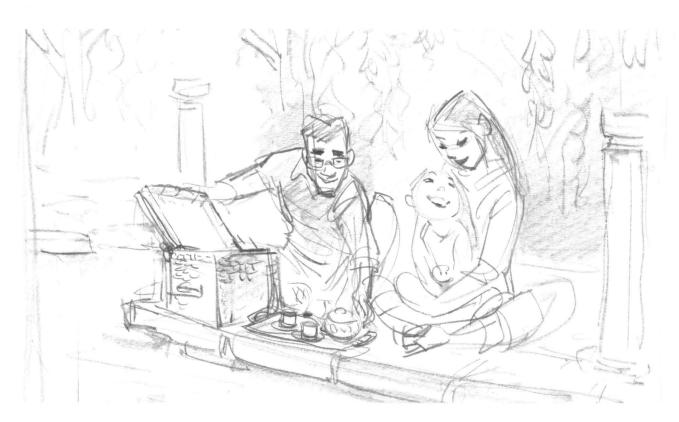

THIS SPREAD: Artwork of a young Fei Fei and her family in the Special Place, by Glen Keane (above and opposite) and Tian Yuan (below).

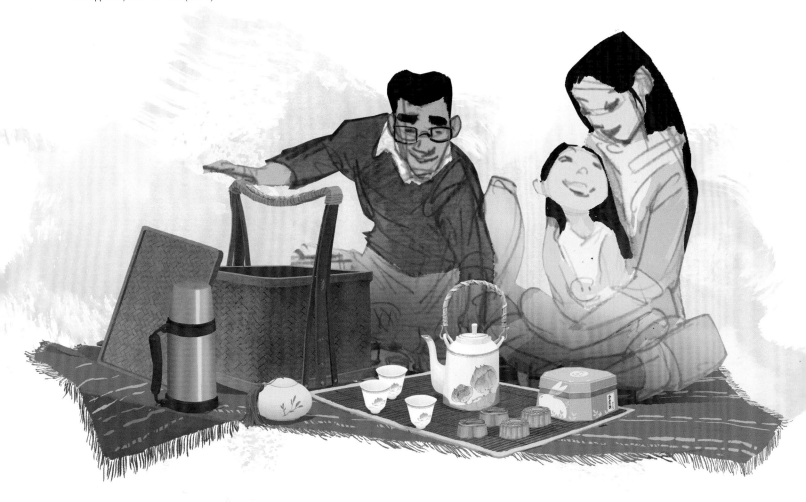

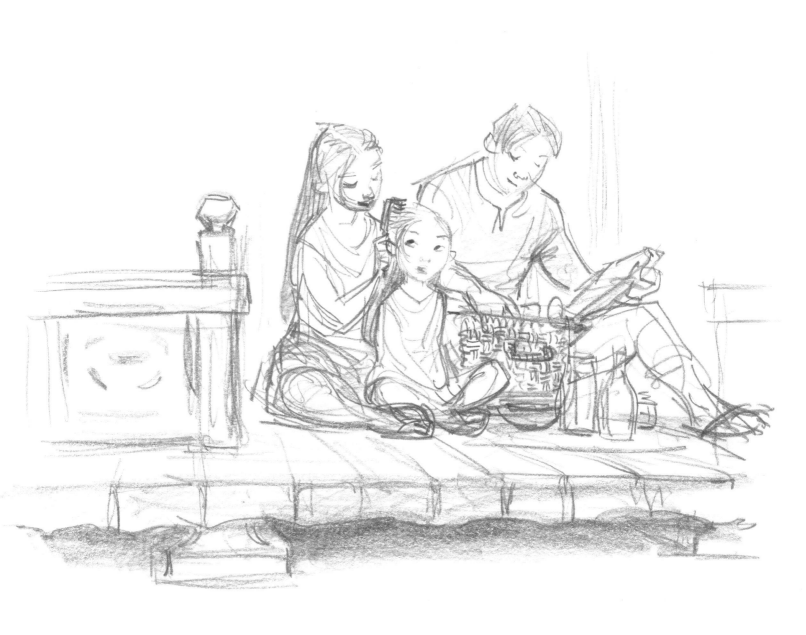

YOUNG FEI FEI
"BABA, DO YOU THINK
CHANG'E IS REAL?"

FATHER
"IF YOUR MOTHER SAYS
SHE'S REAL, THEN SHE IS
ABSOLUTELY REAL."

THE HOUSE AND SHOP

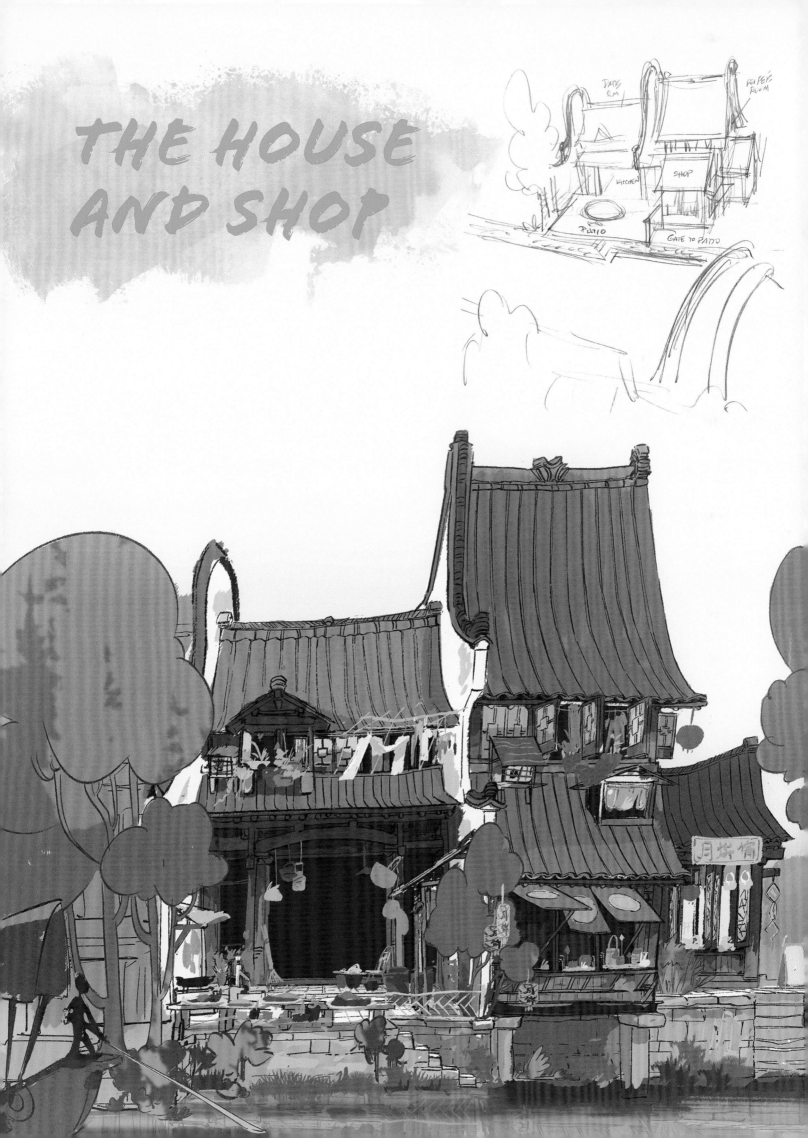

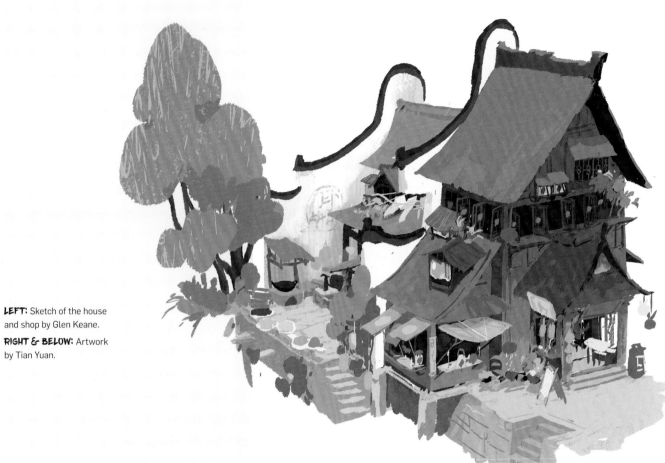

LEFT: Sketch of the house and shop by Glen Keane.

RIGHT & BELOW: Artwork by Tian Yuan.

BOTTOM: Artwork by Mehrdad Isvandi.

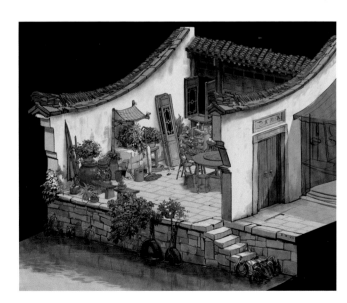

One task facing the burgeoning team was logistical: this project would be a co-production of Netflix, based in Los Angeles, and Pearl Studio, located in Shanghai (while its executive Peilin Chou spends most of her time in New York), with much of the animation executed by the artists at Sony Pictures Imageworks in Vancouver. Audrey Wells worked from home in Southern California. Logistics worked themselves out. Chou says, "I think the most challenging thing to me is the time zone, especially with China, because twelve hours is the furthest apart you can be. So somebody has to be at work at night. Either that side or this side. We try to be equitable about it, we try to split it up, so if we have a weekly meeting one week, New York will be at night. The next week, Shanghai will be at night."

THIS PAGE: Designs of the house interior by Cedric Schmitt (top), and Tian Yuan (below).

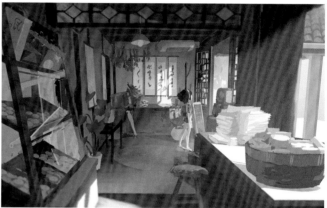

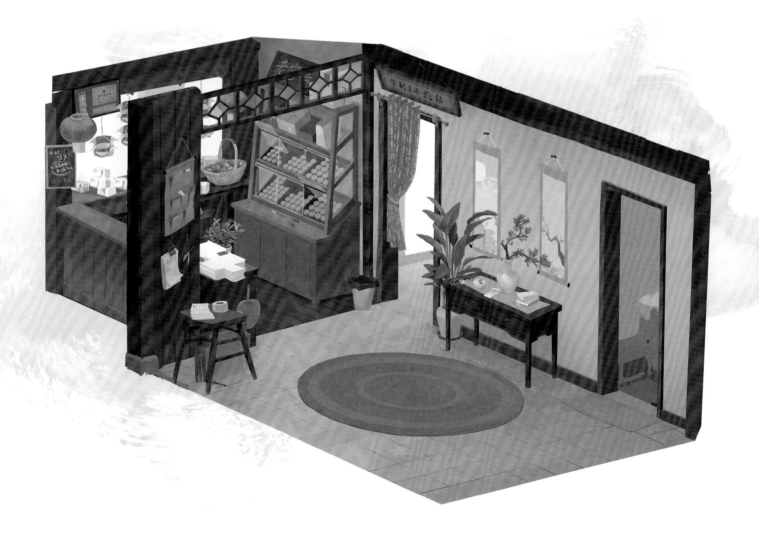

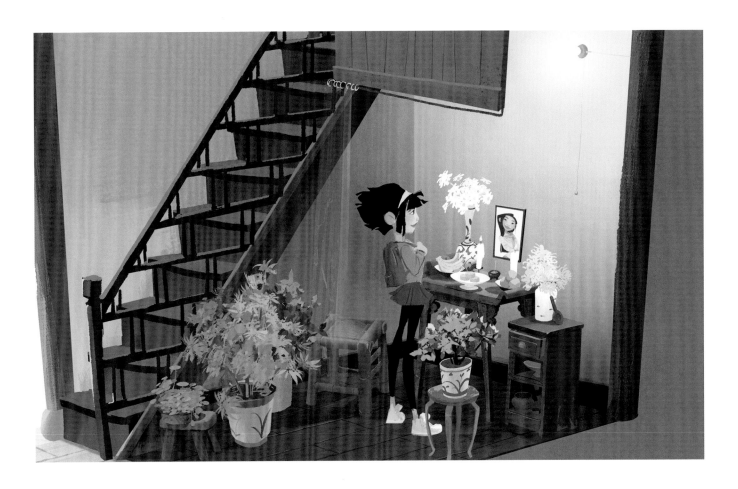

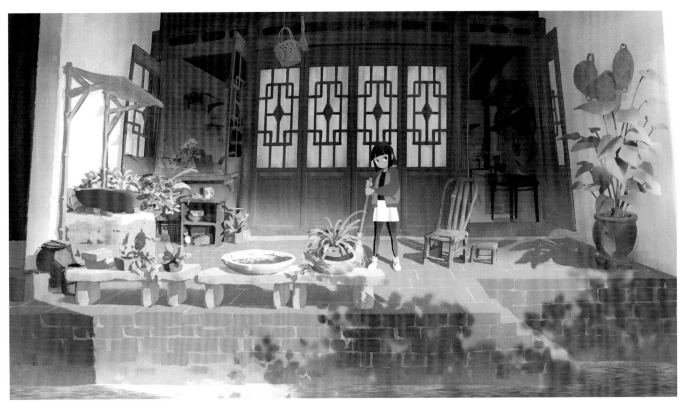

ABOVE: Artwork by Elle Shi.

TOP: Artwork by Tian Yuan.

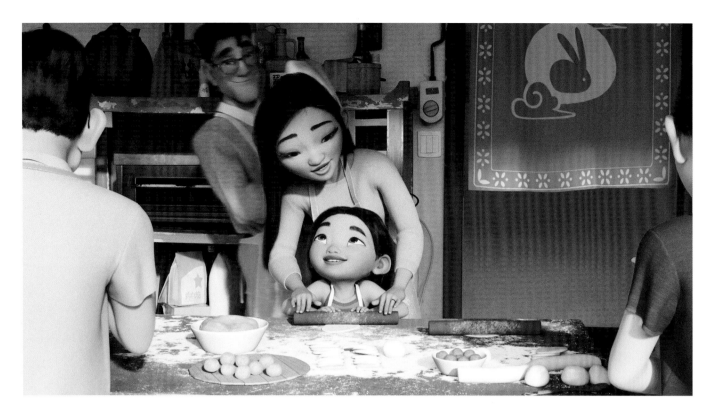

ABOVE: Artwork by Mehrdad Isvandi.

Crucial to every step that followed was Keane being willing, even eager, to be pushed outside his comfort zone. At first, he planned to design the characters for *Over the Moon* himself, but "everything I designed looked like it was a Disney movie." He realized that Disney was part of his DNA and asked himself, "How do I think differently and yet don't leave behind all the good, wonderful things I've learned?"

One answer came unexpectedly. "I just happened to be on Facebook going through images and there was a drawing of a Little Mermaid there by a girl named Brittany Myers. When I looked at it, I said, 'Is that my drawing? It's sketchy, it's very much like an animated drawing, except she does it with paint and color. There's something really fresh and new. It feels like me, but it's not me. I wonder how she's doing that?' And Gennie said, 'Well, let's hire her.'"

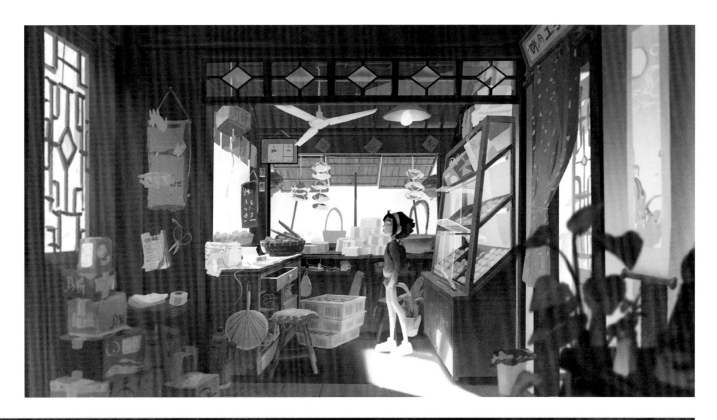

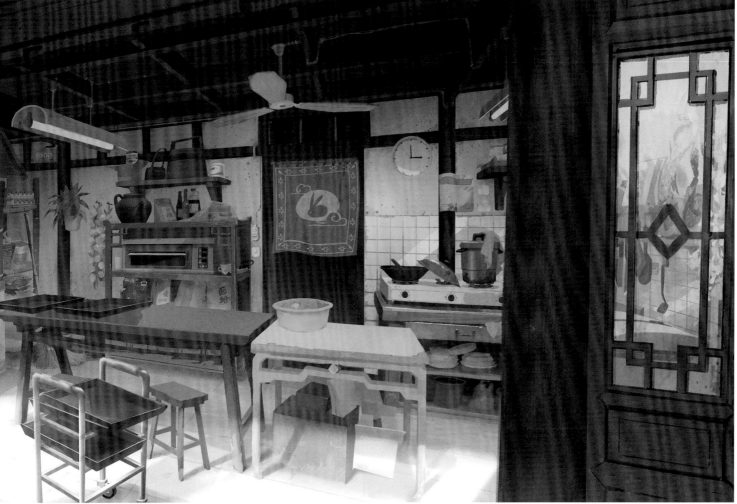

THIS PAGE: Artwork by Tian Yuan.

MOONCAKES

■ Fei Fei's family make a living making and selling mooncakes, a traditional Chinese dessert eaten around the Mid-Autumn Festival. These have all sorts of different fillings from salty egg yolk to custard to red dates, which Mrs Zhong puts in her cakes.

RIGHT: Tian Yuan's design of Fei Fei's family's mooncakes, with a distinctive rabbit design.

BELOW: Fei Fei and her mother with their mooncake cart by Tian Yuan.

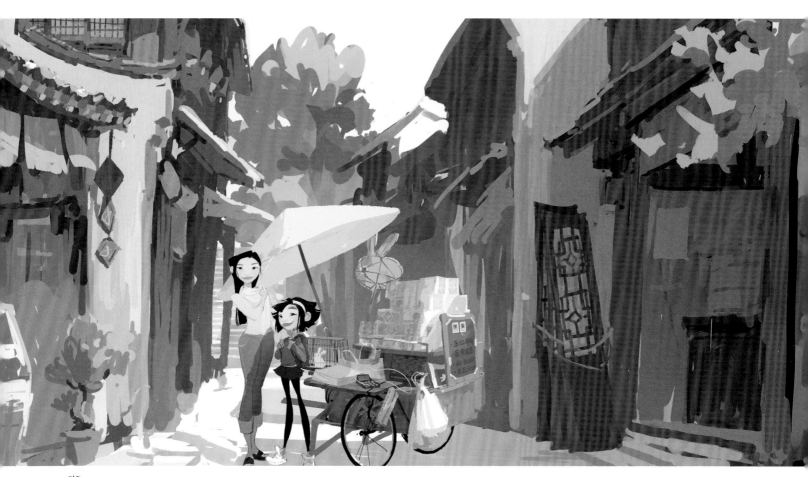

LEFT & BELOW: Various mooncake designs, by Elle Shi (left) and Wang Rui (below).

RIGHT: The mooncake cart. Artwork by Tian Yuan.

BELOW: Mooncake boxes. Artwork by Wang Rui.

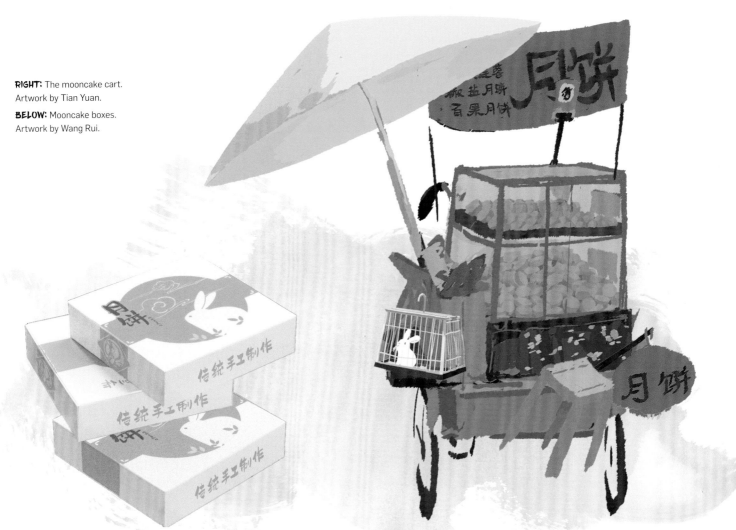

BUNGEE

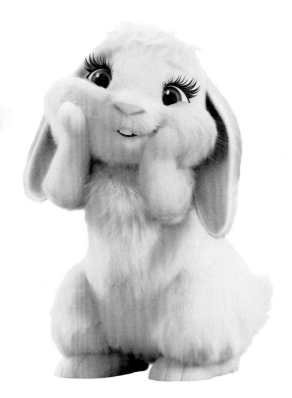

■ A gift from her parents shortly before the death of her mother, Bungee is Fei Fei's beloved pet and joins her on her adventure to the moon.

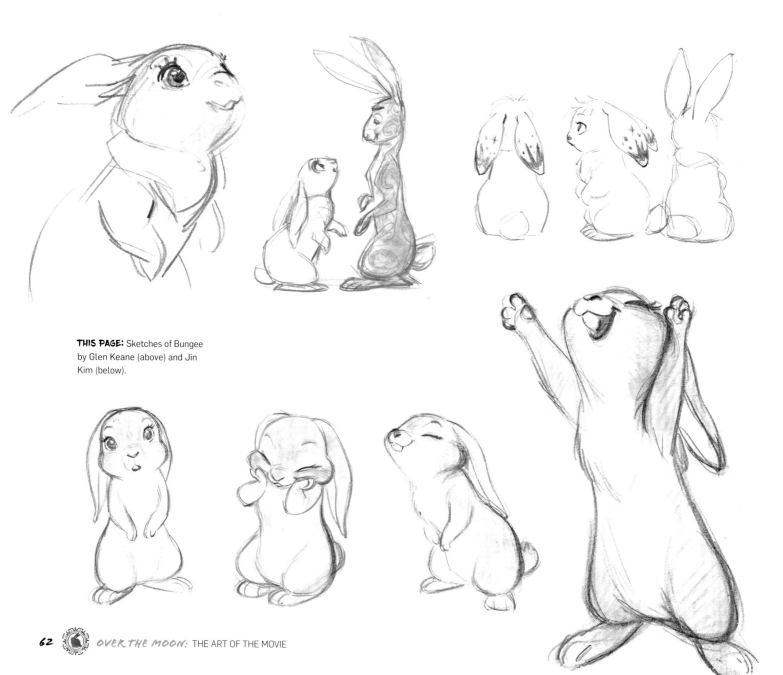

THIS PAGE: Sketches of Bungee by Glen Keane (above) and Jin Kim (below).

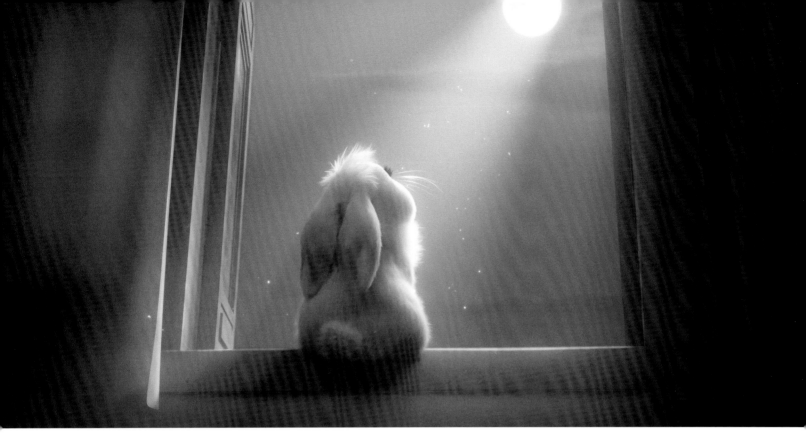

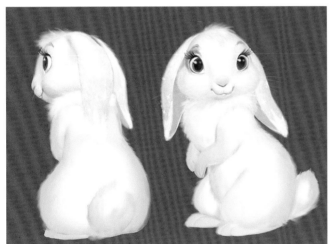

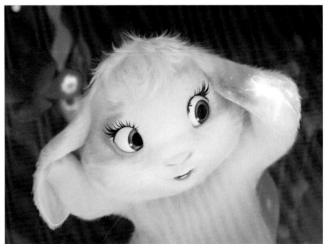

ABOVE: Artwork by Marion Louw.

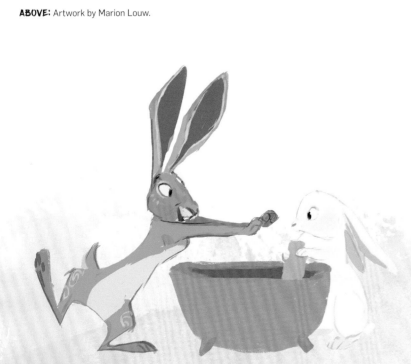

LEFT: Bungee with Jade Rabbit.
Artwork by Brittany Myers.

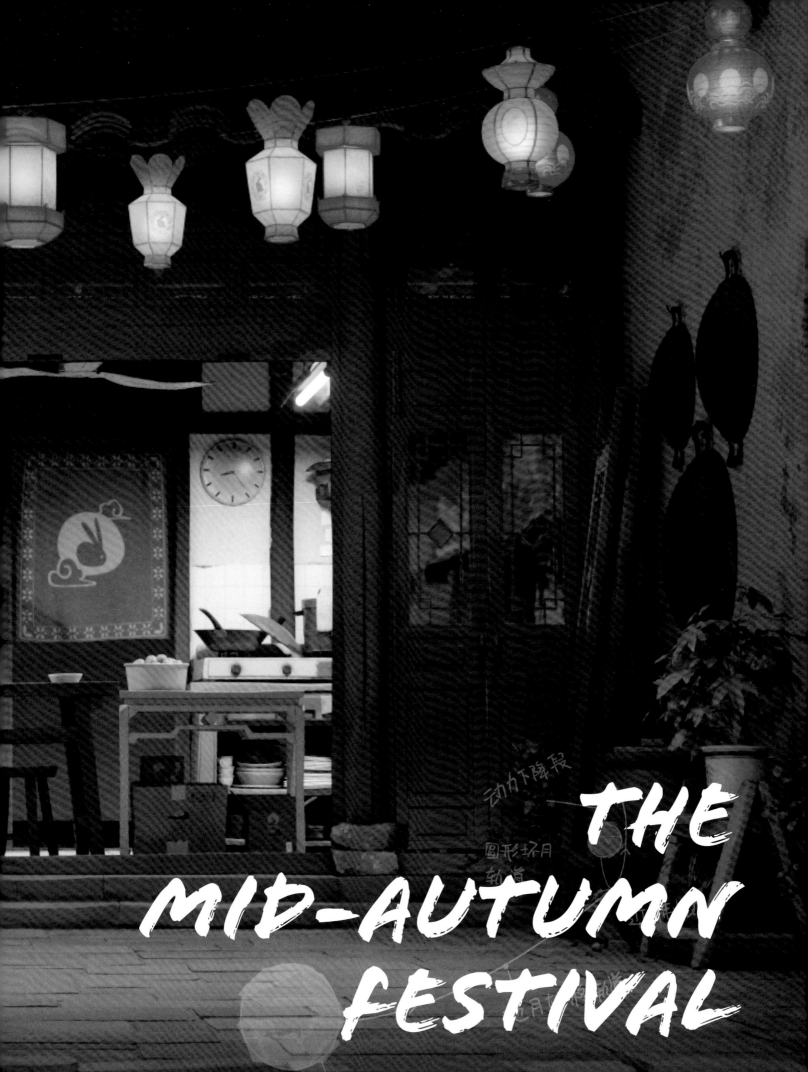

FAMILY DINNER

■ One of the key motifs of *Over the Moon* is the family dinner—it starts and ends with Fei Fei's whole family sitting around a table, sharing food to celebrate the Mid-Autumn Festival. Family togetherness is a key theme of the film.

BELOW RIGHT: Early design of the "lazy Susan" style table by Elle Shi.

BELOW LEFT: The crew eating dinner around a "lazy Susan" style table on their trip to China.

BOTTOM: A sketch of a Chinese family dinner, drawn by Glen Keane during a trip to Shanghai.

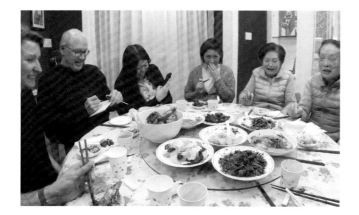

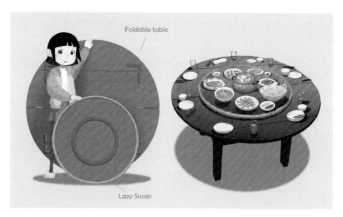

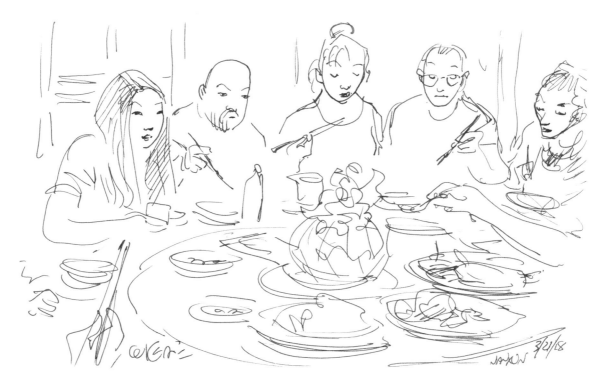

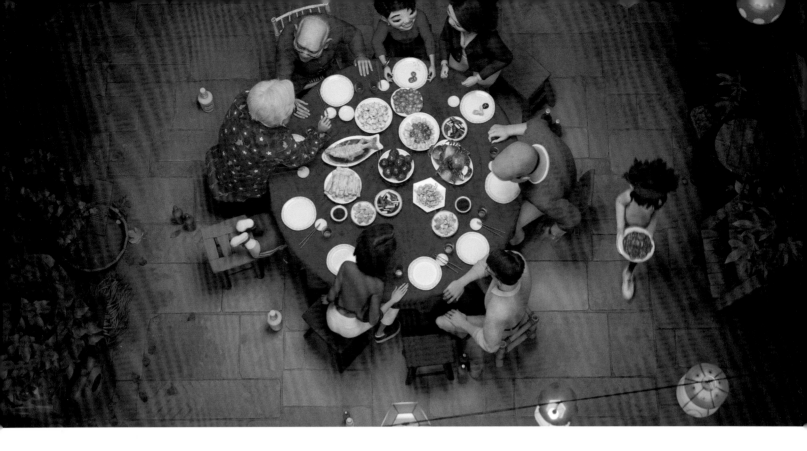

ABOVE: Final frame of Fei Fei's family around the dinner table.

LEFT: Photos taken during the team's Shanghai research trip.

BELOW: An image by Elle Shi, showing the different dishes.

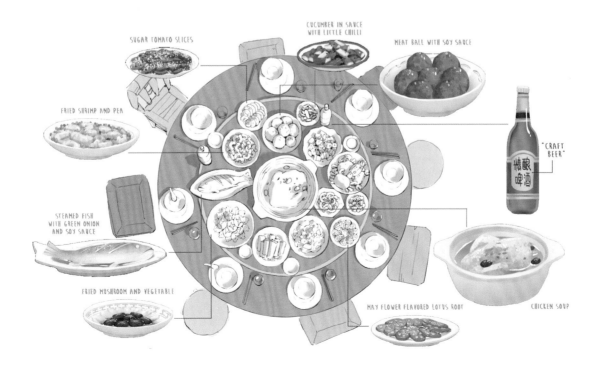

SUGAR TOMATO SLICES

CUCUMBER IN SAUCE WITH LITTLE CHILLI

MEAT BALL WITH SOY SAUCE

FRIED SHRIMP AND PEA

"CRAFT BEER"

STEAMED FISH WITH GREEN ONION AND SOY SAUCE

FRIED MUSHROOM AND VEGETABLE

MAY FLOWER FLAVORED LOTUS ROOT

CHICKEN SOUP

MRS ZHONG

■ The kind Mrs Zhong shakes up Fei Fei's life when she enters her father's life, following the death of her mother, bringing with her a new family: her hyperactive son, Chin, his pet frog, Croak… and a new mooncake recipe.

Rim got in touch with Brittany Myers, who couldn't quite believe what was happening. Keane is now her biggest booster. "She has a way of stretching and elongating things and putting them in proportion that's fresh and new. So I started trying to draw like Brittany! I would take her drawings and translate them through me. I never would have gotten there without her."

The irony is that Myers, who's been drawing all her life, was first inspired by Keane's rendering of Rapunzel. "I saw *Tangled* when I was twelve or thirteen," she recalls, "and that was when I fell in love with her on the screen. I just thought she was adorable. So I Googled Glen and I [thought], *Oh, you can actually draw characters*, because that's all I did. I drew characters in my spare time after school: cute girls, princesses, all that stuff you'd start with when you're young." She decided to pursue a career in animation, little dreaming that she would someday be working alongside the man who first lit that fire within her. "My twelve-year-old, thirteen-year-old self would never have believed that. At all."

THIS PAGE: Artwork of Mrs Zhong by Brittany Myers (left) and Marion Louw (right).

ABOVE: Sketches of Mrs Zhong, showing different expressions, by Jin Kim.

BELOW: A paintover of a scene with Fei Fei and Mrs Zhong by Céline Desrumaux.

FAMILY

■In Fei Fei's world, family is everything! The Mid-Autumn Festival sees Fei Fei's home filled with aunties, uncles, and grandparents, all cooking and eating together.

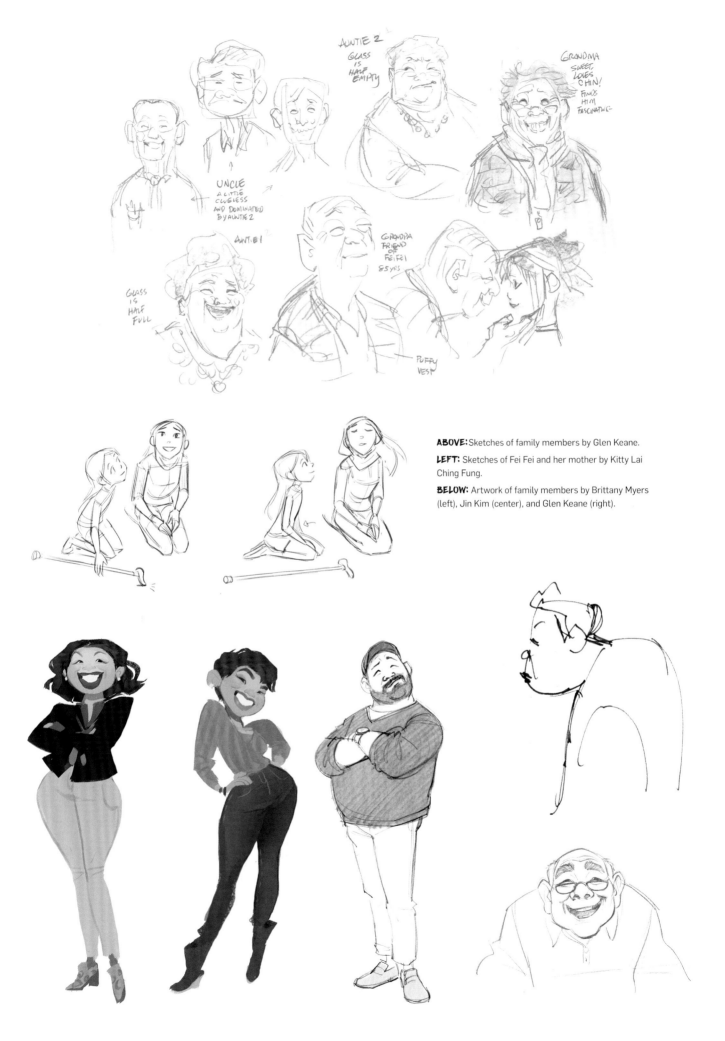

ABOVE: Sketches of family members by Glen Keane.

LEFT: Sketches of Fei Fei and her mother by Kitty Lai Ching Fung.

BELOW: Artwork of family members by Brittany Myers (left), Jin Kim (center), and Glen Keane (right).

THE SPECIAL PLACE

■The veranda behind Fei Fei's house is a very special place, where she used to sit with her mother and father. Many key points of the film happen here, including her decision to build a rocket to the moon.

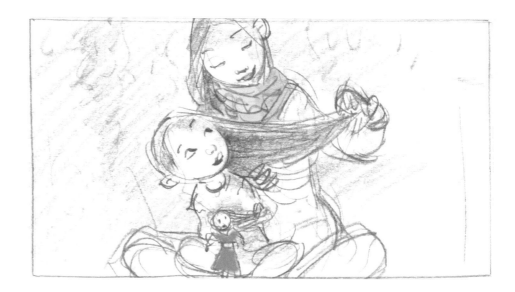

RIGHT: A sketch of Fei Fei and her mother at the Special Place, drawn by Glen Keane.

It helped that Myers related to Fei Fei so strongly. "My favorite part of her is that she's not perfect," she says. "Being a girl myself and watching movies with young girls, I sometimes think they're too perfect, too nice, too princessy. We're not perfect, we get frustrated. There's times in the movie she gets frustrated with her Dad and she throws tantrums a little bit. She is spunky and it shows. That was very fun; it's just kind of free, like her hair."

Although Fei Fei doesn't seem like a complicated character in terms of design, that "simplicity" was the result of much trial and error. "I did a lot of exploration in shape and style," says Myers. "Where's the line [between] realism and cartoon? It's a very emotional film, so we wanted to make sure the acting was very subtle in the designs. We found a style language. Then we developed her wardrobe and we hit every hair strand. I remember

working with Glen for so long and perfecting her chopped-up hair from the silhouette. It gets kinda nitpicky. You know, the headband, how would her hair flow if it's all chopped up? We hit every design detail. How she would dress or how she would hold herself up. One of the fun things that I remember we did, was a little detail where she has the long sweater and her sleeves are always kind of covering her hands. I know I always did that as a kid."

Keane paired her with Jin Kim, who has years of experience as an animator and character designer at studios ranging from Disney to Hanna-Barbera. They may be decades apart in age but "they were fantastic as a team," says Keane. It was Kim who had to make sure that Myers' designs would translate to the CG medium. "Some initial designs were very graphic and then very stylized—very difficult to transform to CG," Kim says. "I was kind of a bridge between 2D and CG."

BELOW: Scenes in the Special Place.
Final frame (top) and Lightkey by
Céline Desrumaux (middle).

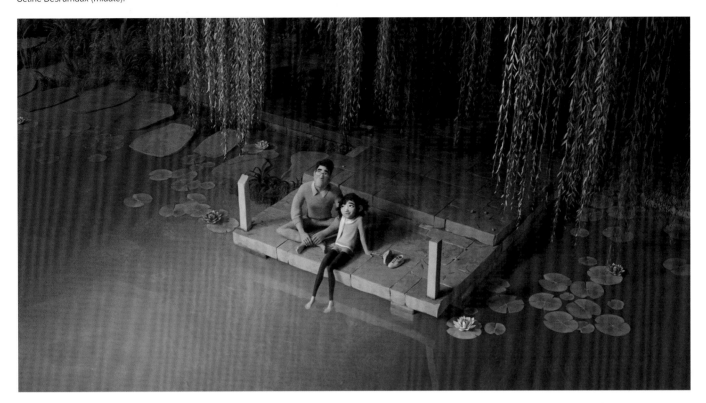

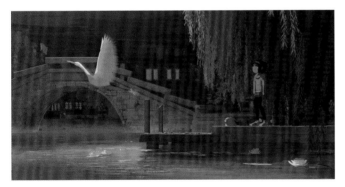

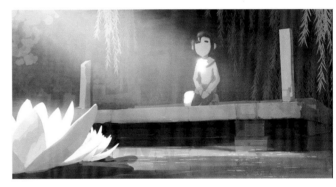

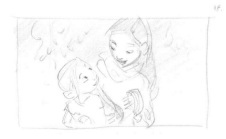

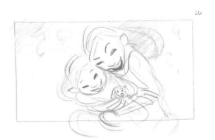

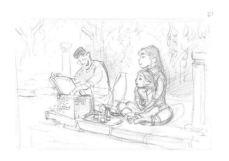

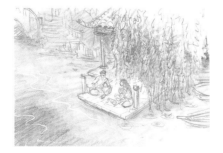

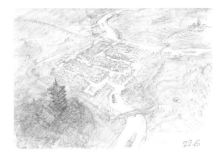

ABOVE: Storyboards of the film's
first scene by Glen Keane.

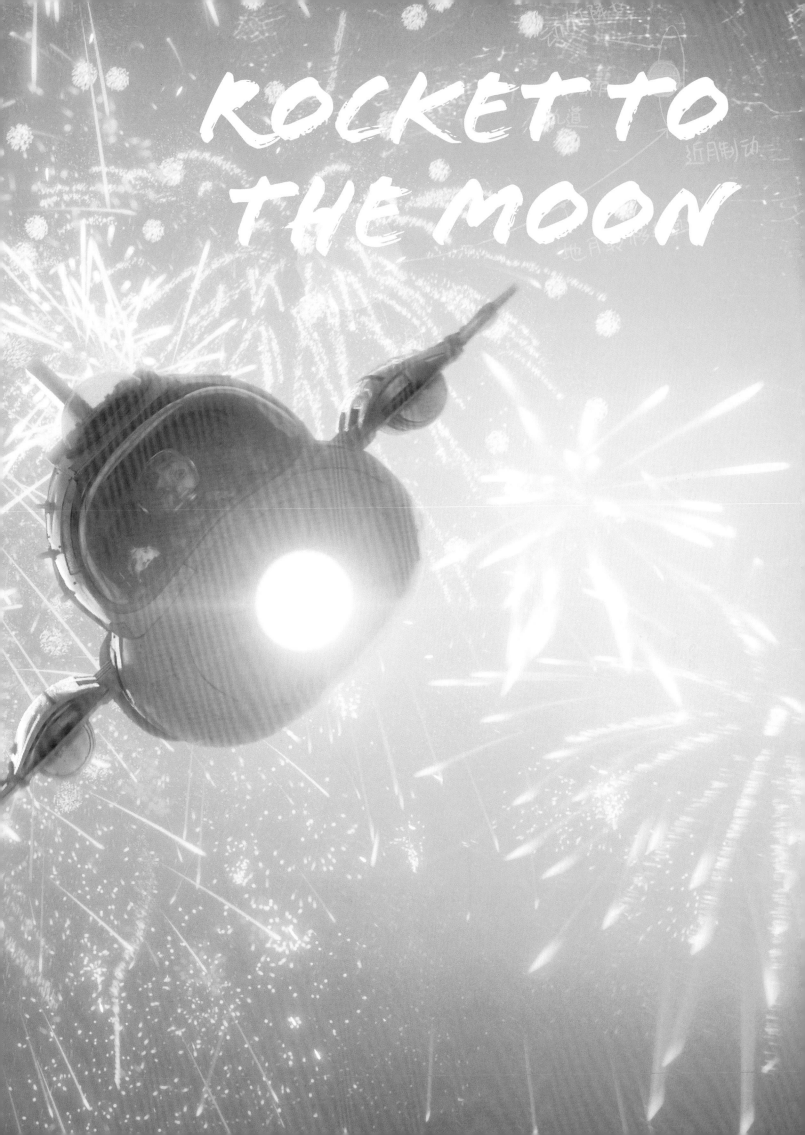

ROCKET TO THE MOON

CHIN

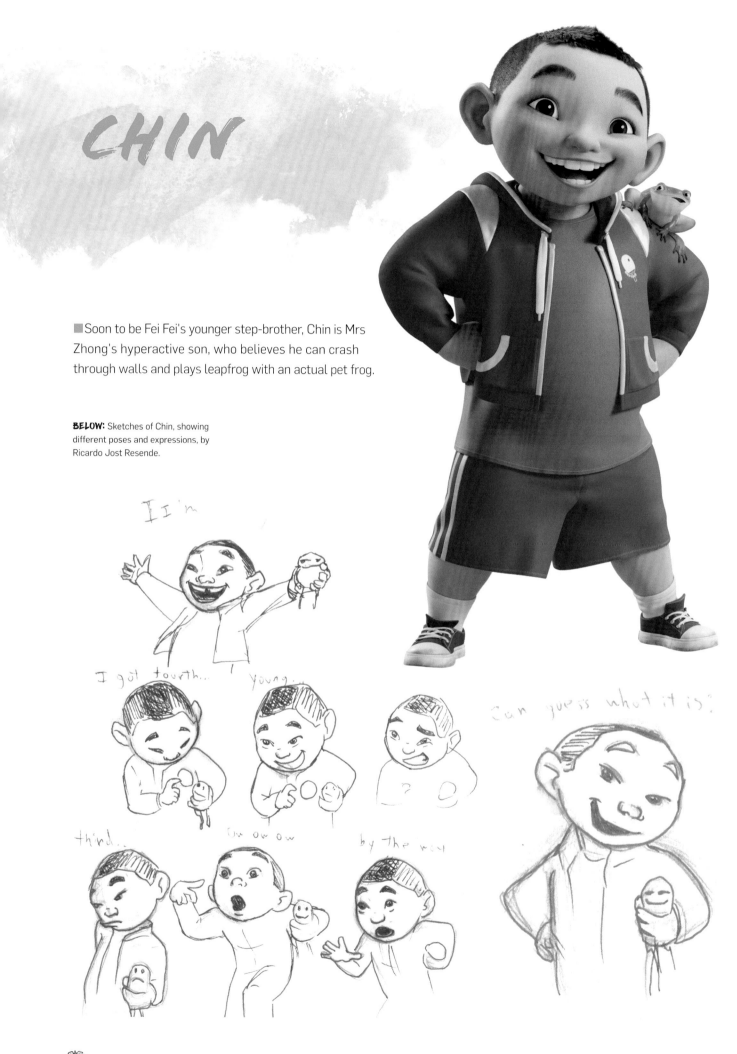

■ Soon to be Fei Fei's younger step-brother, Chin is Mrs Zhong's hyperactive son, who believes he can crash through walls and plays leapfrog with an actual pet frog.

BELOW: Sketches of Chin, showing different poses and expressions, by Ricardo Jost Resende.

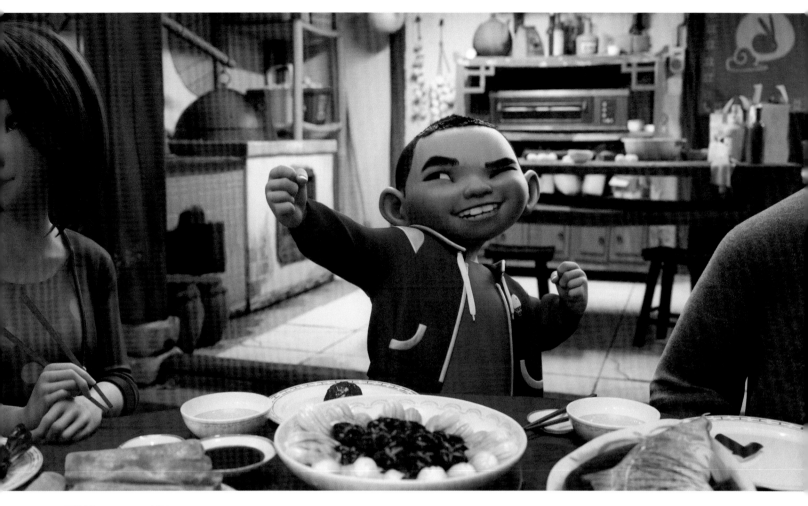

BELOW: Turnaround of Chin.
Sketches by Jin Kim (top) and
colors by Brittany Myers (bottom).

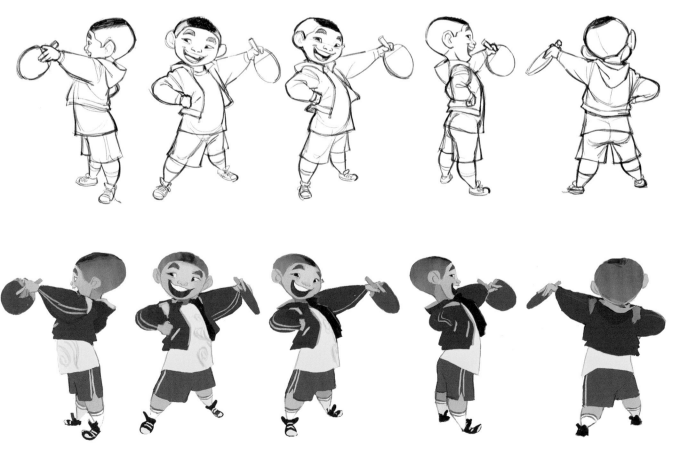

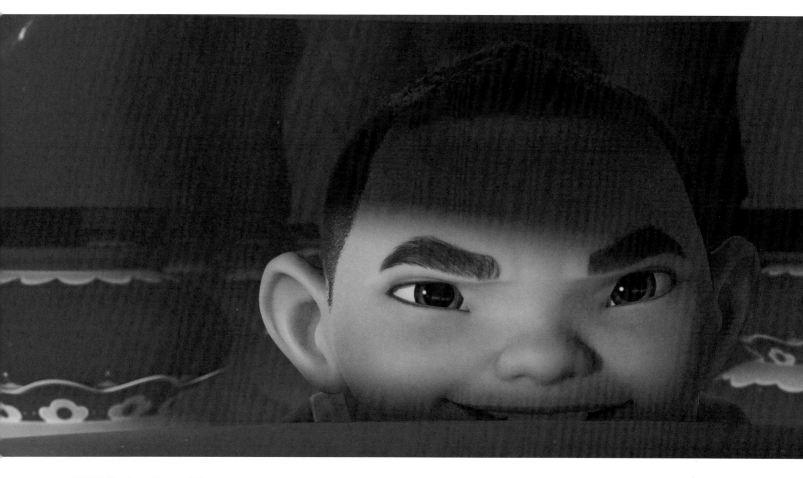

BELOW: Sketches of Chin by Jin Kim.

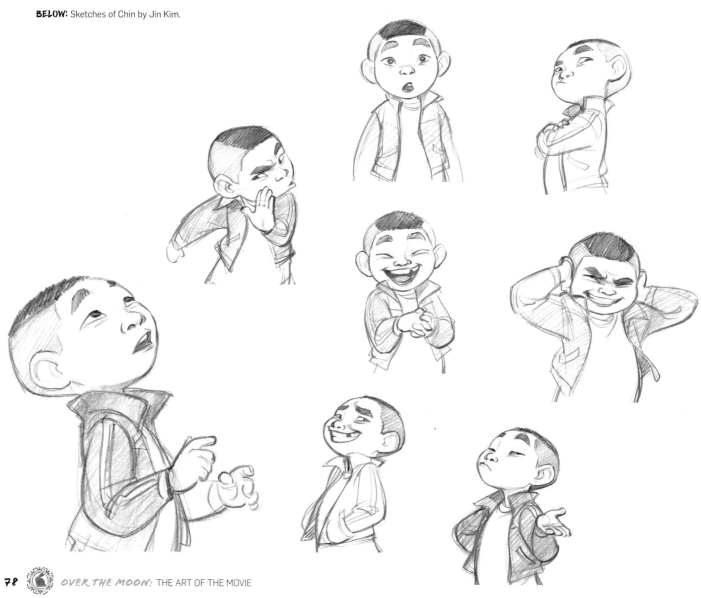

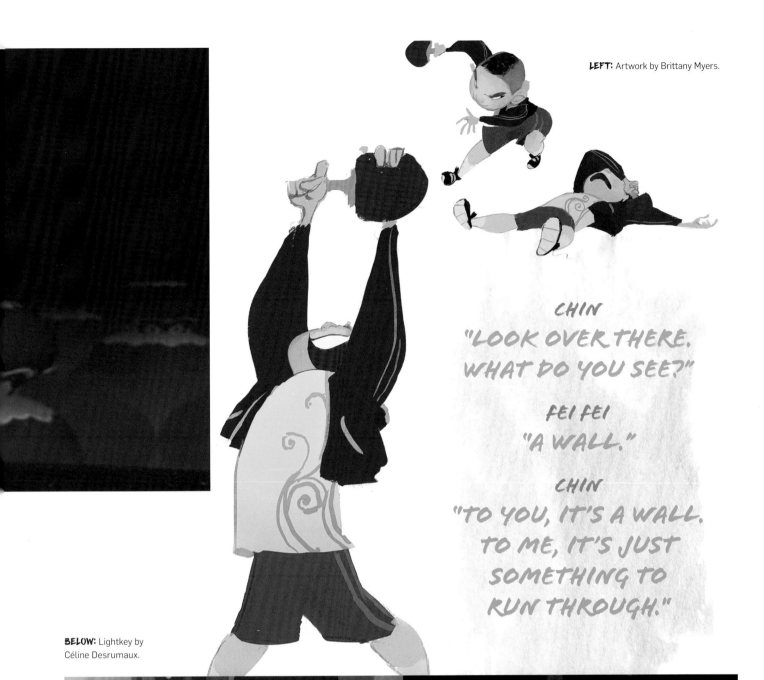

CHIN
"LOOK OVER THERE.
WHAT DO YOU SEE?"

FEI FEI
"A WALL."

CHIN
"TO YOU, IT'S A WALL.
TO ME, IT'S JUST
SOMETHING TO
RUN THROUGH."

BELOW: Lightkey by
Céline Desrumaux.

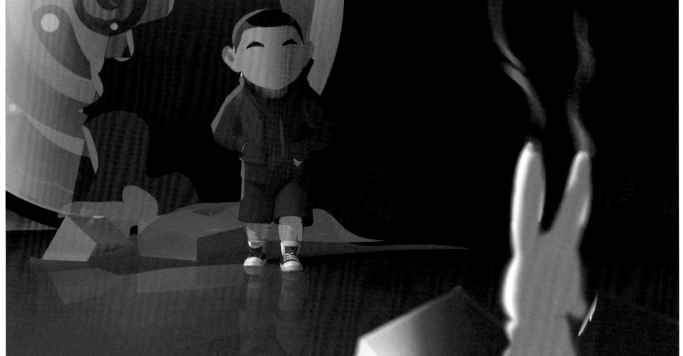

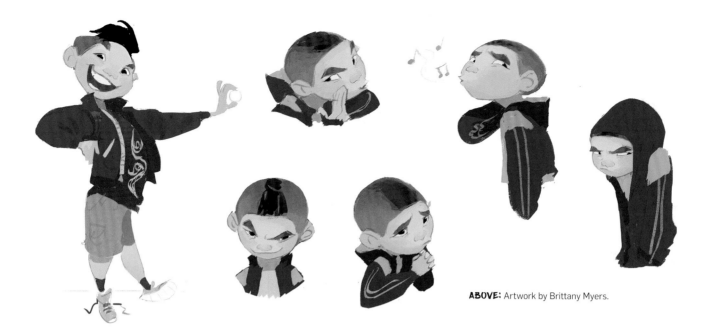

Myers has nothing but respect for her veteran colleague. "Once we found a design we liked, Jin Kim did the beautiful work of expressions, then turnarounds and making sure she actually works." Knowing how Fei Fei looks from any conceivable angle is crucial to the animators who have to bring her to life and maintain consistency in their drawings.

"Kim made sure she would actually work with her anatomy," she relates. "Then we took it to the modeler and Leo Sanchez did a beautiful job at developing what we all found in the design. He really made it come to life, and it's hard to do. She was very appealing."

Keane calls this kind of experience "reverse mentorship" and it's one of the engines that drove the production of *Over the Moon.* "I'm finding that more and more I want people around me who are doing that, who are constantly reminding me that creativity is really about thinking like a child," he says "You cannot let go of that."

His enthusiasm was infectious. "We had an artist named Eusong Lee come on and he started to do some images of Chang'e. He drew her about twelve feet tall and I said, 'What!?' and he said, 'Yes! She's a goddess!' I was amazed at the courage of pushing the bounds that far. And I started to realize how this idea of reverse mentorship was what this

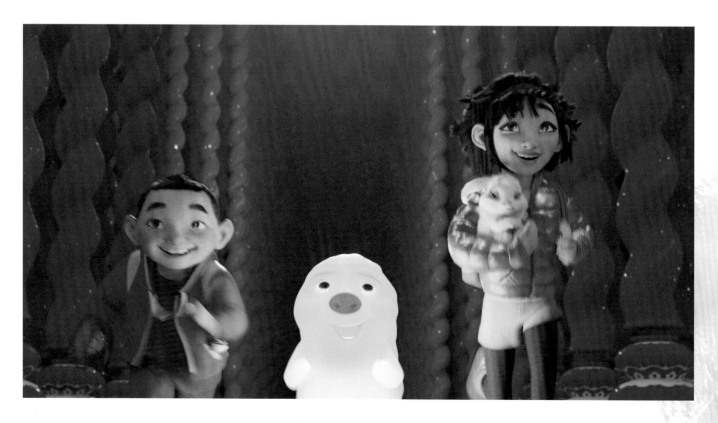

movie was going to be creatively [about] for me: learning from other, younger people that would teach me a new approach to this art form that I've been doing for so long."

As screenwriter Audrey Wells had already done, Keane and key members of his team embarked on a research expedition to China, especially the water towns where the story begins and ends.

Looking back, Keane says, "Céline [Desrumaux] was constantly reminding us of the rules of this world and bringing us back to a very grounded way of thinking about all of this. It's really nice if you have a production designer who truly believes in the world that you've created."

ABOVE: Sketch by Glen Keane.
TOP LEFT: Early design by Brittany Myers.

BELOW: Sketches of Chin's frog, Croak, by Jin Kim.

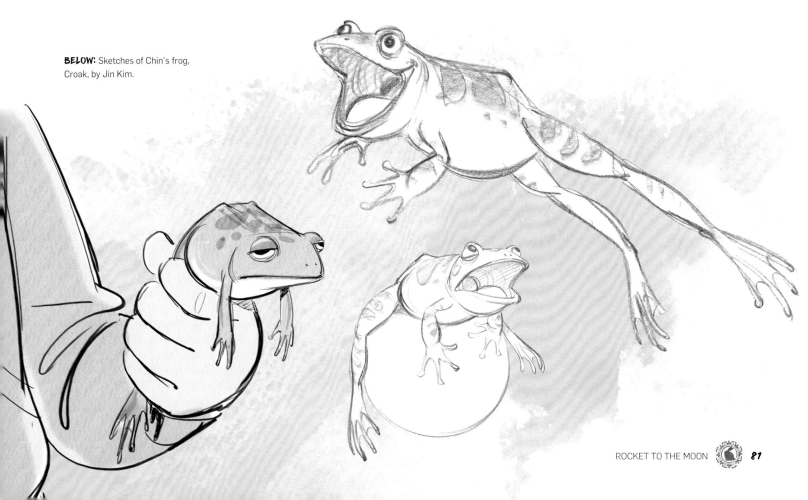

FEI FEI'S BEDROOM

BELOW: Fei Fei's bedroom wall, complete with plans for her rocket, by Wang Rui, Tian Yuan, and Elle Shi.

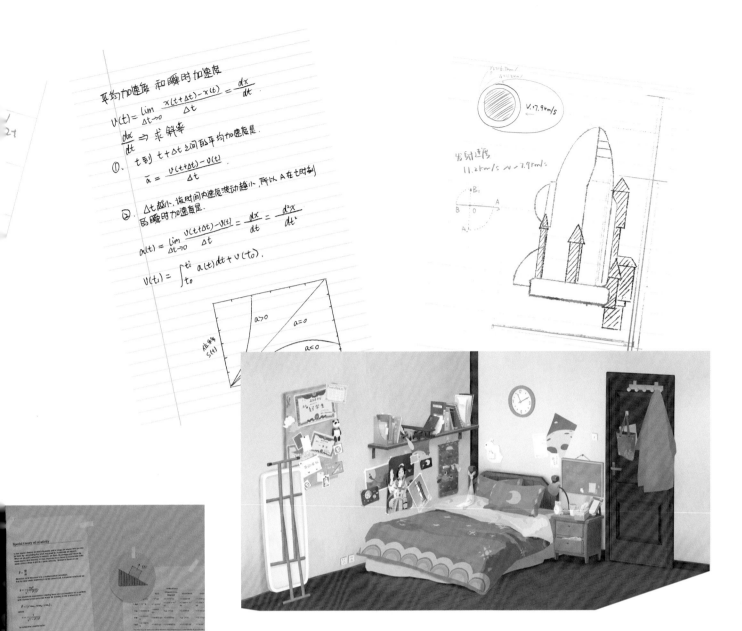

ABOVE: Design of Fei Fei's bedroom by Tian Yuan.

TOP: Detail of the rocket designs on Fei Fei's wall by Wang Rui and Elle Shi.

Desrumaux took endless photographs of seemingly mundane details every place they visited—not just postcard views but what was on the walls and shelves of ordinary residences.

They also learned about the ritual of the family meal from the Shanghai-based artists at Pearl Studio, especially a trio of talented women from diverse backgrounds: Wang Rui, architecture, Elle Shi, graphic design, and Tian Yuan, painting. Keane recalls, "I expected them to talk about what art school they went to. One person would say, 'I'm from the southern province and we have a thin long kind of noodle that's our favorite food' and I said, 'OK, but tell me about where you went to school.' But they really wanted to talk about their noodles. Then another person would say, 'I'm from the Northern province and ours is a very flat and wide noodle.' Somebody else had a round kind, and that's what I learned. I don't remember anything about their backgrounds, but I did remember how important noodles were for everyone."

THE ROCKET

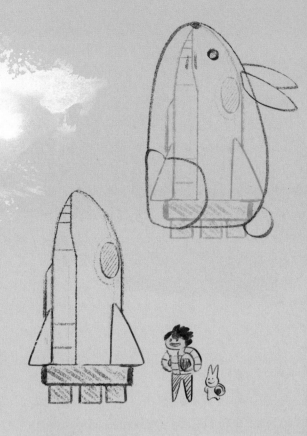

Throughout the song 'Rocket to the Moon,' we see Fei Fei designing and building her rocket, inspired by the futuristic maglev train that is being built near her home. The final rocket is styled like a rabbit, inspired by her loyal pet Bungee, and is powered, in true Mid-Autumn Festival fashion, by fireworks.

ABOVE: Sketches by Elle Shi.

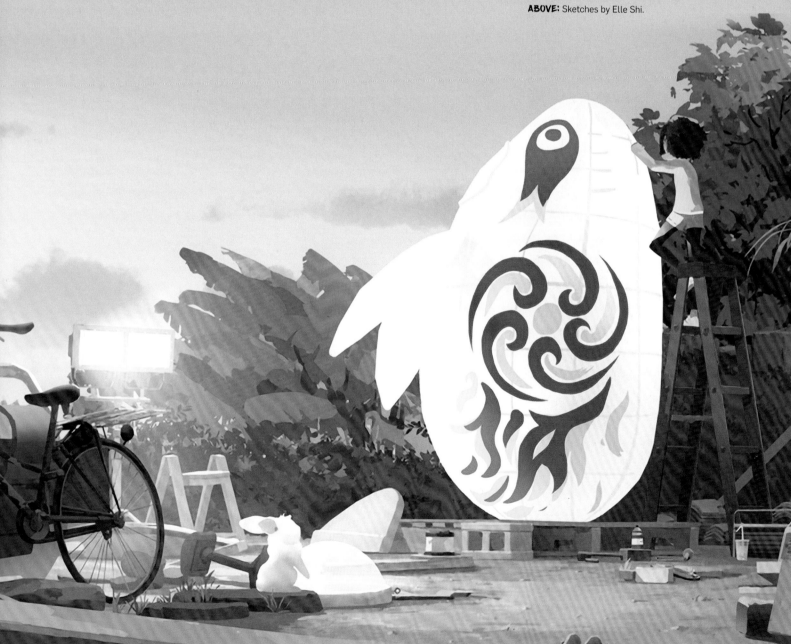

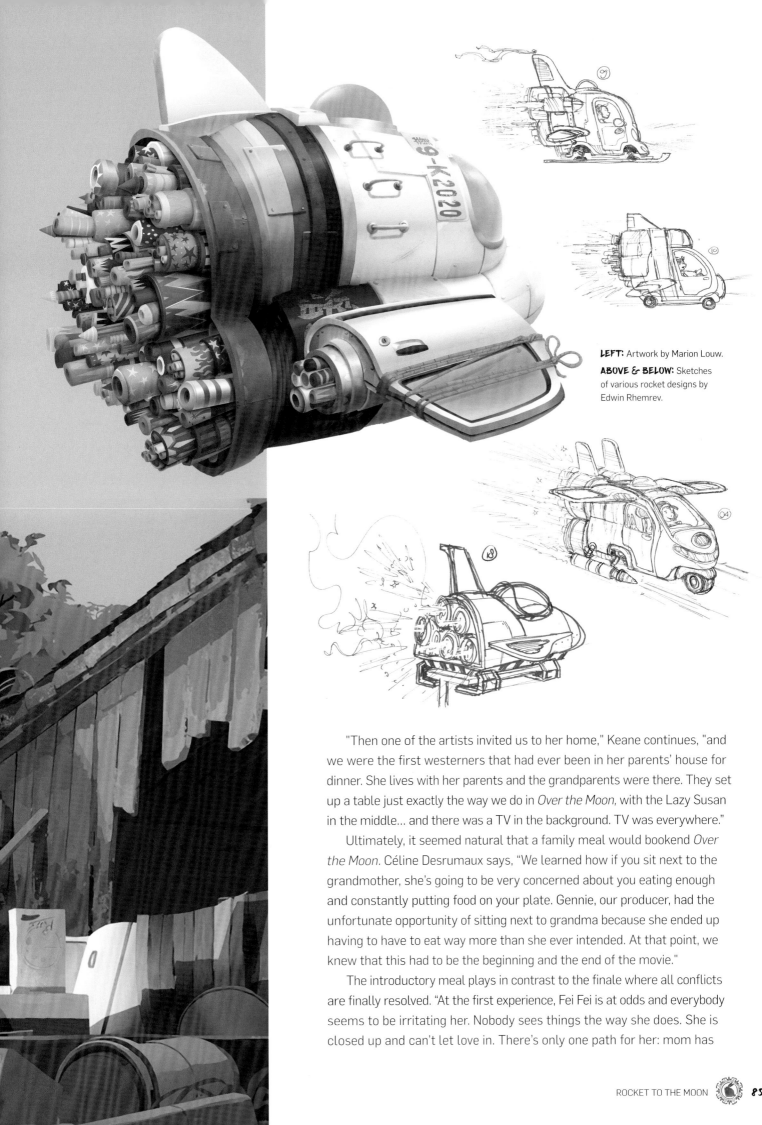

LEFT: Artwork by Marion Louw.

ABOVE & BELOW: Sketches of various rocket designs by Edwin Rhemrev.

"Then one of the artists invited us to her home," Keane continues, "and we were the first westerners that had ever been in her parents' house for dinner. She lives with her parents and the grandparents were there. They set up a table just exactly the way we do in *Over the Moon,* with the Lazy Susan in the middle… and there was a TV in the background. TV was everywhere."

Ultimately, it seemed natural that a family meal would bookend *Over the Moon.* Céline Desrumaux says, "We learned how if you sit next to the grandmother, she's going to be very concerned about you eating enough and constantly putting food on your plate. Gennie, our producer, had the unfortunate opportunity of sitting next to grandma because she ended up having to have to eat way more than she ever intended. At that point, we knew that this had to be the beginning and the end of the movie."

The introductory meal plays in contrast to the finale where all conflicts are finally resolved. "At the first experience, Fei Fei is at odds and everybody seems to be irritating her. Nobody sees things the way she does. She is closed up and can't let love in. There's only one path for her: mom has

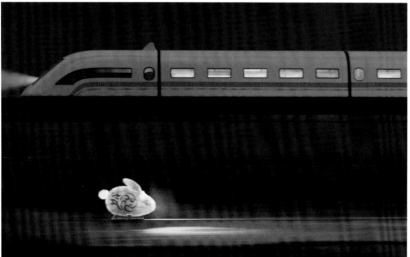

TOP: Artwork of the rocket crash-landed on the moon by Tian Yuan.

FEI FEI USES CRANE TO PUT BUNNY ON TRACK

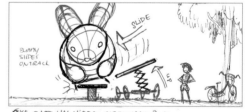

BUNNY SLIDES ON TRACK

SLIDE

BIKE CART HAS HIDDEN MECHANISM? :)

ABOVE: Storyboards by Edwin Rhemrev.

to come back and that woman can't be here. She's totally closed, just like Chang'e. At the end, having gone through unlocking Chang'e and Chang'e unlocking her, she's at the same dinner table and everybody's being themselves—but now it's this wonderful symphony of people talking and music is building and Fei Fei is hearing the harmony of it all."

Desrumaux and Keane also learned how sacred Chang'e was to those who grew up with her story. This beautiful goddess was always portrayed in the most rhythmic ways, floating in the air with flowing cloths, as if her feet would touch the ground and she wouldn't weigh anything.

"Audrey wrote this character who really needed to be healed," Keane says. "It was an assumption by everybody that Chang'e was up on the moon longing for her lover Houyi, unchanged and still the same. Audrey said, 'No, that's going to change a person.' Here's this woman who is a goddess, and all the beings in Lunaria have sprung from her tears. Everything is about her and she has become obsessed with bringing Houyi back to life. These dominoes have started to fall. She didn't start out that way, but this is who we pick up. Both she and Fei Fei have to unlock one another's hearts."

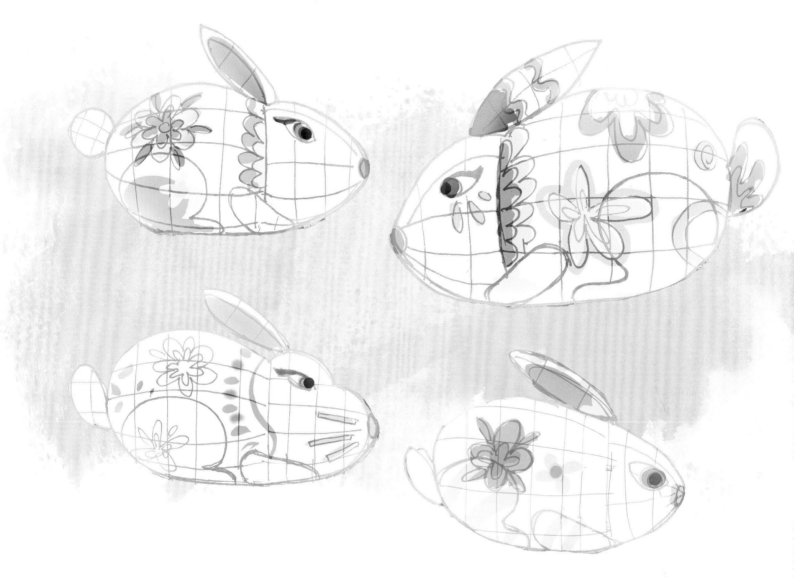

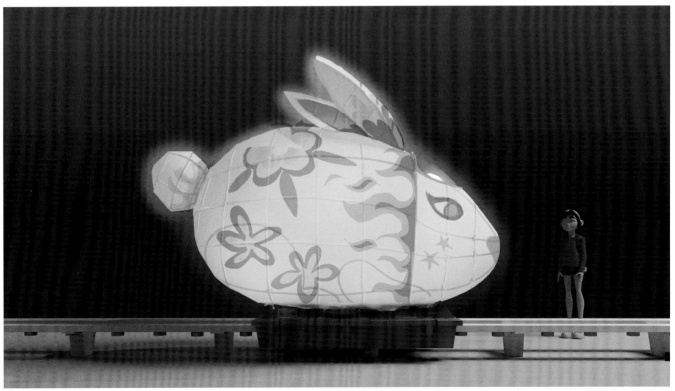

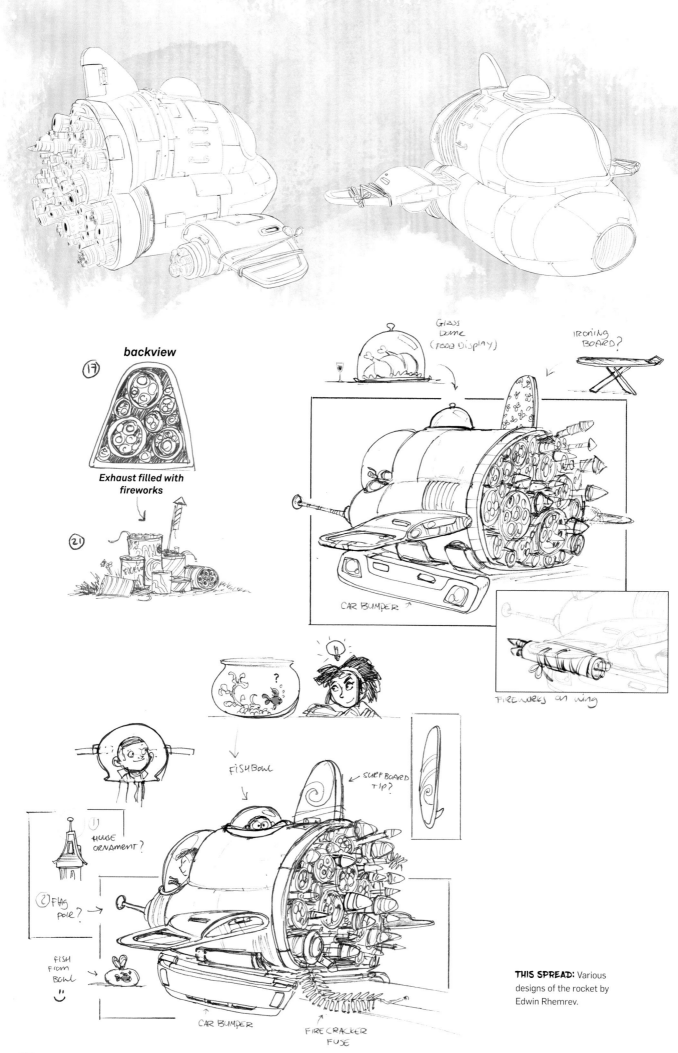

backview

⑰

Exhaust filled with
fireworks

㉑

Glass
Dome
(food display)

IRONING
BOARD?

CAR BUMPER →

FIREWORKS on wing

FISHBOWL

SURFBOARD
TIP?

HOUSE
ORNAMENT?

① FLAG
POLE?

FISH
FROM
BOWL

CAR BUMPER

FIRE CRACKER
FUSE

THIS SPREAD: Various
designs of the rocket by
Edwin Rhemrev.

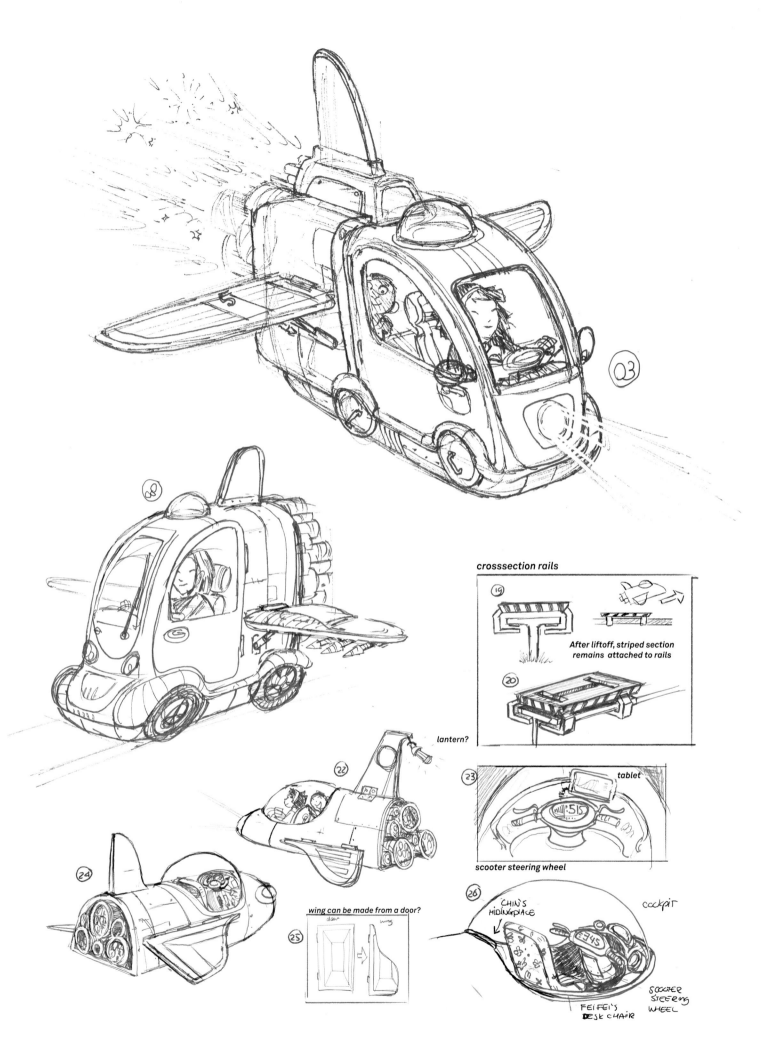

03

08

crosssection rails

19

After liftoff, striped section remains attached to rails

20

lantern?

22

23

tablet

:515

scooter steering wheel

24

25

wing can be made from a door?

door ⇒ wing

26

CHIN'S HIDINGPLACE

cockpit

E345

FEIFEI'S DESK CHAIR

SCOOTER STEERING WHEEL

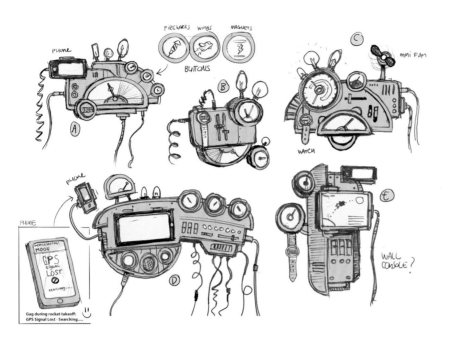

BOTTOM: Artwork by Marion Louw.

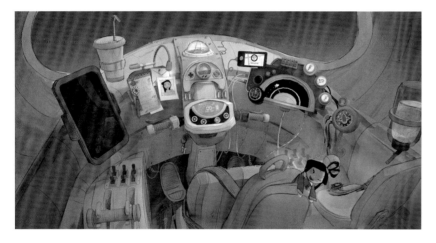

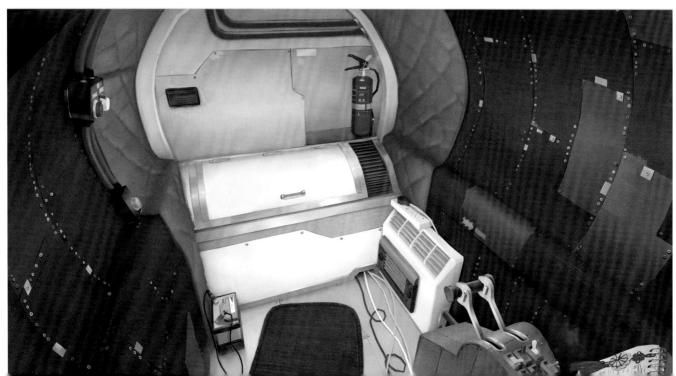

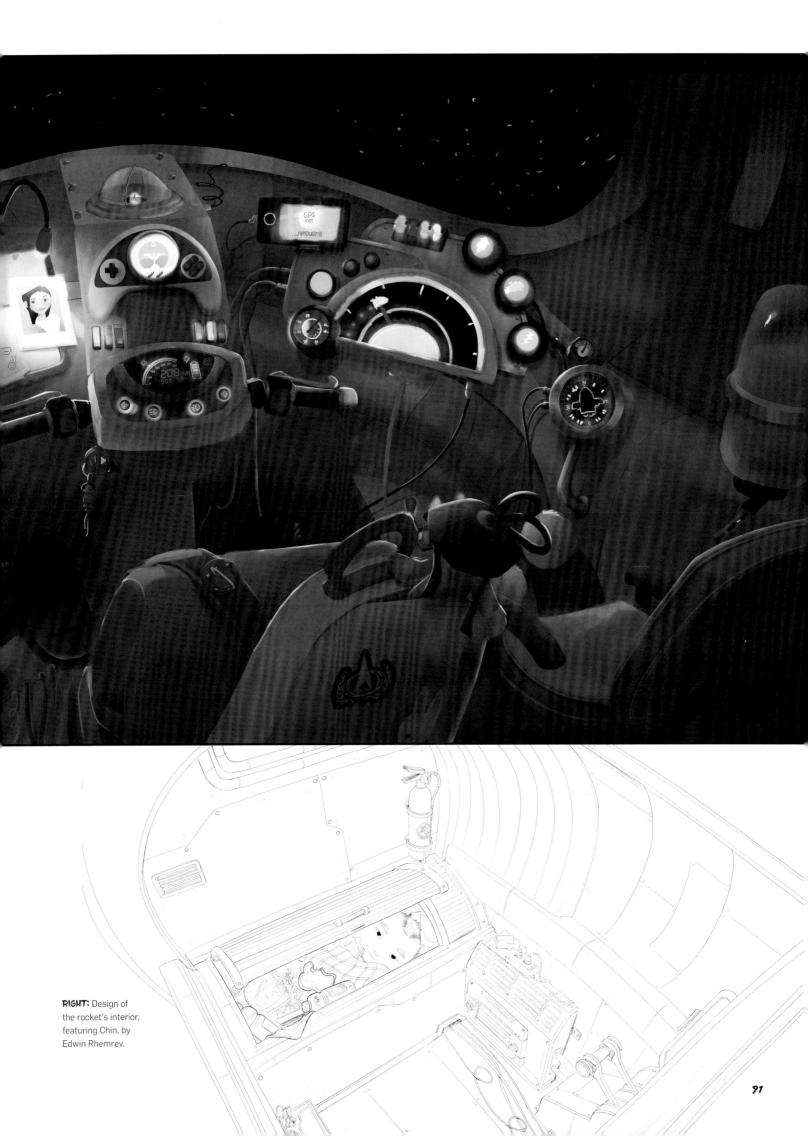

GPS
lost
...rerouting

RIGHT: Design of the rocket's interior, featuring Chin, by Edwin Rhemrev.

over the MOON
Act 1

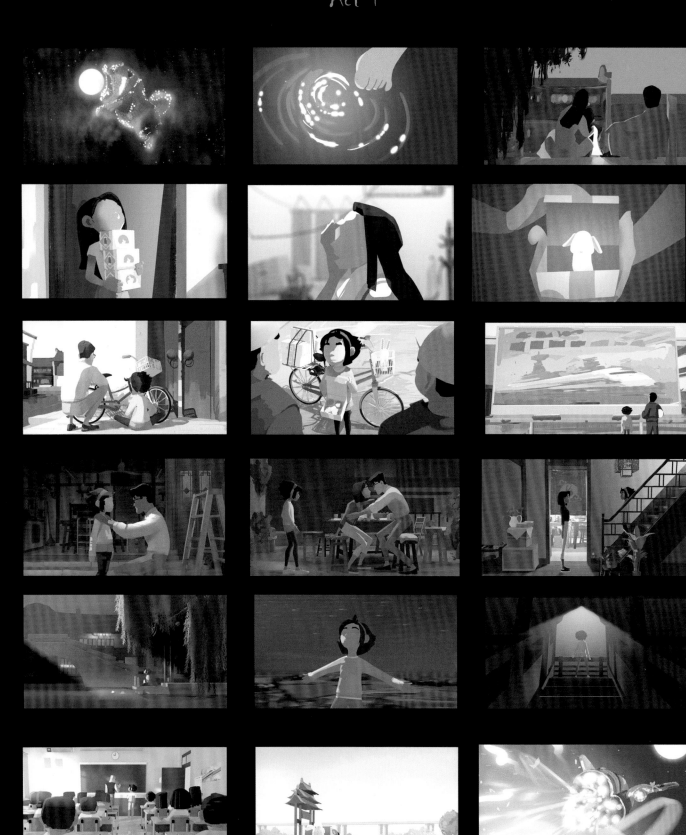

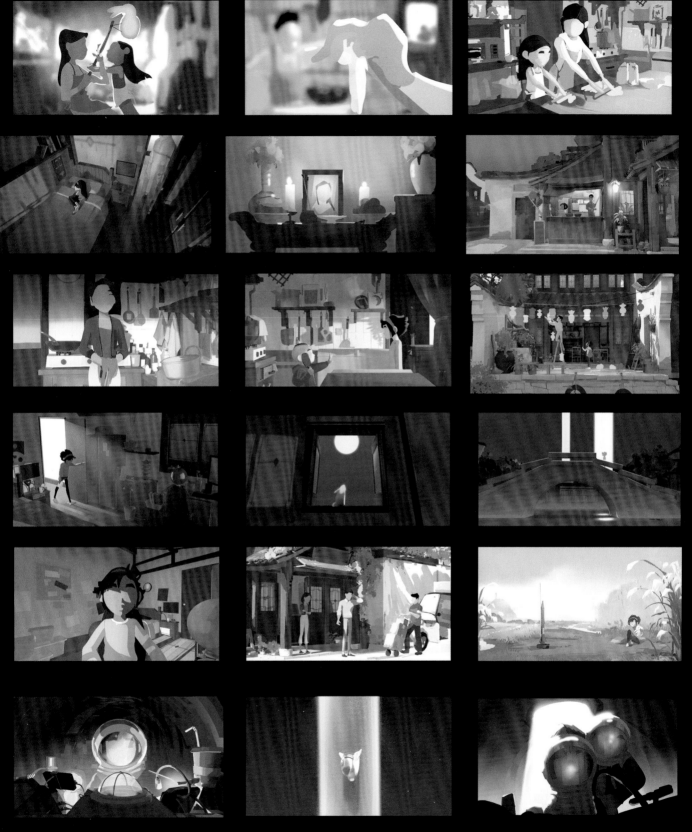

THIS SPREAD: Act 1 color script by Céline Desrumaux.

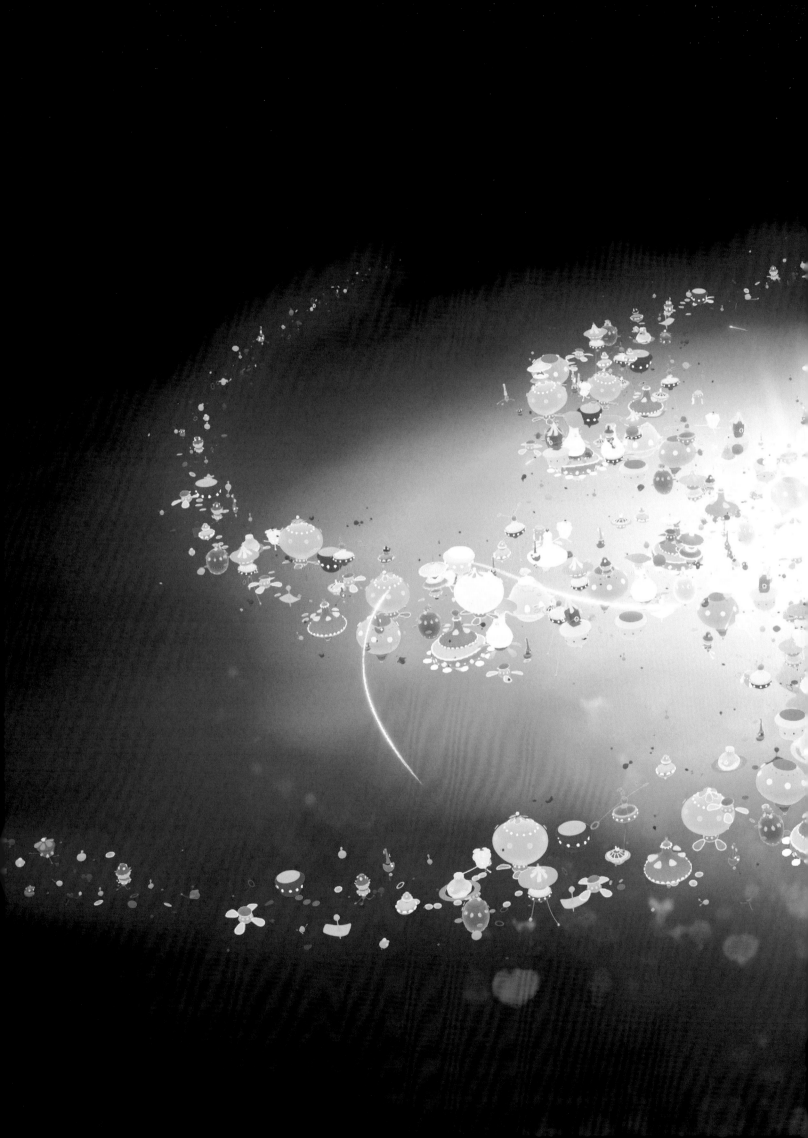

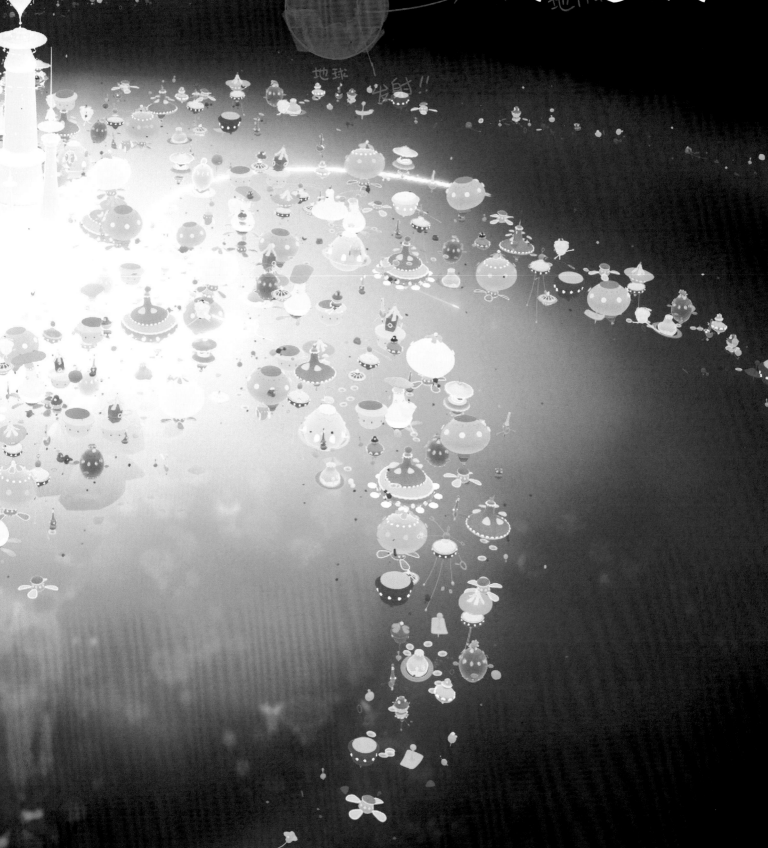

WELCOME TO LUNARIA

CITY OF LUNARIA

■ Welcome to the otherworldly beauty of the City of Lunaria, Chang'e's home city on the surface of the moon itself.

BELOW: Artwork by Tian Yuan.

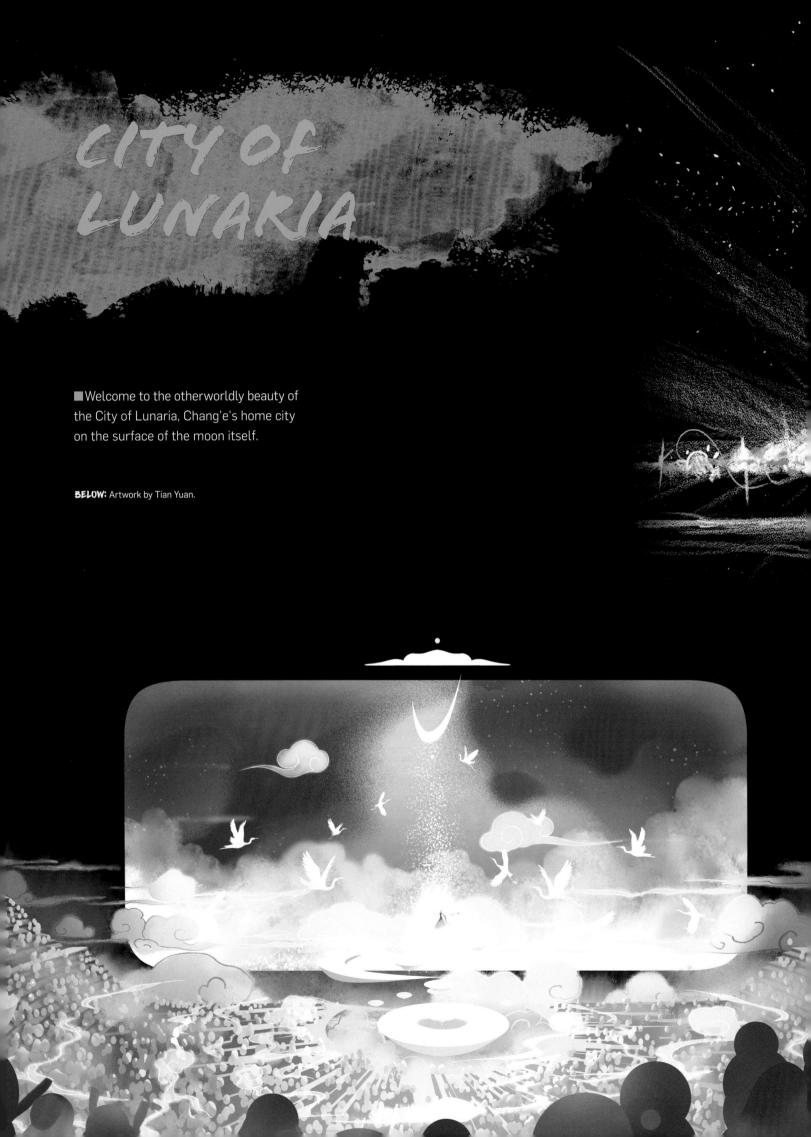

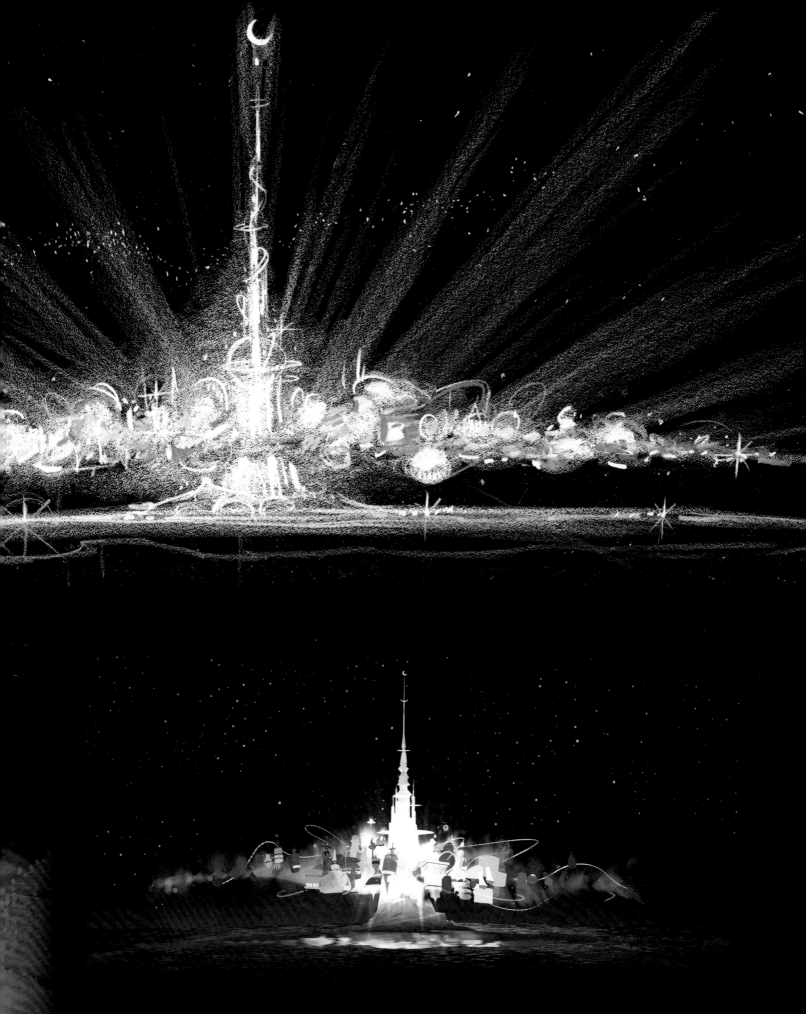

ABOVE: Artwork by Céline Desrumeaux.
TOP: Artwork by Glen Keane.

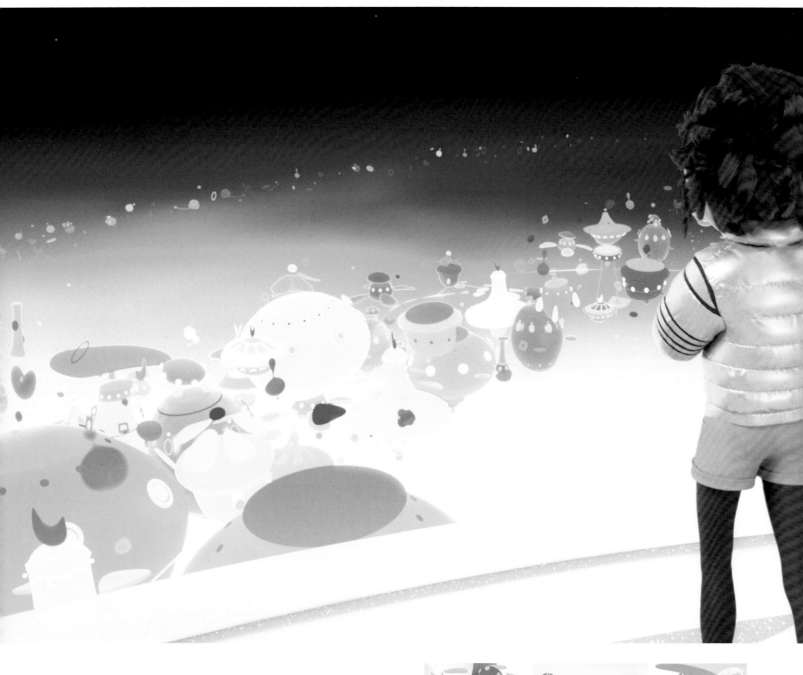

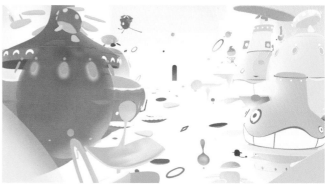

LEFT: Artwork by Jérémy Baudry.

ABOVE: Artwork by Céline Desrumeax.

RIGHT: Artwork by Jérémy Baudry.

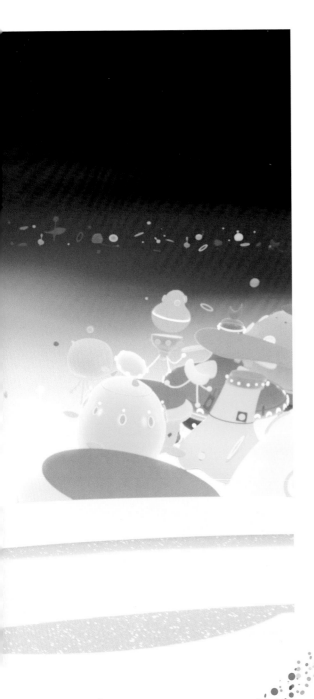

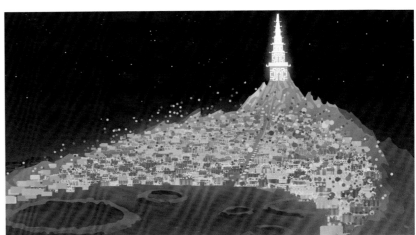

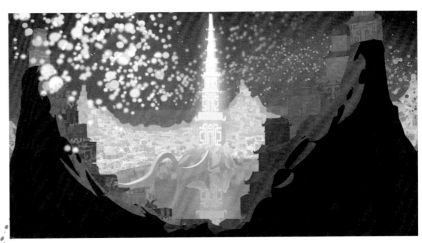

It took time for Glen Keane to comprehend the significance of death in the Chinese culture. "For instance, putting two chopsticks in rice is a symbol of death. One of the first sequences I storyboarded was around the dinner table and Chin sticks these two chopsticks in a bowl of rice. Peilin [Chou] said, 'You can't do that!' and why. That's exactly what my grandson would do. 'No, but you don't understand what that symbolizes here.' So I started to learn that the idea of these characters, Chang'e and Houyi, trying to get together—one person living, and the other person having gone on, with a longing to connect—is a deeply ingrained truth in Chinese culture. Their presence has a continuing lasting impact on the lives of those who remain."

Co-director John Kahrs joined the production in progress and understood the foundation of the narrative right away. "It has that classic structure of being thrown out of your world into this new adventure and then you come home and you're changed. You're transformed by this experience, but it also has a deeper layer: Fei Fei's grief-stricken and she's in this hole of not being able to process the loss of her mother. Chang'e is a reflection, it's like a possible version of herself. Chang'e, even though she has all these walls built up around her, [she and Fei Fei] are very similar in that they're unable to move past the loss of their loved one." Bingo!

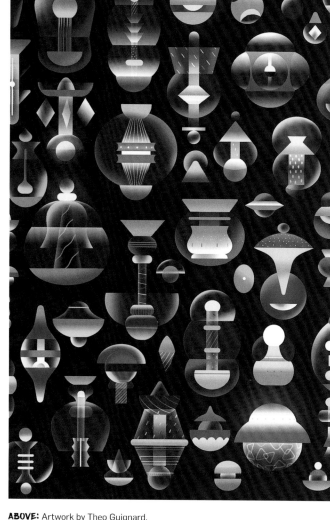

ABOVE: Artwork by Theo Guignard.

ABOVE: Design of Lunarian buildings by Marion Louw.
OPPOSITE: Artwork of Lunaria by Jérémy Baudry.

Some feelings are so difficult to express in words that they come out most clearly, and memorably, in song. Audrey Wells didn't write *Over the Moon* as a musical but when Keane asked, "Would you consider it being a musical?" she said, "Yes, I would love that."

Gennie Rim concurs. "She really wanted to be part of the songwriting process, so she went with us to New York when we interviewed three different songwriting teams. Chris Curtis and Marjorie Duffield had been working together for a while and they had actually done an artist-in-residency at Pearl Studio, where they had spent a week writing exploratory songs on *Over the Moon* when it was in development. They shared those songs with us and they were very classic Broadway-theatrical songwriting. They were great, emotional songs. Actually, 'Rocket to the Moon' was one of them and it hasn't changed too much from that point."

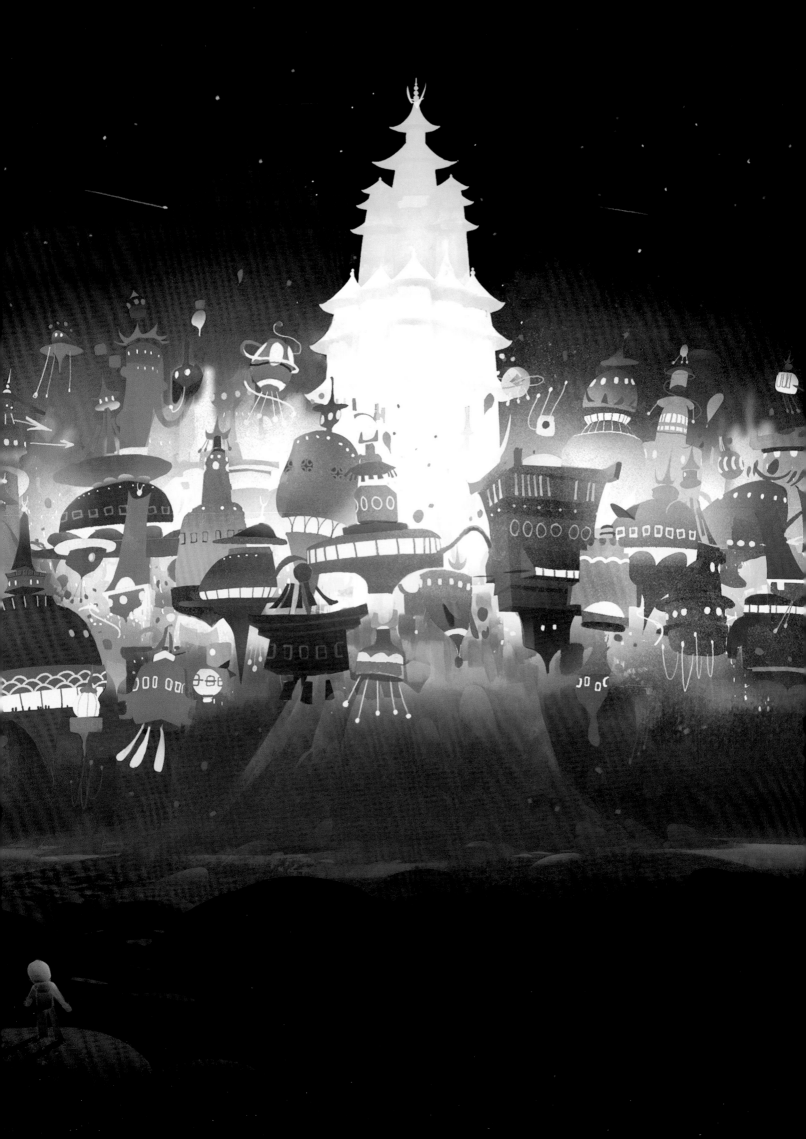

WINGED LIONS

BELOW: The stone winged lions outside Fei Fei's house. Artwork by Wang Rui.

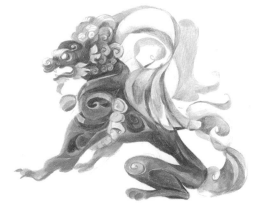

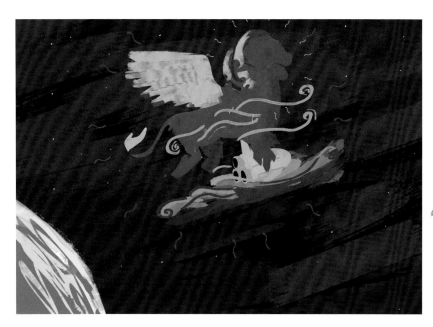

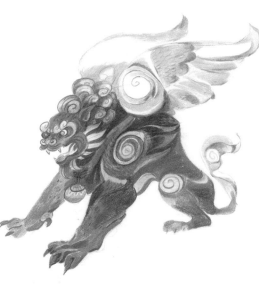

ABOVE: Winged lion artwork by Alice Dieudonné.

LEFT: Artwork by Céline Desrumaux.

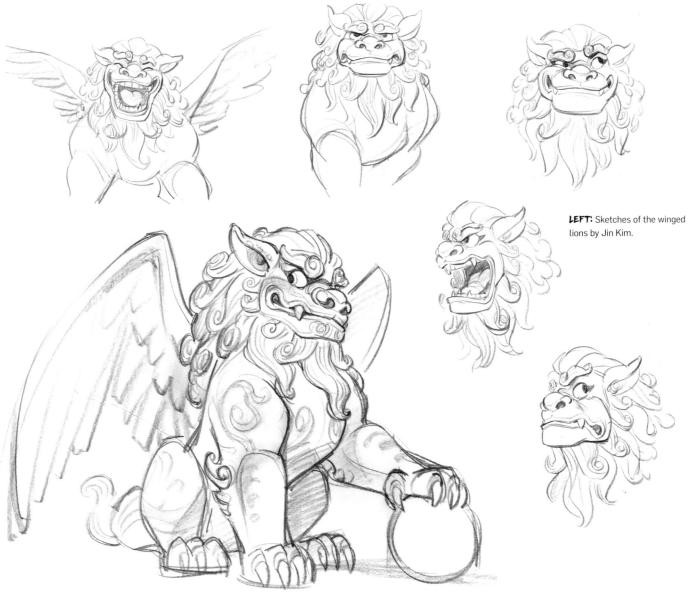

LEFT: Sketches of the winged lions by Jin Kim.

CHANG'E

The Goddess of the Moon, Chang'e is a household name in Chinese culture, and is portrayed in *Over the Moon* as an incredible, colorful, powerful force of nature.

OPPOSITE: Artwork of Chang'e by Tian Yuan.
BELOW: Designs for Chang'e's hair by Jin Kim.
LEFT: Sketch of Chang'e by Glen Keane.

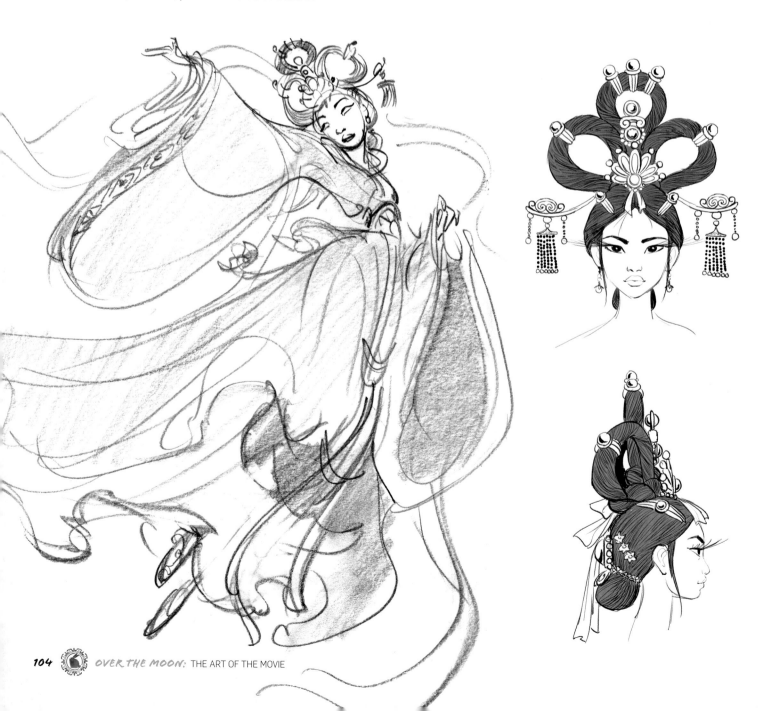

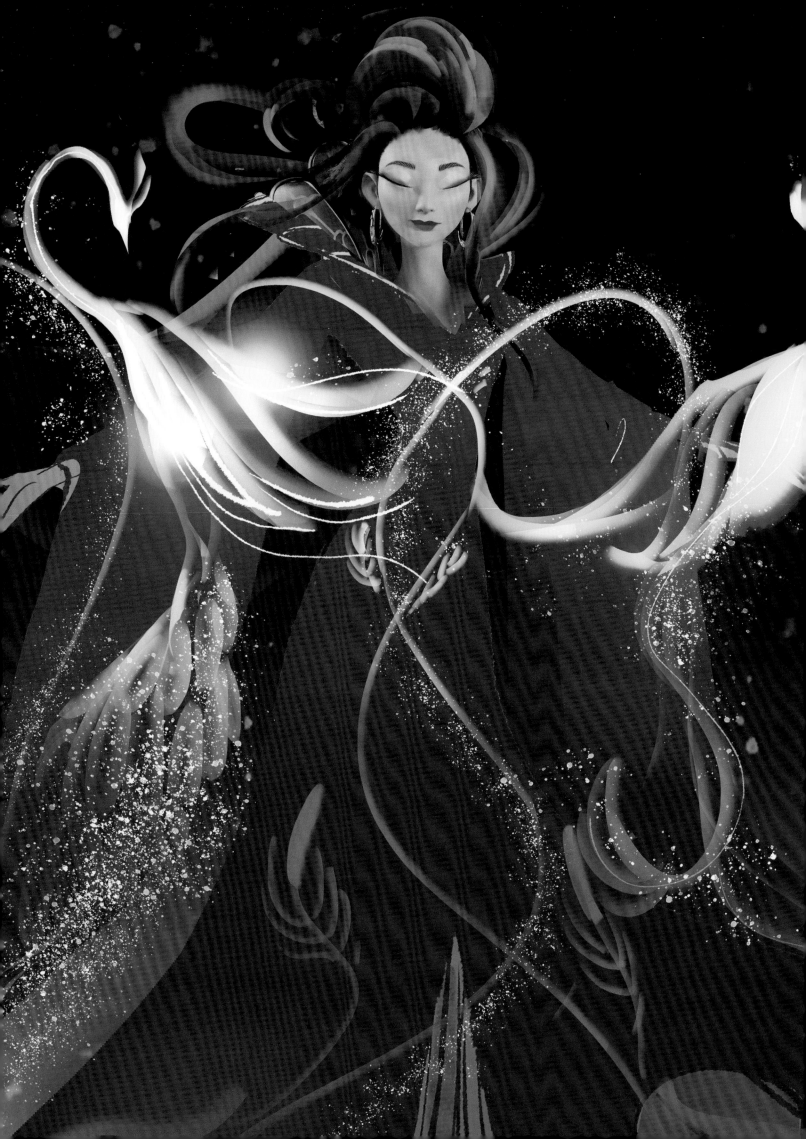

LEFT: Design for Chang'e's ping-pong costume by Jin Kim.

BELOW: Designs for Chang'e's hair by Jin Kim (right and top left) and Brittany Myers (bottom left).

OPPOSITE: Artwork of Chang'e by Marion Louw.

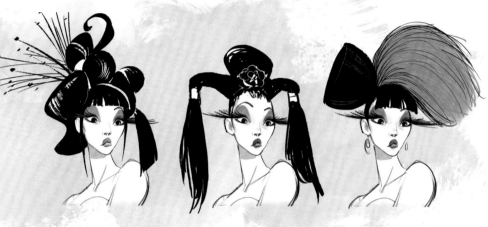

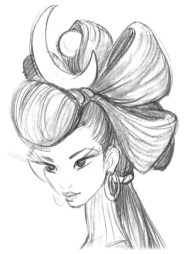

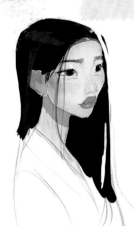

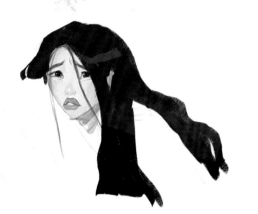

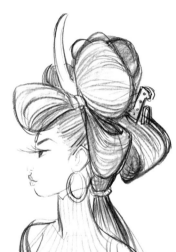

But Gennie Rim and her colleagues also wanted something different. One of the other people they met on this New York expedition was Helen Park, who had written an immersive off-Broadway musical called K-POP that they all loved. They hesitated at the idea of discarding the Broadway sound—if it ain't broke, don't fix it—but they were invigorated by the fresh energy of Korean pop. Then inspiration struck: what if they could blend them together?

Curtis and Duffield had seen some preliminary artwork for *Over the Moon* and fallen in love with it. As a Korean-American, Helen Park knew how significant it was to make a film with an Asian girl as the central character.

Looking back, she relates, "I never met Chris or Marjorie before. We had no relationship whatsoever before this film, so I was a little nervous about collaborating with them, but we turned out to be a really good team. The process itself was so joyous; it was just kind of magical how it all worked out."

Best of all, the trio got to work directly with Audrey Wells. Duffield says, "Audrey clearly was a fierce, creative force and early on, even in the initial explorations we did at our residency in China, when we sent just the musicalizations of moments from her screenplay, she was so generous about what she was hearing. A screenwriter could say, 'Who are these people stepping on my toes?' [Instead,] she was the first cheerleader. Her approval meant so much to us because you were in the presence of an incredibly fine writer and you knew that if she liked it, then you must be doing something right."

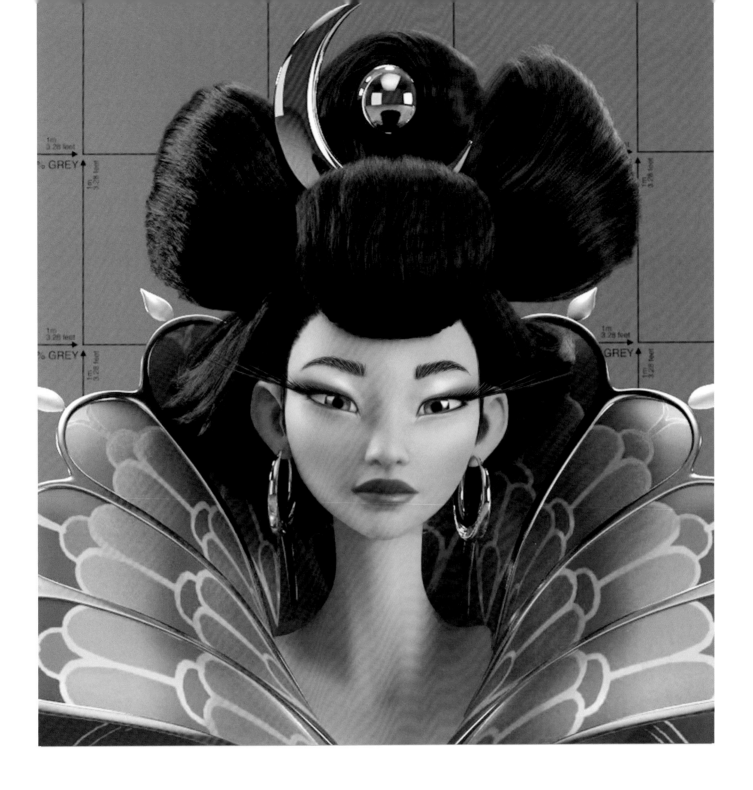

"EVERYTHING IS CENTERED
AND LINKED TO CHANG'E.
SHE'S THE SOURCE OF LIGHT,
SHE'S A SOURCE OF ENERGY."

CÉLINE DESRUMAUX
PRODUCTION DESIGNER

Curtis adds, "I think also that we had a higher purpose in this and that was Audrey and her script. All the songs were inspired from that script. And I think we always had a higher purpose to honor her vision and her voice. So there was almost like a selfless approach to this whole thing. We just wanted to serve this beautiful, beautiful story that she created and that kind of guided us."

But the process was also great fun, especially when the director was involved. Curtis says, "The ping-pong song was really Glen's idea because he really wanted to have this as a sung moment. I'm so glad that we did all those nine-hundred and seventy-five drafts of that song," he says with a laugh, "because it's really a fun moment."

"Glen is like a big kid," Curtis continues. "It would be fun because we'd be around the piano and he would say, 'Play more wistful. Not melancholy, make that more wistful! You know what I mean?' He always loved to say, 'This is what I'm feeling. Make what I'm feeling into music.' We had so much fun with him and he is so encouraging and positive. He's an incredibly kind person and really smart about what he wants."

As in any good musical, every song serves a purpose. No one understood that better than Cathy Ang, who provided the voice of Fei Fei and whose signature piece is 'Rocket to the Moon.' "That song comes out of a moment when Fei Fei's father tells her that he wants to remarry." And to her, that feels like losing her mom again," says Ang.

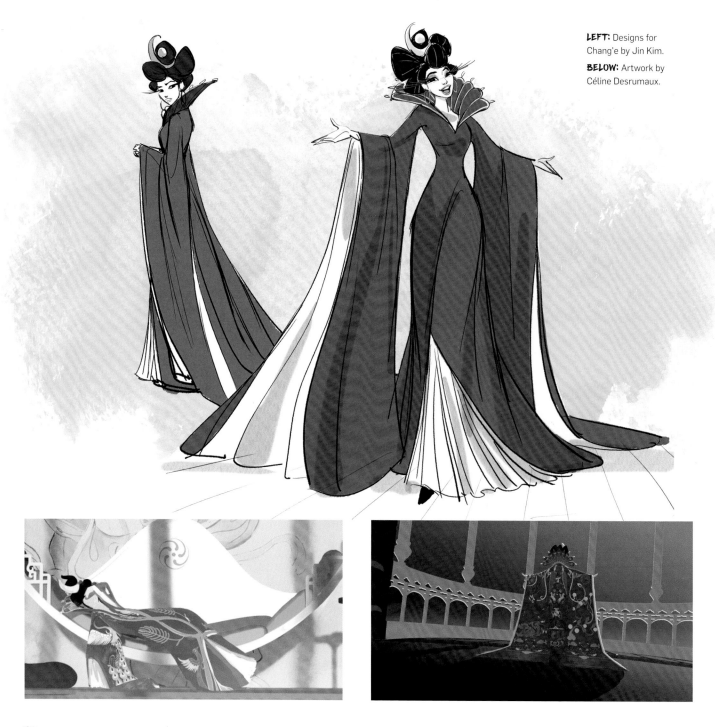

LEFT: Designs for Chang'e by Jin Kim.

BELOW: Artwork by Céline Desrumaux.

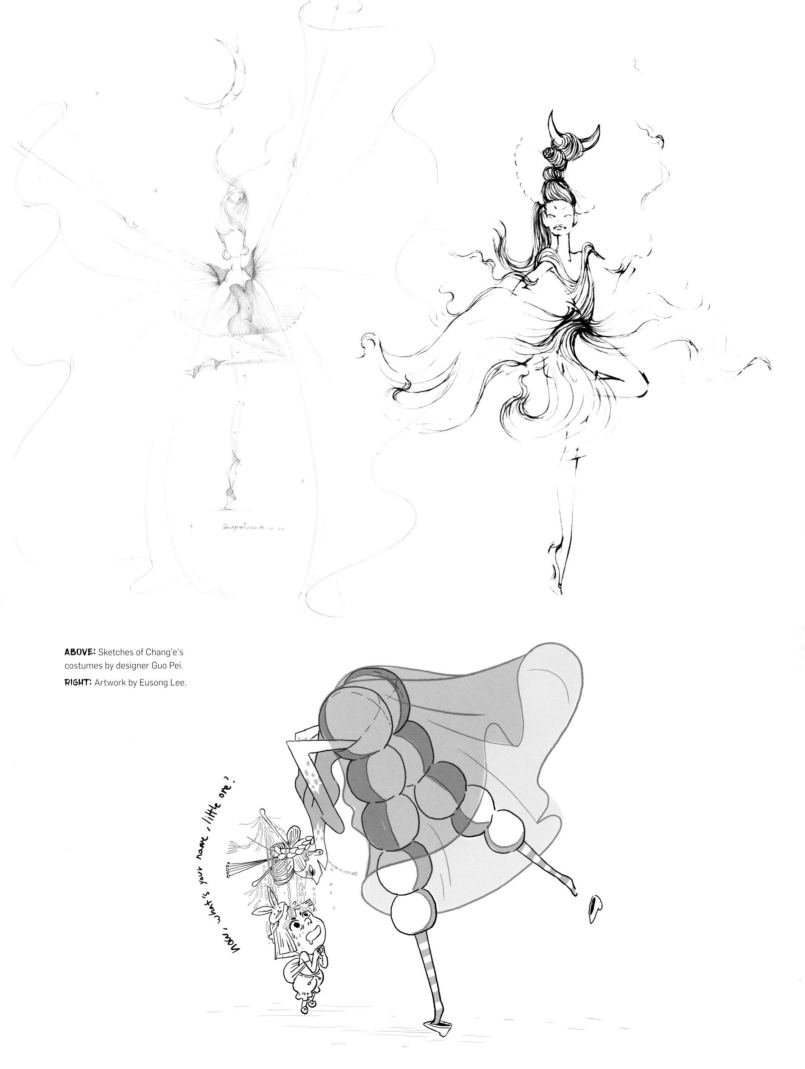

ABOVE: Sketches of Chang'e's costumes by designer Guo Pei.

RIGHT: Artwork by Eusong Lee.

Now, what's your name, little one?

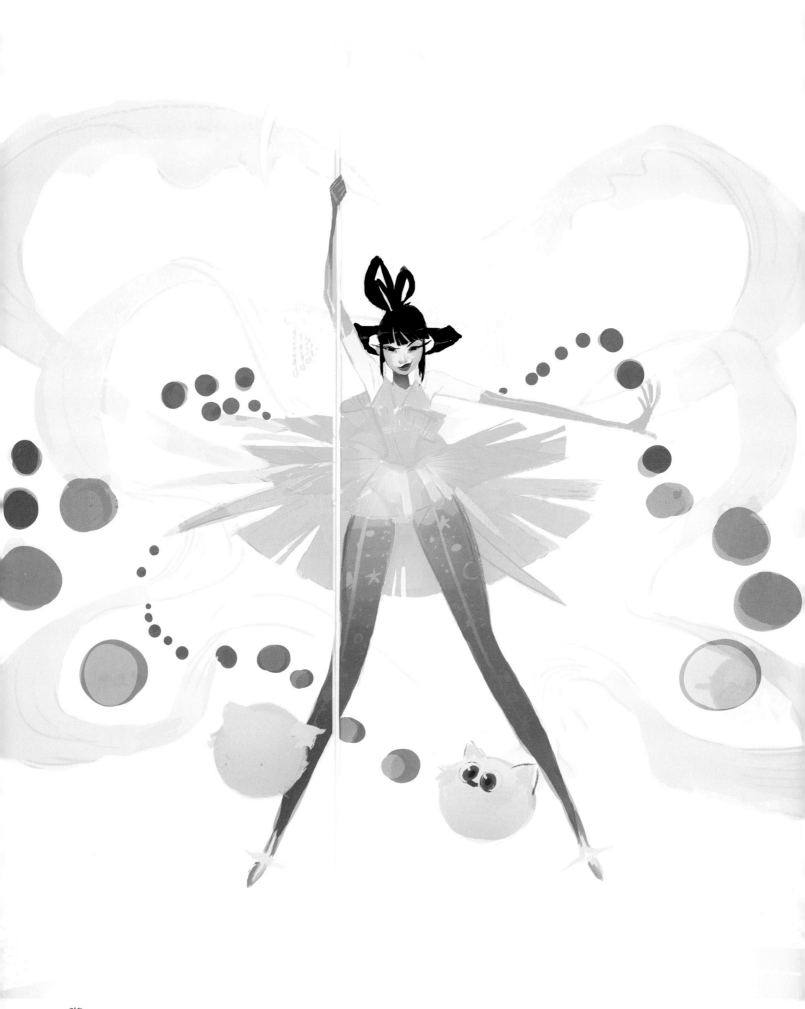

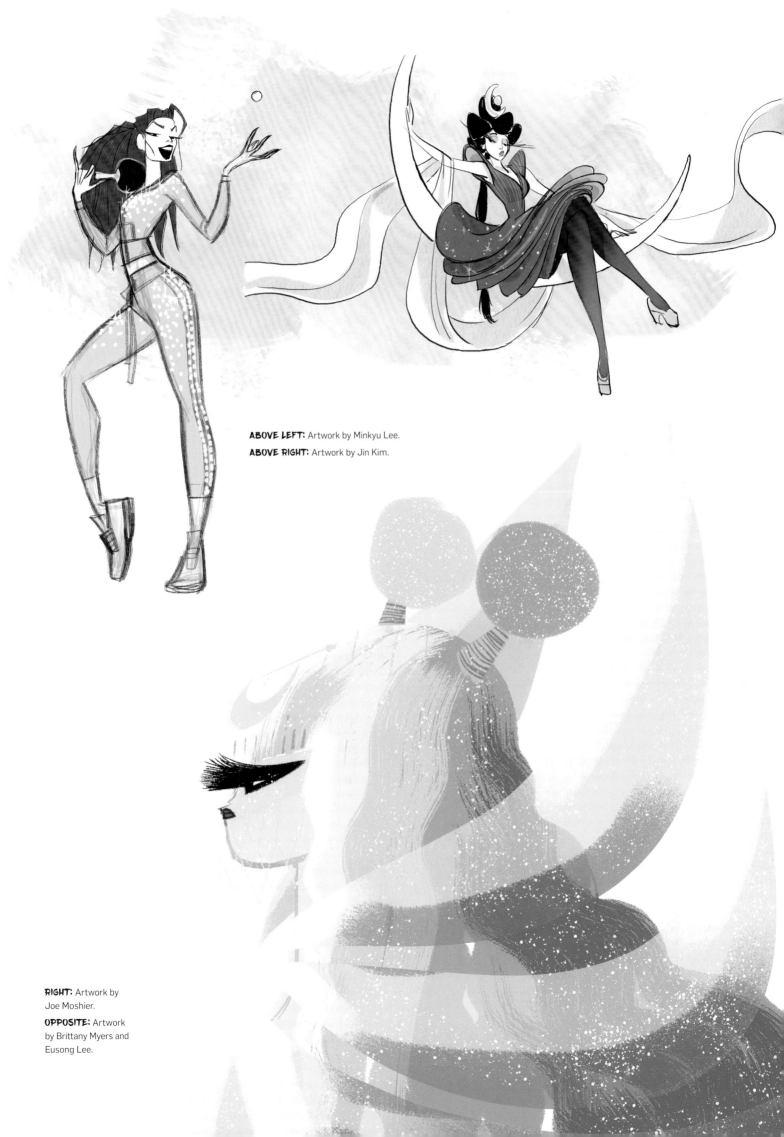

ABOVE LEFT: Artwork by Minkyu Lee.
ABOVE RIGHT: Artwork by Jin Kim.

RIGHT: Artwork by
Joe Moshier.

OPPOSITE: Artwork
by Brittany Myers and
Eusong Lee.

CHANG'E'S PALACE

Chang'e's palace on the moon is beautiful and strange, with an otherworldly animation style that is different from anything seen on Earth. Filled with creatures, or Lunarians, sprung from Chang'e's tears, it is, in many ways, a monument to her isolation and grief.

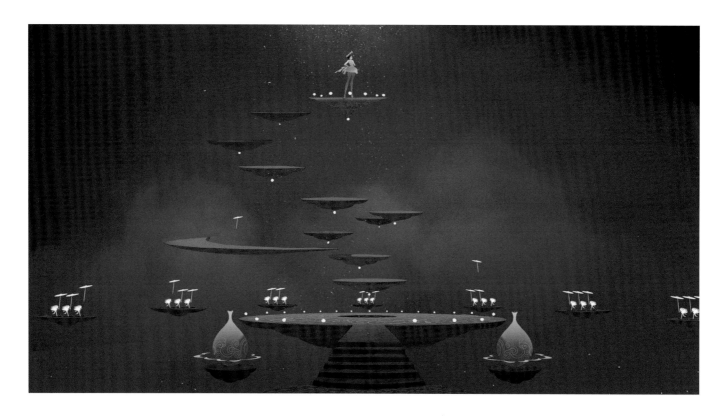

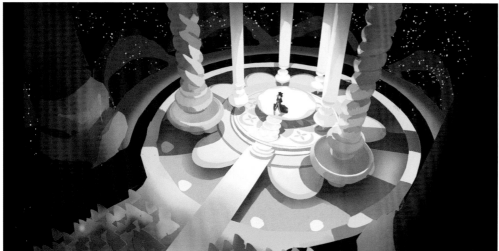

ABOVE: Artwork of Chang'e's dramatic entrance by Jérémy Baudry.

LEFT & BELOW: Artwork of Chang'e's palace by Tian Yuan.

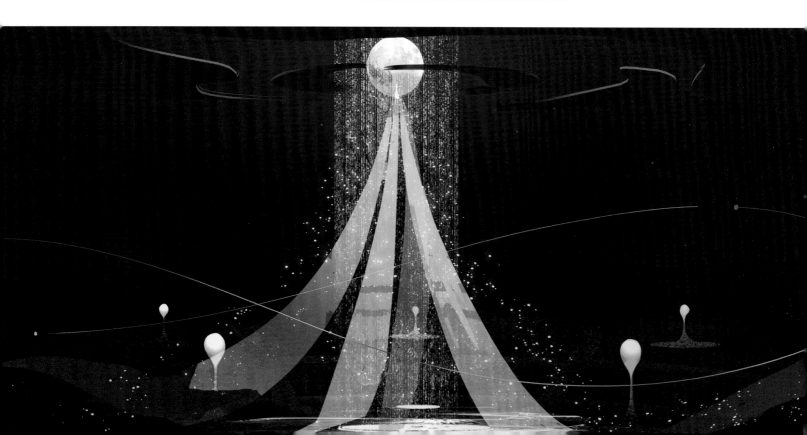

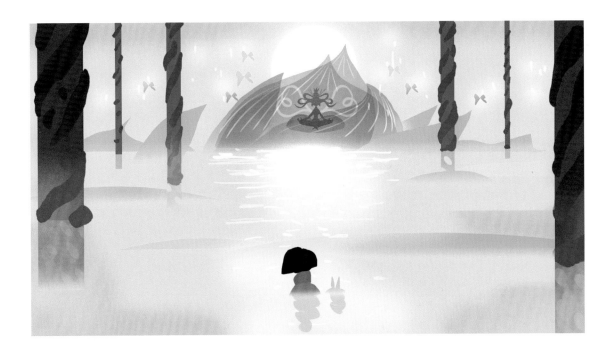

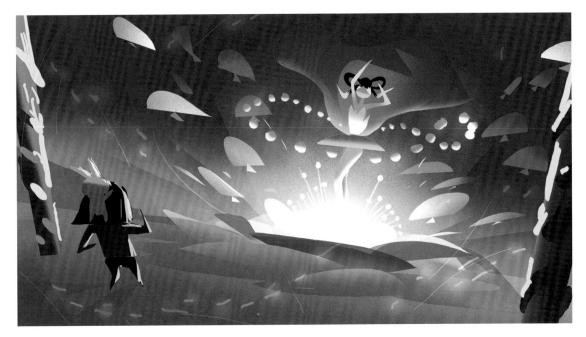

ABOVE: Artwork by Eusong Lee.

"She is desperate to connect with this goddess who, to her, has always represented eternal love and has always been a source of connection and joy with her mom," Ang continues. "There's just a sense of desperation at the beginning and so much love that she doesn't know where to put it right now because she's still grieving. And as she gets the song, she realizes, *OK, I have to do this for my mom, and for myself, for my family*. She gets so inspired by singing this song to go to the moon. It's a beautiful piece."

With eight songs and two reprises, *Over the Moon* is most assuredly a musical, yet each of

those musical showpieces works in support of the story.

Every actor the producers approached was eager to participate in a film that would represent Chinese culture, both real and fanciful. Comic actor Ken Jeong, who lends his voice to the irrepressible Gobi, echoes his fellow cast members when he says, "We all brought our A-game because we knew this was a special project." Speaking for himself, he adds, "I've never cried during an animated voice recording session... but the script and Glen brought out such a humanity in everybody's performance and helped me bring out the heart."

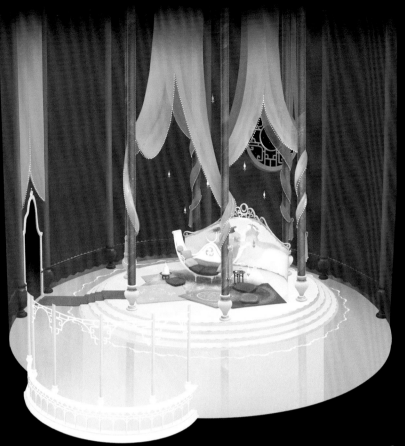

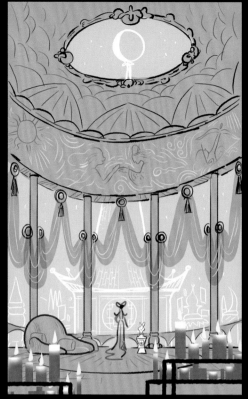

ABOVE & RIGHT: Designs by Jérémy
Baudry, colors by Marion Louw

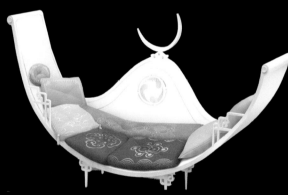

BELOW: Artwork of Chang'e's bedroom, including
frieze showing her love story with Houyi, by Elle Shi.

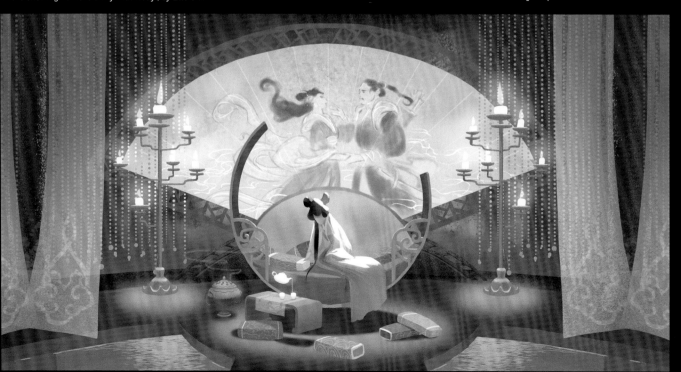

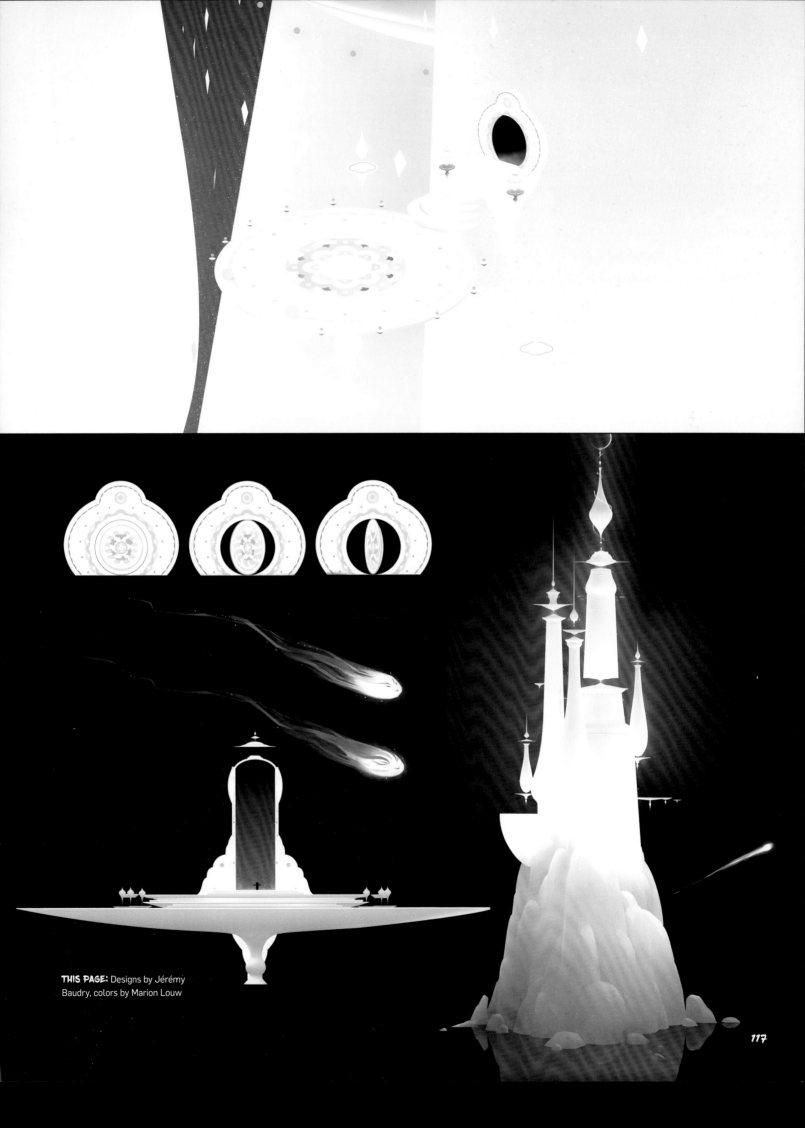

THIS PAGE: Designs by Jérémy Baudry, colors by Marion Louw

LUNARIANS

■ These strange creatures, created from Chang'e's tears of grief, make up most of the population of the City of Lunaria.

ABOVE: Sketches of Chin meeting a Lunarian by Brittany Myers.

LEFT & BELOW: Lunarian designs by Alexis Liddell.

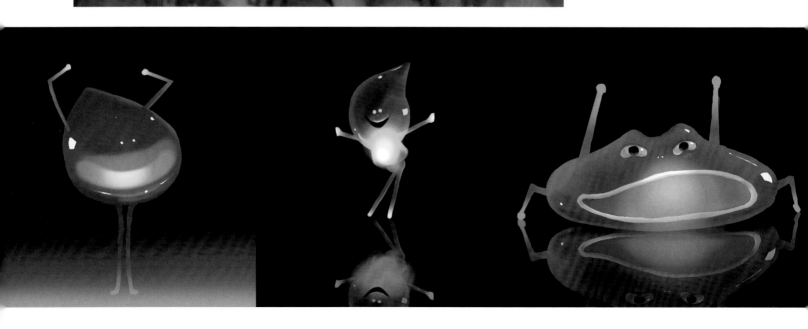

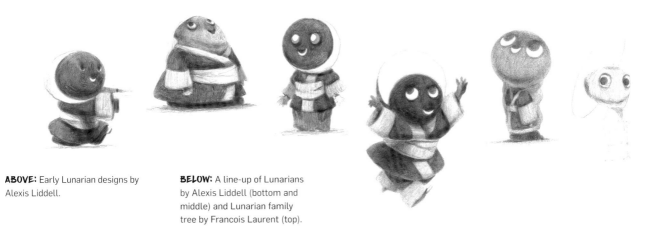

ABOVE: Early Lunarian designs by Alexis Liddell.

BELOW: A line-up of Lunarians by Alexis Liddell (bottom and middle) and Lunarian family tree by Francois Laurent (top).

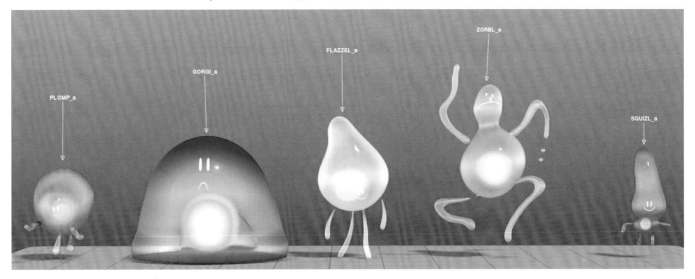

PLOMP_a

GORGI_a

FLAZZEL_a

ZORBL_a

SQUIZL_a

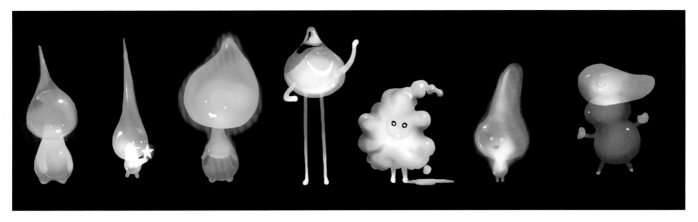

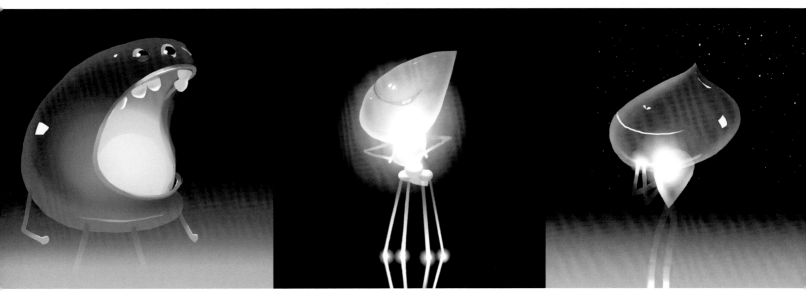

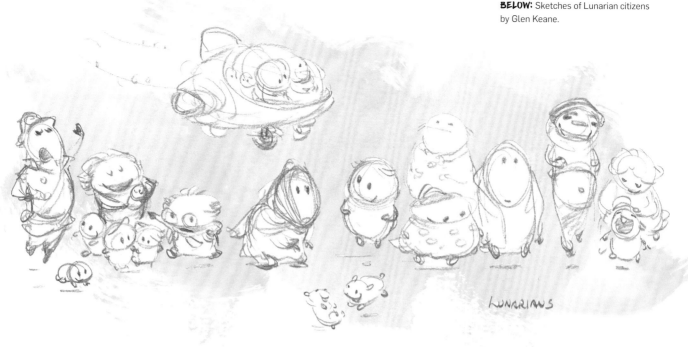

LUNARIANS

ABOVE: Lunette by Alice Dieudonné.

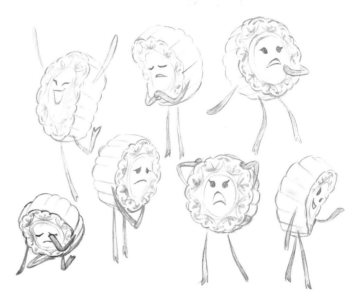

ABOVE: Lunettes by Jin Kim.

ABOVE & RIGHT: Lunettes by Brittany Myers.

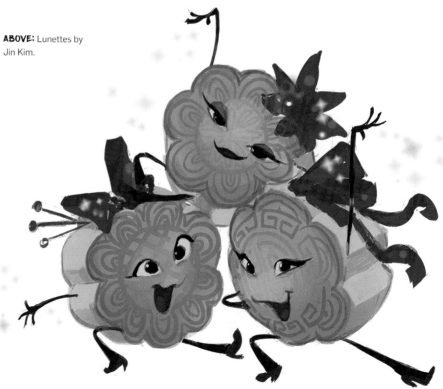

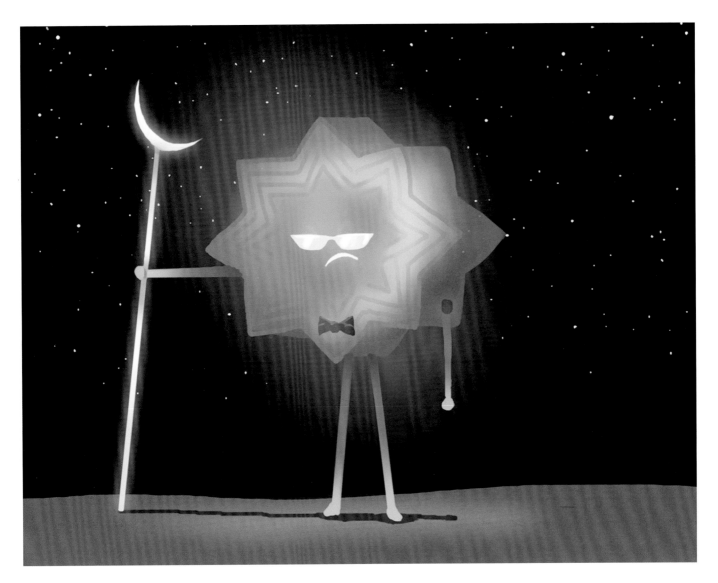

ABOVE: Lunarian guard artwork by Jin Kim.

ABOVE: Lunar vehicles and Lunarian designs by Tian Yuan.

GUO PEI
COSTUMES

■ The production was lucky enough to have Guo Pei, one of the biggest fashion designers in China, as Chang'e's costume designer.

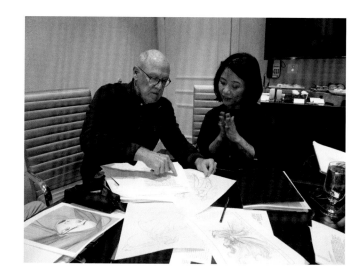

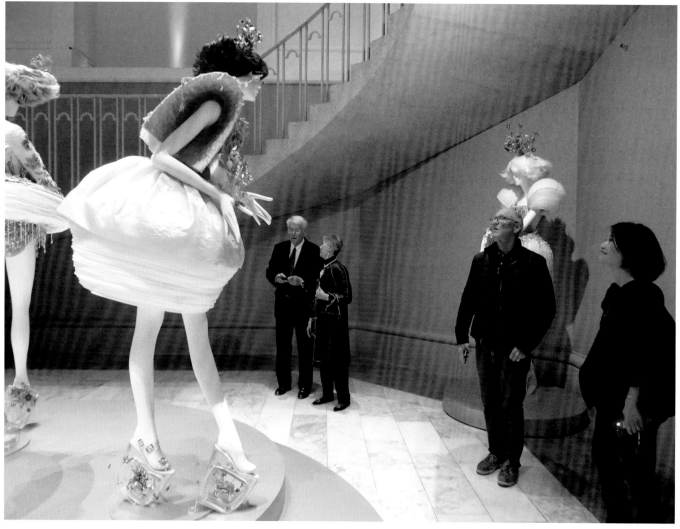

TOP: Glen Keane and Guo Pei exploring ideas for Chang'e's outfits.

ABOVE: Glen Keane and Guo Pei viewing the exhibit, Guo Pei: Couture *Beyond*, at the Vancouver Art Gallery.

OPPOSITE: A drawing of Chang'e, drawn by Glen Keane as a gift for Guo Pei.

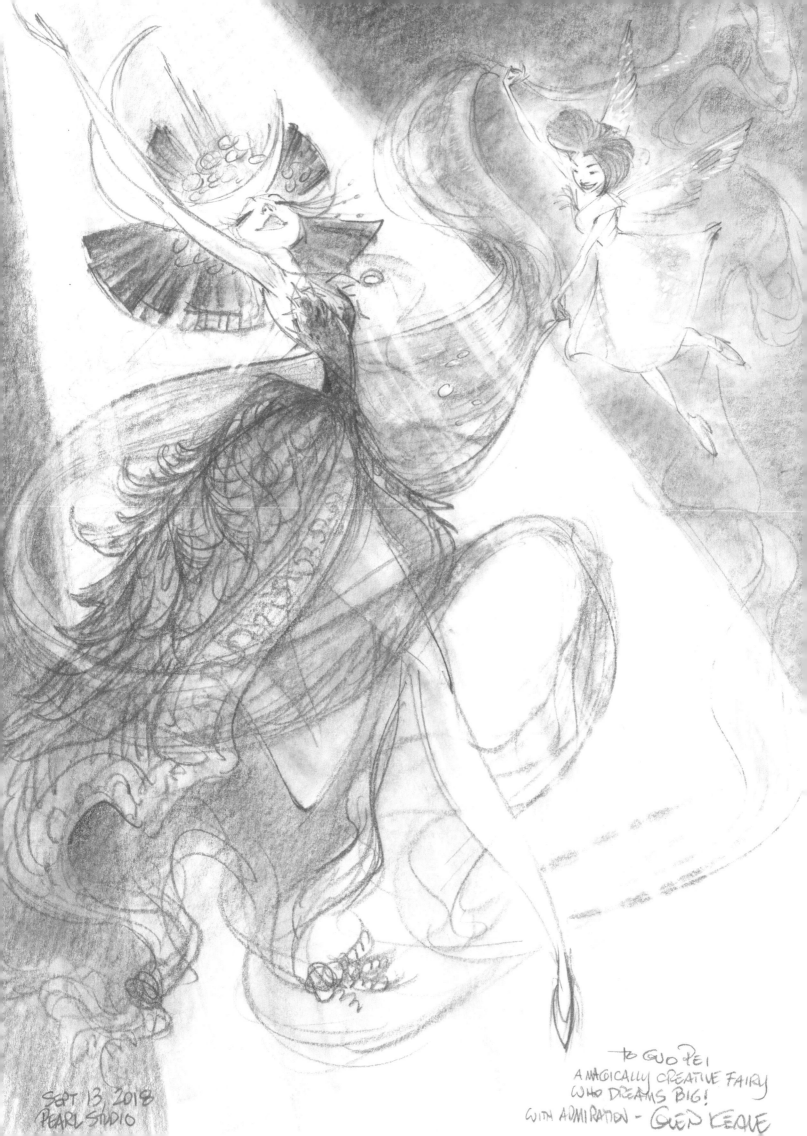

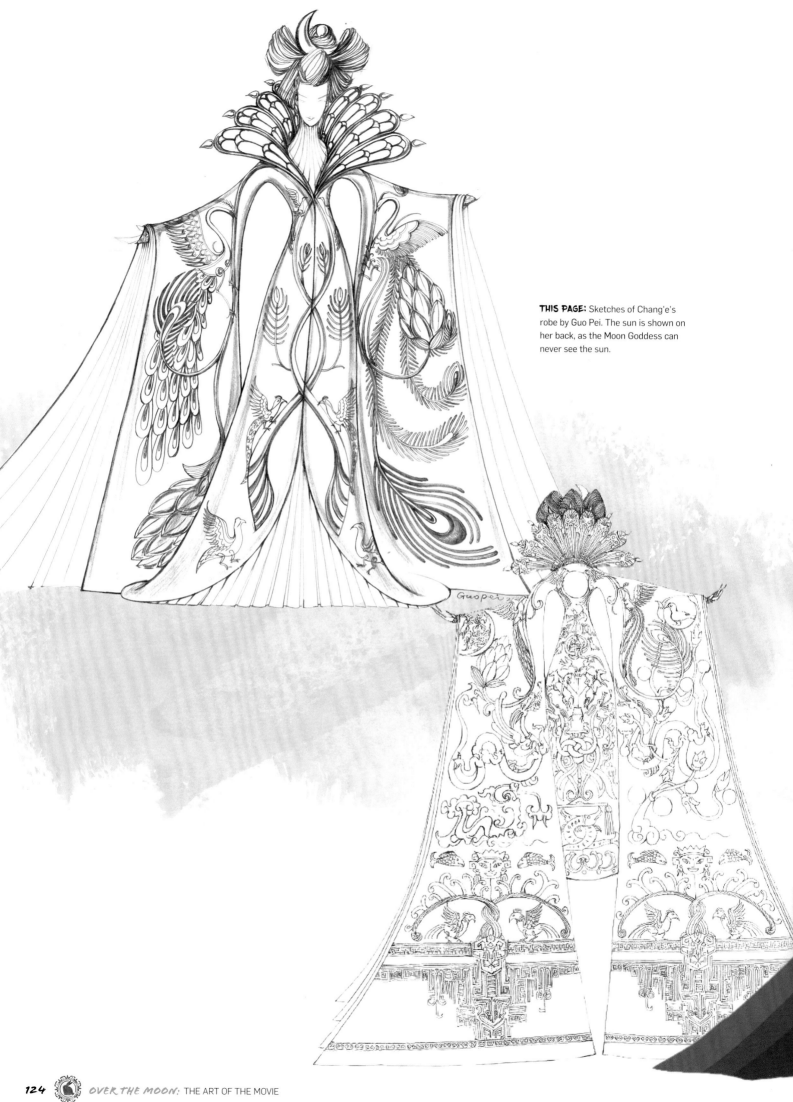

THIS PAGE: Sketches of Chang'e's robe by Guo Pei. The sun is shown on her back, as the Moon Goddess can never see the sun.

The same could be said of every component in the film. The film offers cutting-edge animation imagery, yet its director and chief mover is most comfortable using an old-fashioned pencil. When he served as animation supervisor on *Tangled*, he actually drew over his colleagues' renderings, one frame at a time, adding a flourish here, a tiny gesture there.

As John Kahrs puts it, "When you're a computer animator, you get this kind of stiff puppet. That's what you start with, this kind of T-pose. And you have to push and push and keep posing that puppet until it comes to life. The way Glen comes at it is just this whirlwind of drawing energy... and emotion... and this visceral search for life.

He doesn't have any of those boundaries on him as a draftsperson. He has the rigorous training of understanding anatomy and the structure of how faces are built. He's got years and years of that training behind him."

Initially, some animators were intimidated by Keane's nonstop flurry of drawings. Then the significance of his work became clear. As Kahrs explained, "You don't have to follow those lines exactly; what you need to go for is the *intent* of the drawing. What is he pushing? What is he exaggerating? What is the emotion that Fei Fei is feeling in this scene and what is that specific thing that Chang'e is doing with her eyes that gives her that special sarcastic energy?"

RIGHT: Céline Desrumaux's colored rendering of the robe.

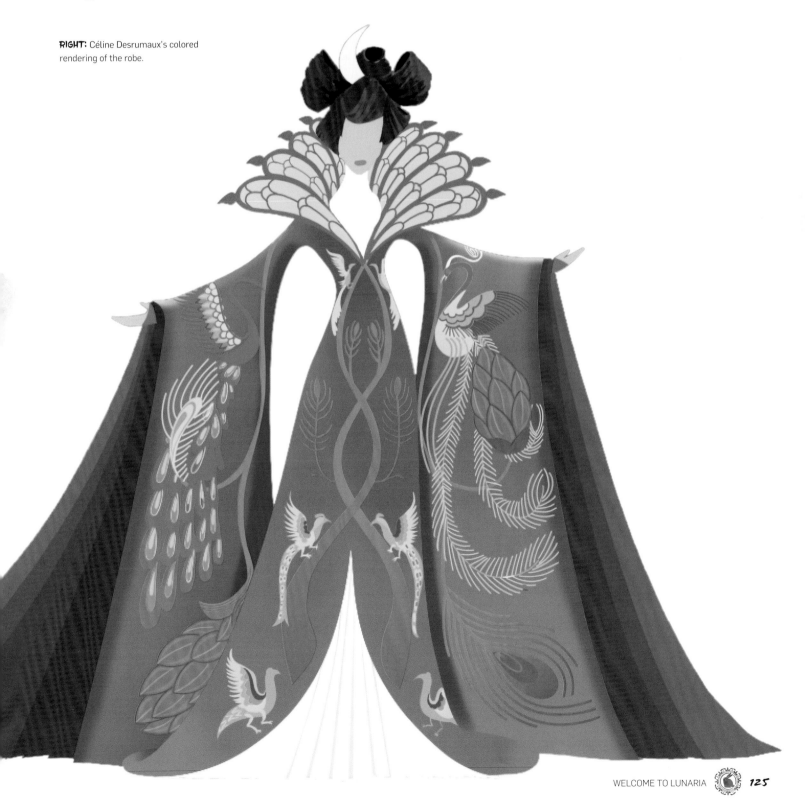

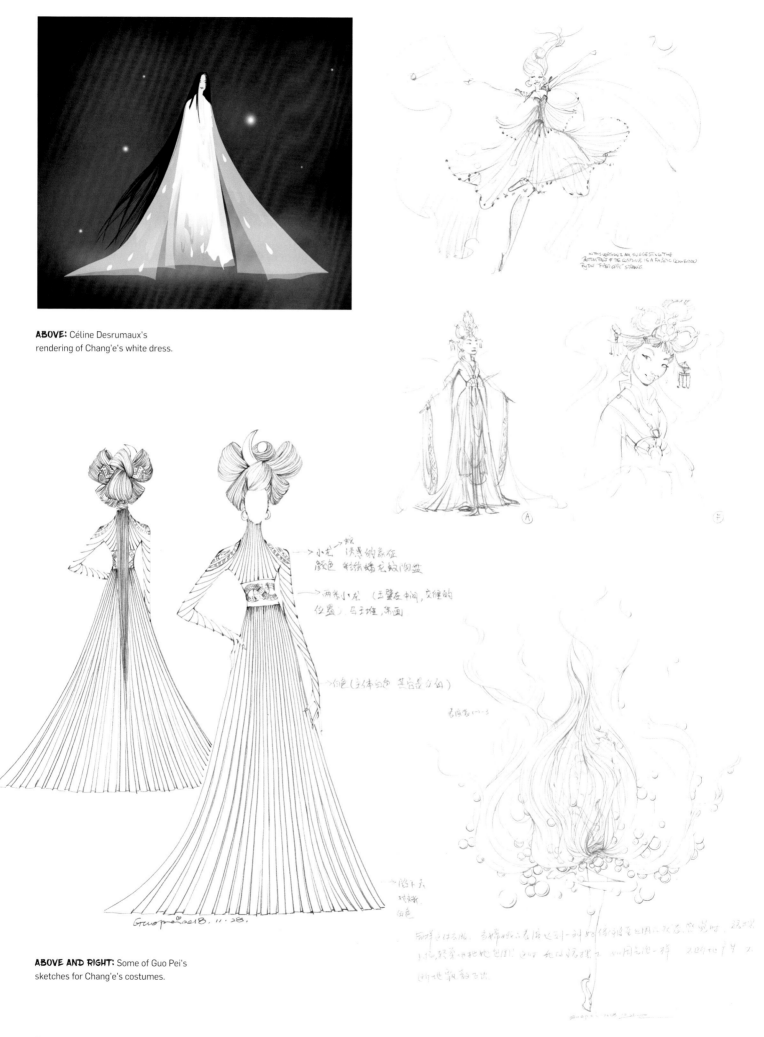

ABOVE: Céline Desrumaux's rendering of Chang'e's white dress.

ABOVE AND RIGHT: Some of Guo Pei's sketches for Chang'e's costumes.

Never far from Keane's mind is a key word he learned from his Disney mentor Ollie Johnston: appeal. If a major character isn't visually appealing to the audience, you're sunk before you even set sail.

Sony Pictures Imageworks' VFX supervisor Dave Smith marvels at Keane's acuity as well as his talent. But he quickly realized that he and his team would have to be inventive in order to execute the director's wishes. "The first thing was to make the tool that you use to annotate much more pencil-like." The next missing ingredient was a CG equivalent of a cell overlay. "We didn't really have something in place that mimicked that so I hacked something together for him. Then our development team wrote something that felt much more like an overlay and they worked for quite some time on getting a better feel to the pencil. So Glen had an immediate impact there.

"Then we did a little test for him. He was really pushing us with his little lines that he would draw. He'll come in and draw the curve in this perfect way and we'd say, 'OK, we're going to need to upgrade the ability to create these very nuanced expressions.'"

Smith realized that he and his colleagues would have to call on programs and technology that Sony Pictures Imageworks normally utilized in live-action movies. "Because we're a company that does both visual effects and animation, they're very experienced in making realistic humans. There's not a lot of forgiveness in that. We brought some of those techniques into our facial rigs so that the physiology performed more realistically, because Glen knows all about the flow of real physiology even though we're putting it on a stylized character."

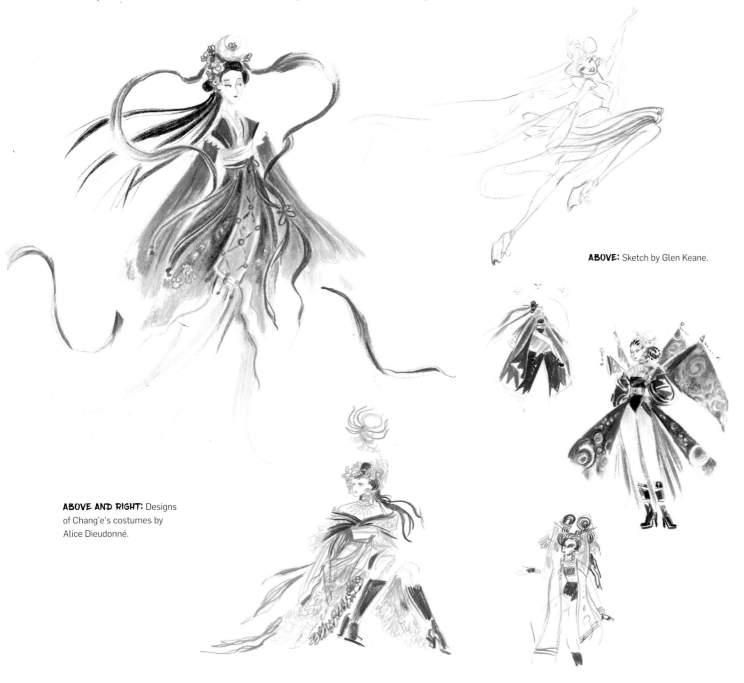

ABOVE: Sketch by Glen Keane.

ABOVE AND RIGHT: Designs of Chang'e's costumes by Alice Dieudonné.

PING-PONG BATTLE
HEY BOY

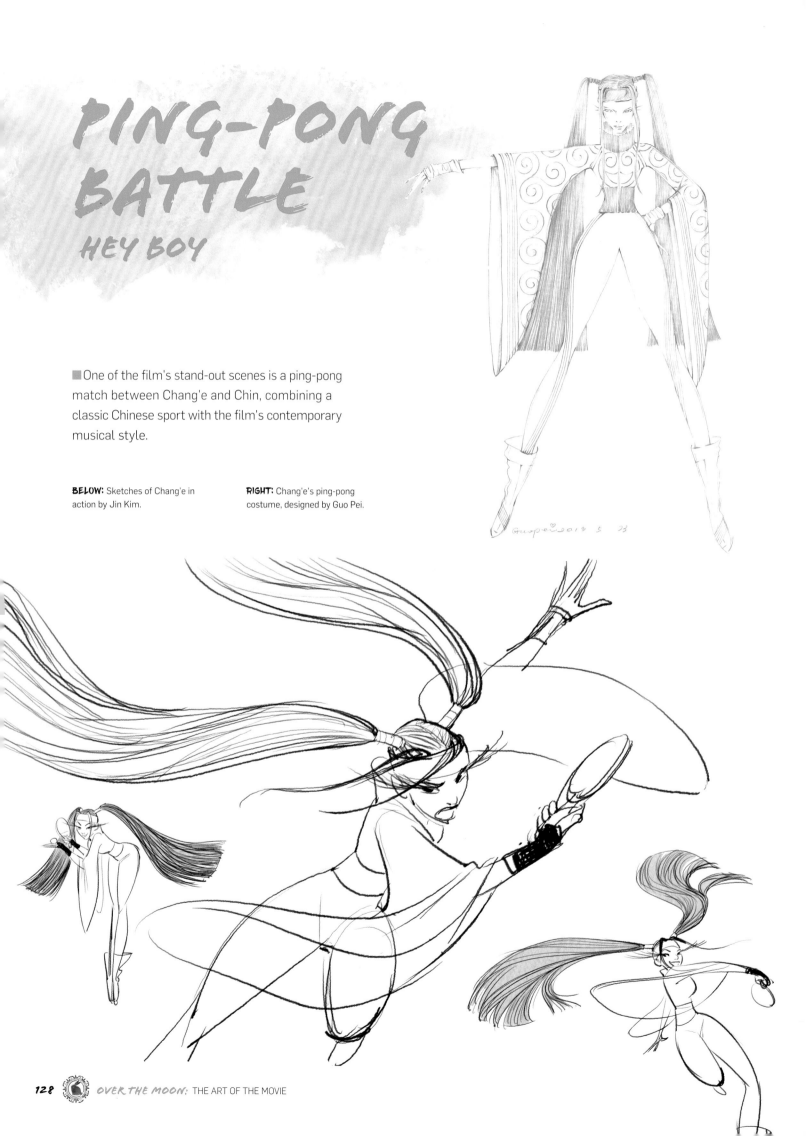

■ One of the film's stand-out scenes is a ping-pong match between Chang'e and Chin, combining a classic Chinese sport with the film's contemporary musical style.

BELOW: Sketches of Chang'e in action by Jin Kim.

RIGHT: Chang'e's ping-pong costume, designed by Guo Pei.

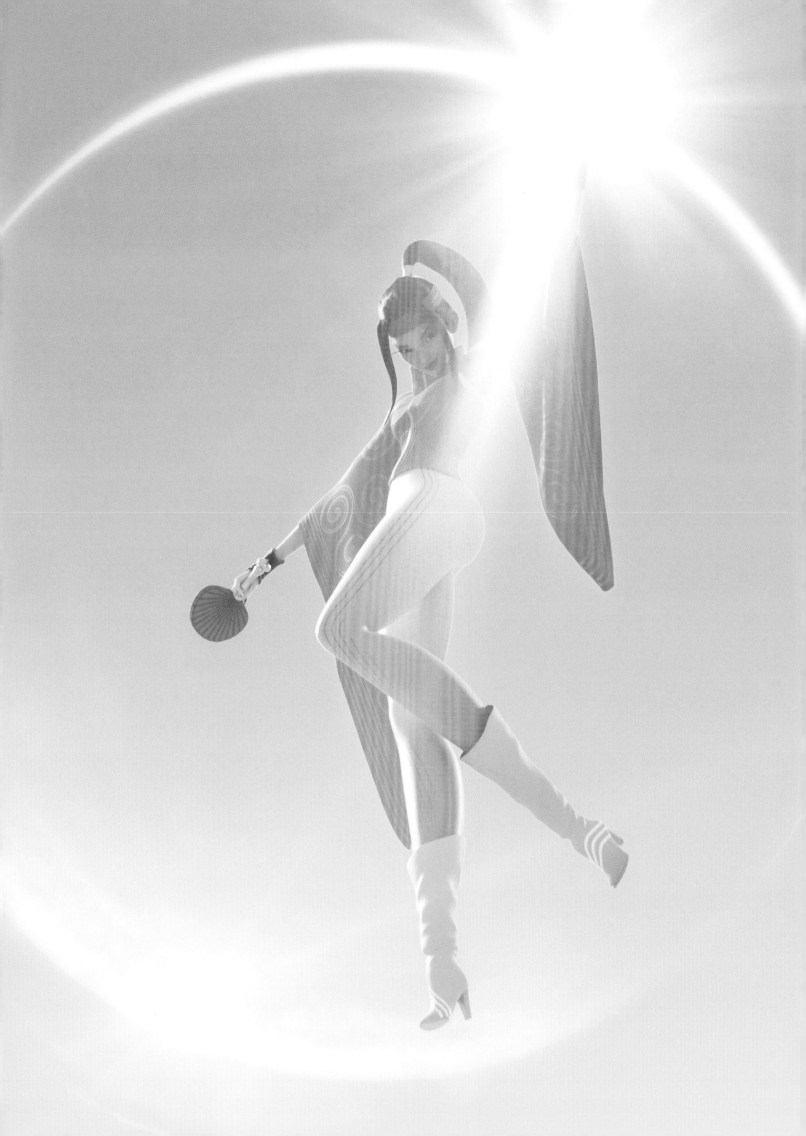

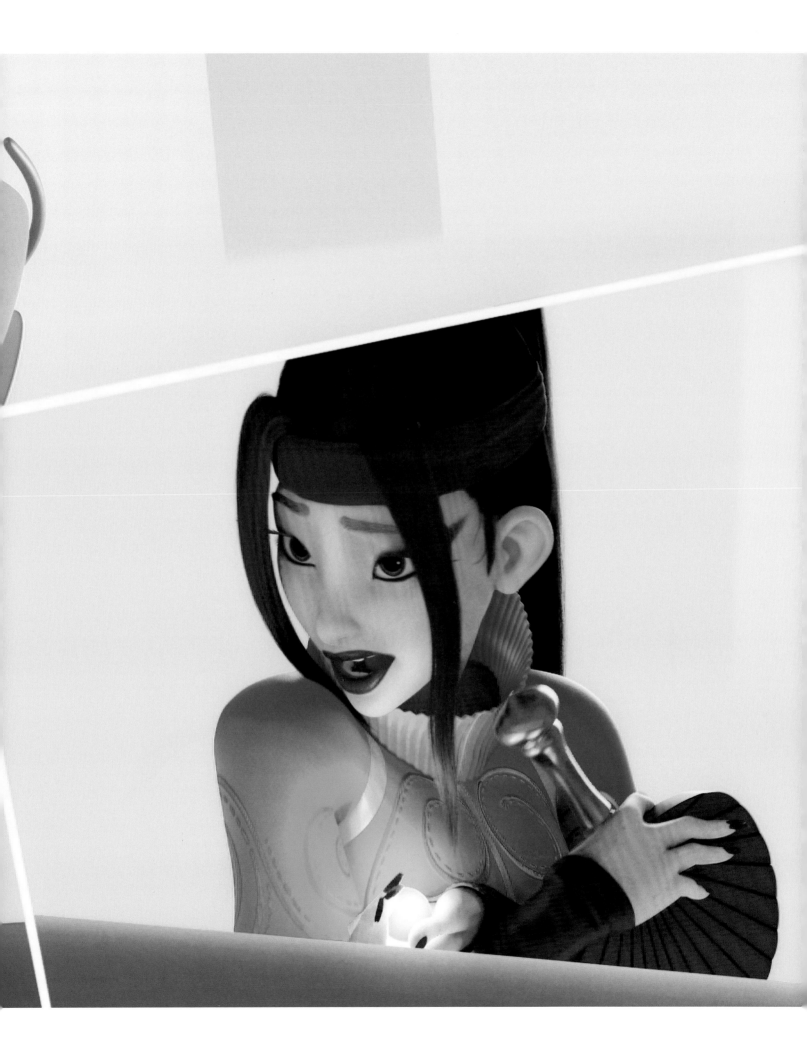

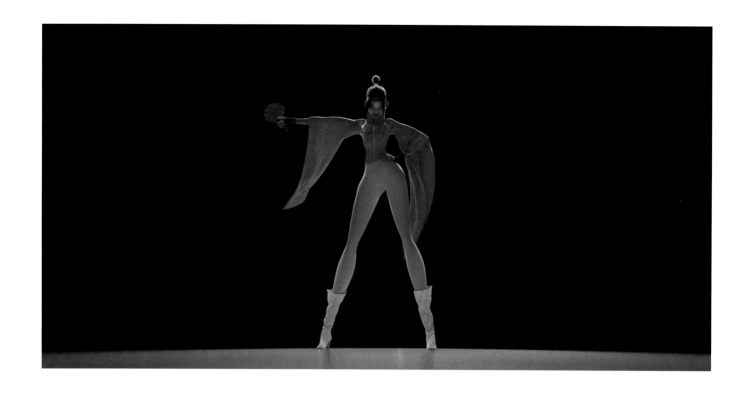

"THE PING-PONG SONG WAS REALLY GLEN'S IDEA BECAUSE HE REALLY WANTED TO HAVE THIS AS A SUNG MOMENT. I'M SO GLAD THAT WE DID ALL THOSE NINE-HUNDRED AND SEVENTY-FIVE DRAFTS OF THAT SONG BECAUSE IT'S REALLY A FUN MOMENT."

CHRISTOPHER CURTIS
SONGWRITER

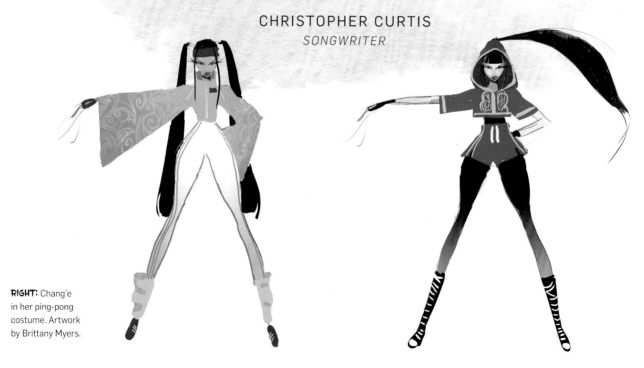

RIGHT: Chang'e in her ping-pong costume. Artwork by Brittany Myers.

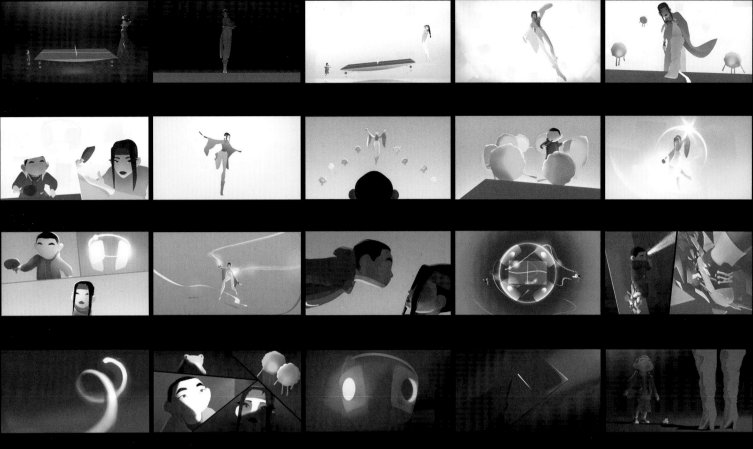

THIS PAGE: Color keys by
Céline Desrumaux.

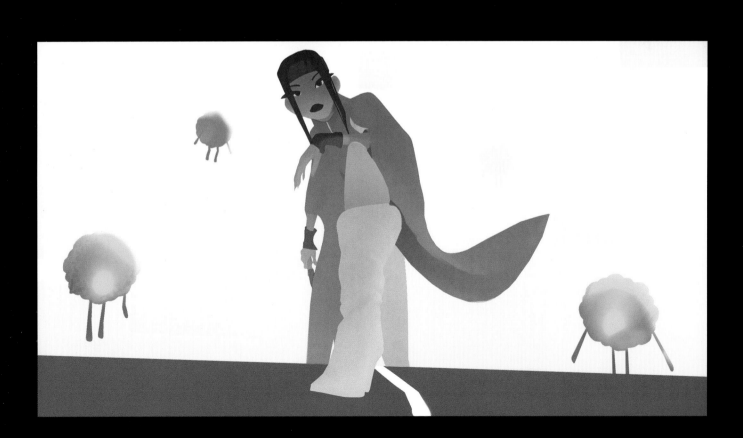

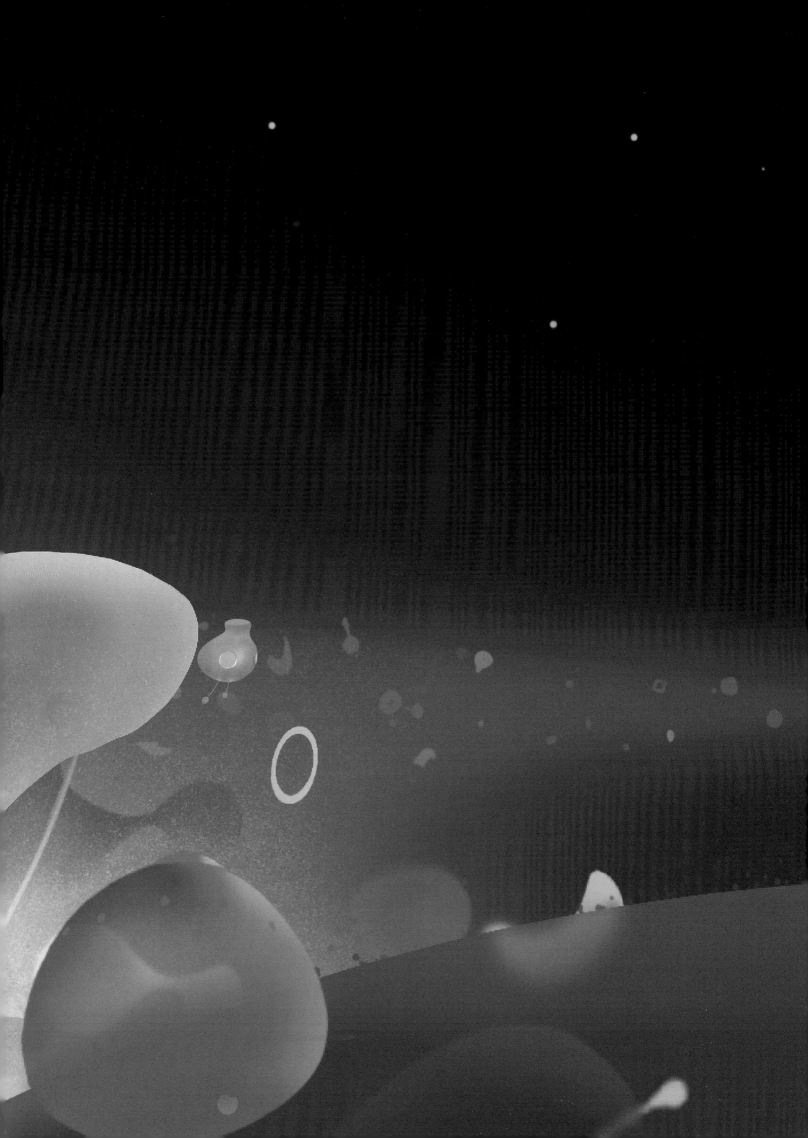

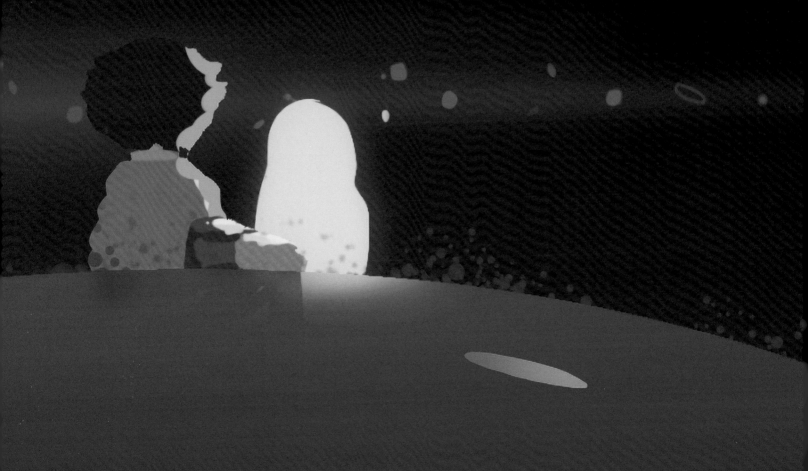

CRASH SITE

■ After her initial meeting with Chang'e, Fei Fei must return to the desolate moonscape where she first crashed, to find "the gift" hidden amongst the remnants of her rocket.

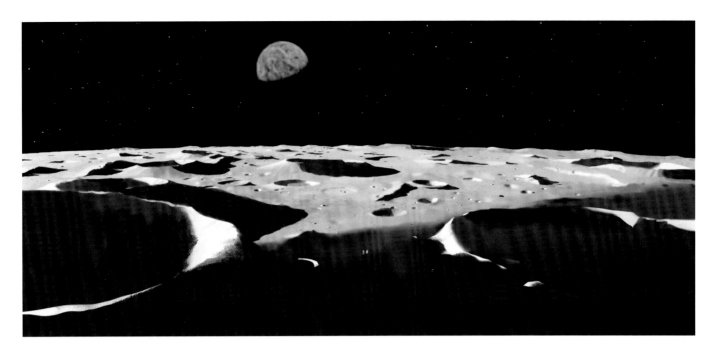

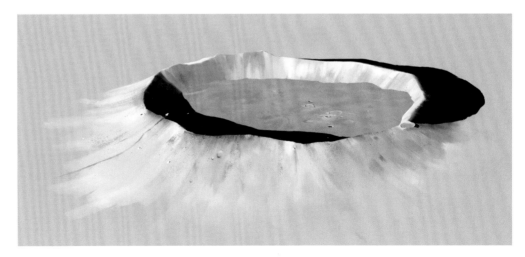

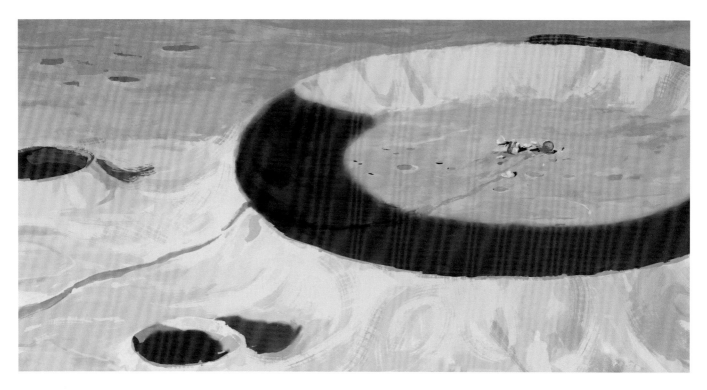

Fortunately, Keane has a partner who understands both his needs and his demands. Gennie Rim says, "Glen comes from a 2D background. He did *Tangled* and he's done a couple of other CG projects, but I think his mind is very much the drawing first. And what I see is an opportunity because I know the CG pipeline and I do know 2D. Where can we blend those two ideas together to make the best execution of Glen's vision, bringing the best of both worlds into it? I don't think a lot of people are striving for that. I think there's an exploration in what animation wants to be going forward."

It wouldn't be unreasonable to wonder how one person—even one as gifted as Keane—can manage so many details on a day-to-day basis for the long haul of making a feature-film. The answer is simple: he couldn't. He's only human. Fortunately, longtime Disney colleague John Kahrs (an Oscar® winner for his innovative 2012 short film *Paperman*) was willing to come in and give Keane a break. It helped a great deal that he understands Keane's m.o. and knows where his priorities lie. He truly earned his title as co-director.

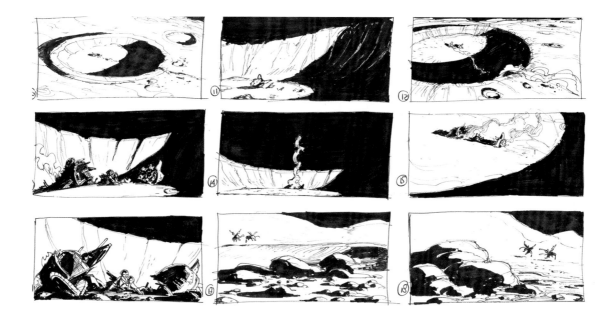

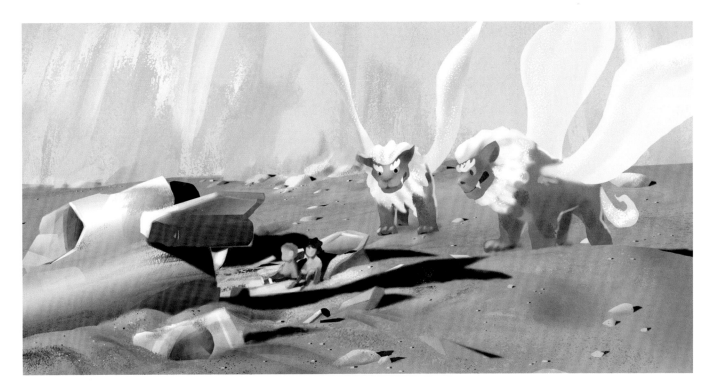

ABOVE: Artwork by Jérémy Baudry.

Kahrs says of Keane, "He's always hunting for the true emotion and the way to express that visually. Glen was definitely pushing the animators already to the next level. So when I came onto the show, I was chasing after that same thing but I was also chasing after things such as the audience can only look at one thing at a time so you need to direct the eye. You need to calm this down and direct the eye to the right place on the screen at the right time. That was something I was hammering home every day."

Animation supervisor Sacha Kapijmpanga oversaw as many as 110 animators in Vancouver and says, "It's like putting together a football team or a baseball team, you want people with different strengths. Some animators are really good at action, specifically, or they're great for those really quick shots that require a lot of really detailed timing. You want people who are good at many different things on your team."

He says it took time to capture the personality of Fei Fei. "A lot of the things that Glen would focus on for dealing

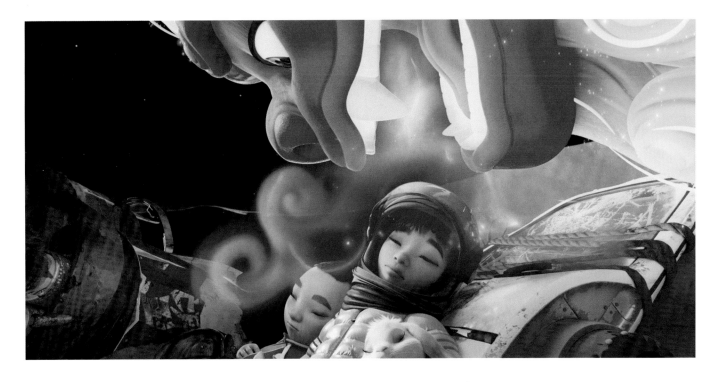

with Fei Fei were very detailed anatomical notes. It was important that the corners of her mouth behaved in a really detailed and certain way. It was important that we can see the structure of her anatomy underneath her clothes and what her arms are doing. We'd show her often in transparent cloth so we can see how the cloth was going to drape on top of her arms. All of those things are important to him. He also emphasized tilt, rhythm, and twist: opposing angles of shoulders to hips and twisting the shoulders relative to the hips... focusing on the poses and getting the most interesting pose we could possibly get."

It's common for productions to shoot video of the voice actors as they record their dialogue, but since they have to stay close to the microphone, there isn't a lot

the animators can glean about all-important body language. Kapijmpanga and his artists decided against hiring actors for reference footage and decided to use themselves instead.

He recalls, "Often that would be the first thing that we would show Glen: the reference performance of an animator trying to act out this scene. We'd show him multiple takes and he might respond more to one than another and we'd go in that direction or we'd choose, 'Let's do this with her body but that expression on your face here is amazing, so let's use that.' And we'd combine some of those things together. It was a great first step for getting down the road more quickly rather than just hopping straight into trying to animate a character."

OPPOSITE PAGE: Artwork by
Céline Desrumaux.

BELOW: Satellite design by Wang Rui.

BOTTOM: Sketch of the crash site by
Edwin Rhemrev.

BIKER CHICKS

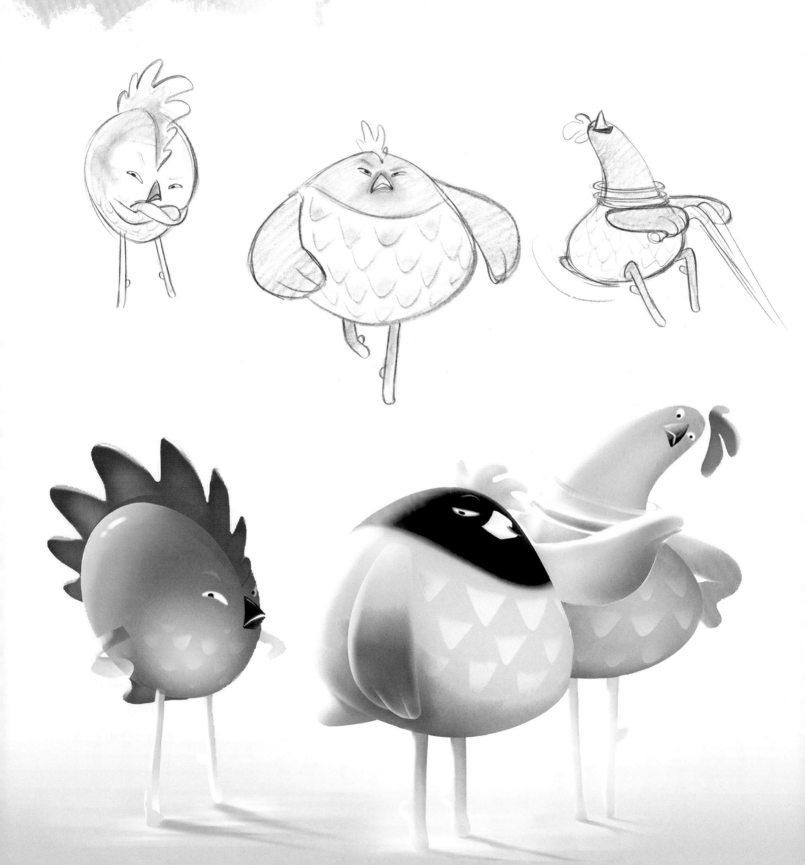

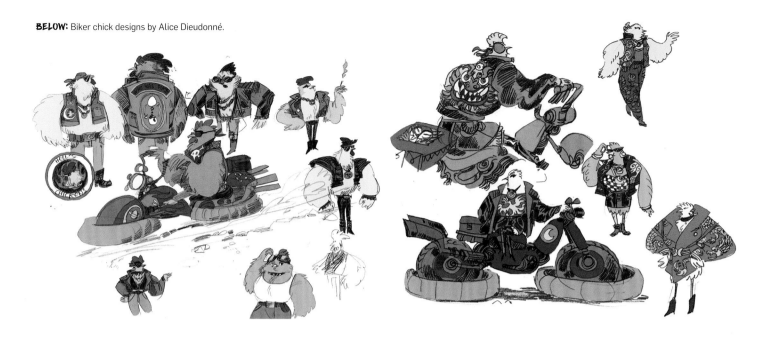

OPPOSITE: Sketches of the biker chicks by Jin Kim (top) and color of biker chicks by Marion Louw (bottom).

ABOVE: Artwork by Jérémy Baudry.

BELOW: Artwork by Alexis Liddell.

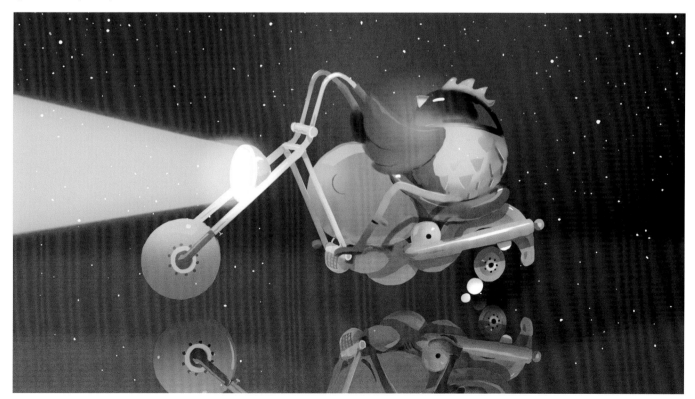

CHANG'E'S
METEOR SHOWER

■ As Fei Fei travels back to the crash site, she must race through a sudden meteor shower caused by Chang'e.

BELOW: Artwork by Edwin Rhemrev.

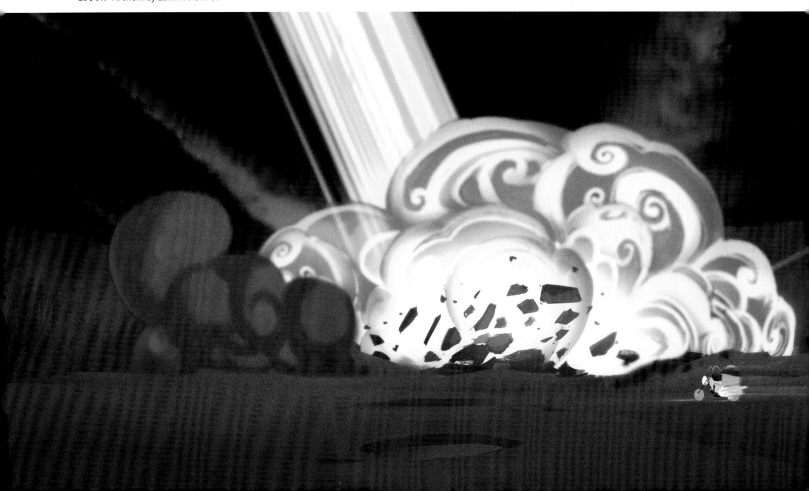

BELOW AND OPPOSITE: Black-and-white artwork by Phillip Vigil.

BOTTOM RIGHT: Meteor designs by Jérémy Baudry.

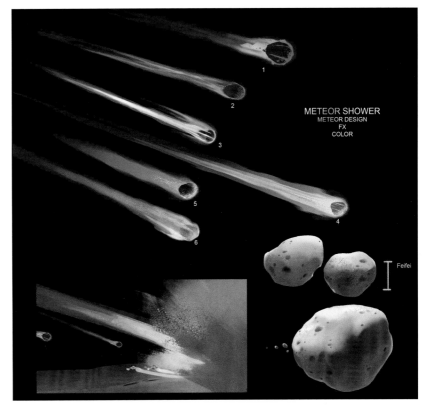

METEOR SHOWER
METEOR DESIGN
FX
COLOR

1

2

3

4

5

6

Feifei

GOBI

■ Fei Fei meets exiled Lunarian creature Gobi at the crash site, who he helps her as she searches for "the gift" and races back to the palace.

OPPOSITE: Paintover of Gobi by Céline Desrumaux.

BELOW: Sketches of Gobi by Jin Kim.

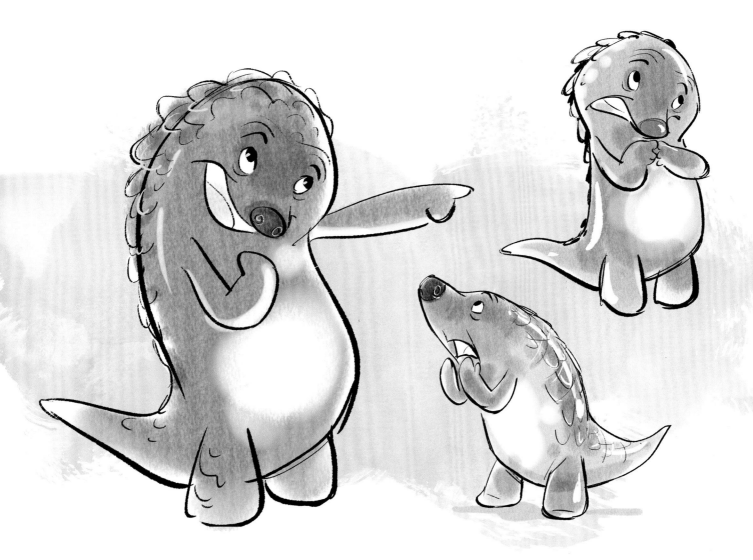

"Glen would look at poses on our bodies when we were acting something out and say, "What you're doing with your shoulders here is amazing compared to your hips. Look at that, make sure you incorporate that into the animation,'" Kapijmpanga continues. "It was great. Early on, we talked about the possibility of hiring an actress to play Fei Fei for body reference and stuff like that. And we didn't. We made the decision that the animators would do the reference. I personally think it's a great part of the process. I love having the animators trying to embody this character and figure out what that character's going through. Having to perform that stuff themselves often gets them thinking about a scene even before they're in the computer trying to pose things out.

"You spend that time either thumbnailing or acting the scene out yourself. And that can get you down the road more quickly, I think. It's also just an enjoyable part of the process."

If the framing story in a serene Chinese water town was based on real life, the sequences in Lunaria were as unreal as anything we've ever seen in a film—animated or otherwise. Early on, Keane gave Céline Desrumaux a copy of Pink Floyd's *Dark Side of the Moon*, which she describes as "just like a prism of white light and then colors." He told her, "I don't have any idea of what it's going to look like but it needs to be as strong as this CD cover."

This inspired the production designer to let her imagination run wild. She pondered the nature of Lunaria. "Everything is centered and linked to Chang'e. She's the source of light, she's a source of energy. When she's angry, she's throwing a meteor shower; when she's happy, all the Lunarians turn yellow. The palace is the center of the city but the palace is not infinity. We tried to brainstorm and ask ourselves how this palace can be modeled fresh but still give the idea of a palace." She brought a book of Winsor McCay's still-futuristic early 1900s comic strip 'Little Nemo in Slumberland' to Pearl one day and found a story where the arcs were high and there were no walls. As she hoped, McCay's illustrations provided inspiration to her colleagues.

LEFT: Artwork by Céline Desrumaux.

BELOW: Sketches by Guillaume Roux.

BELOW LEFT: Early artwork of Gobi by Alexis Liddell.

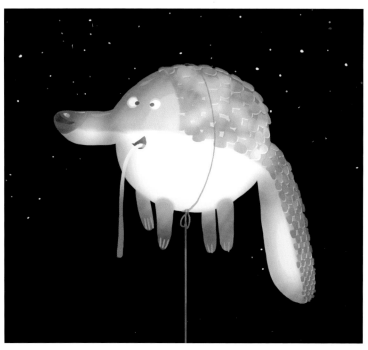

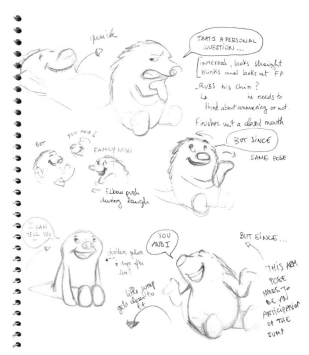

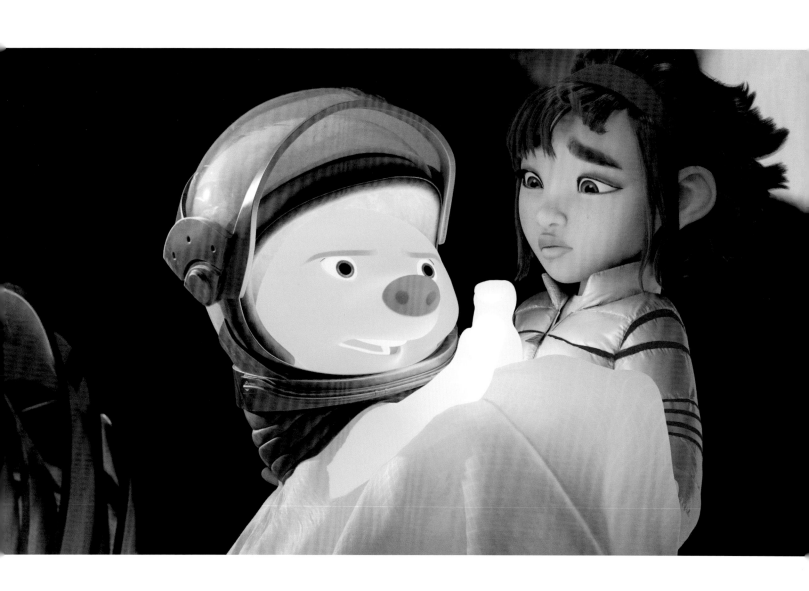

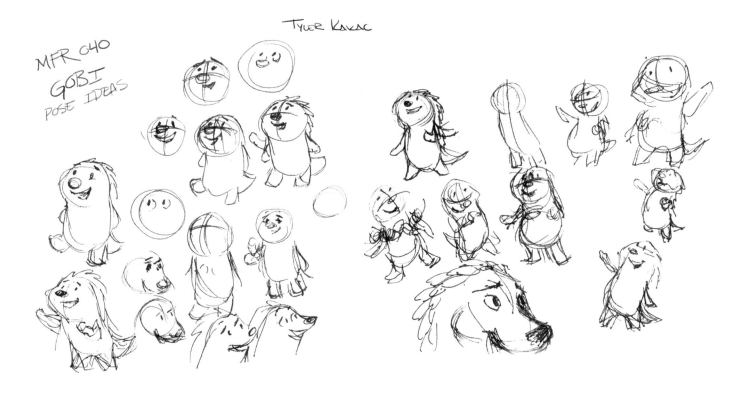

TYLER KAKAC

MFR 040
GOBI
POSE IDEAS

ABOVE: Sketches of Gobi by Tyler Kakac.

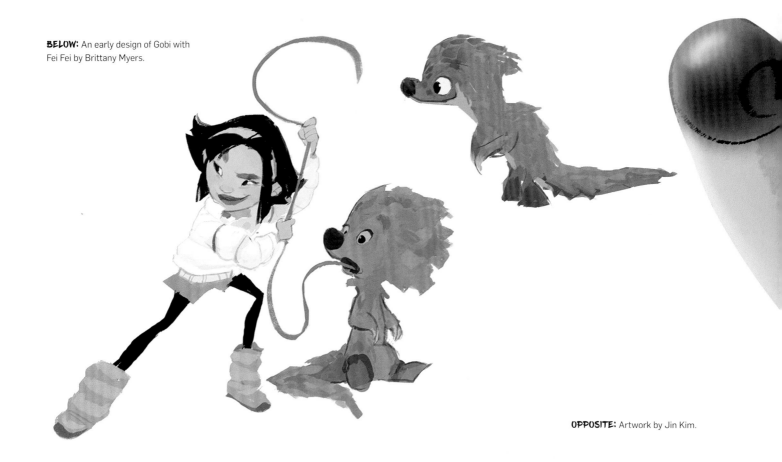

BELOW: An early design of Gobi with Fei Fei by Brittany Myers.

OPPOSITE: Artwork by Jin Kim.

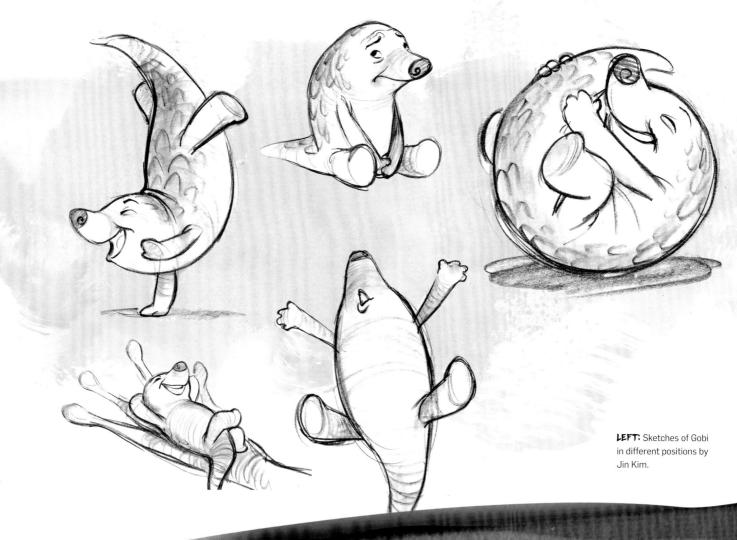

LEFT: Sketches of Gobi in different positions by Jin Kim.

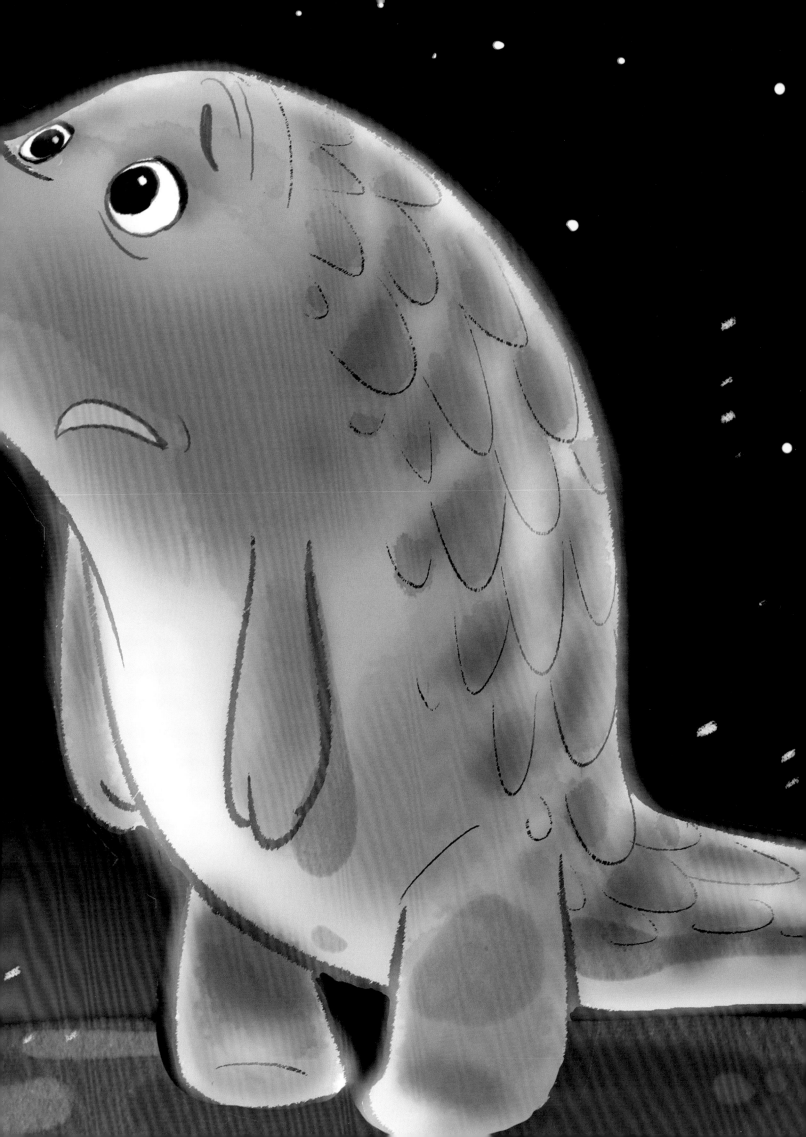

LEAPFROG

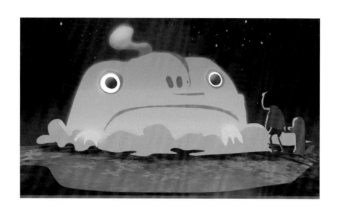

ABOVE AND OPPOSITE: Artwork of the frogs traversing the lunar landscape by Céline Desrumaux.

ABOVE: Artwork by Jin Kim.

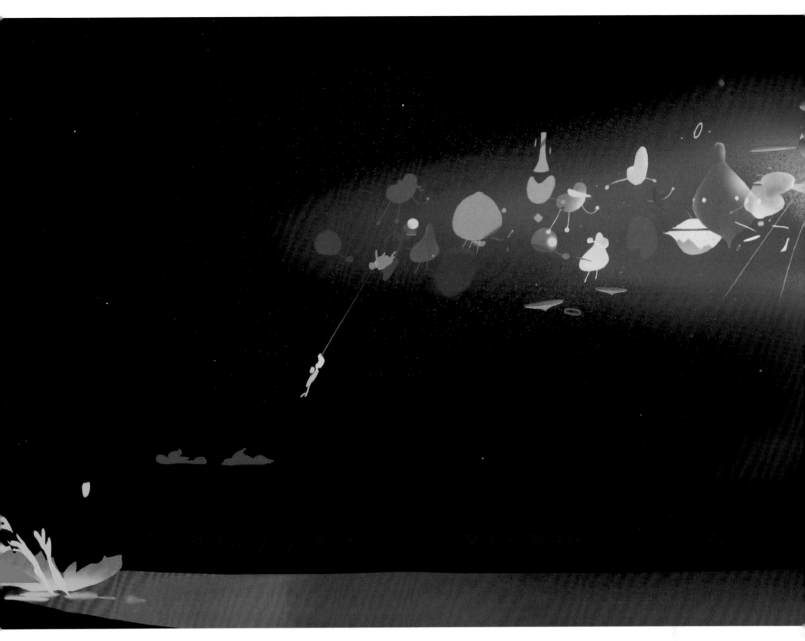

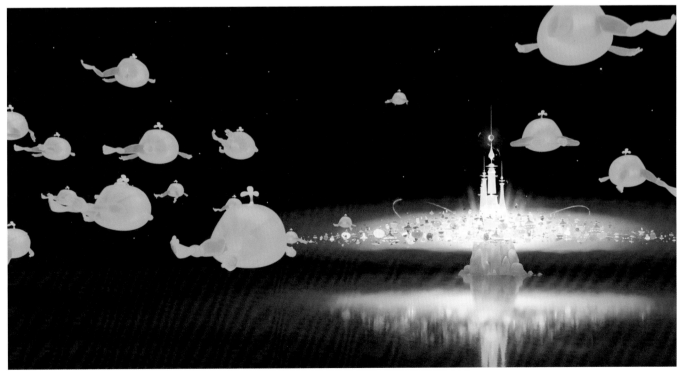

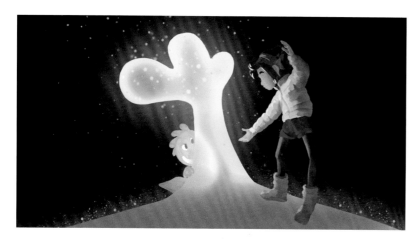

THIS PAGE: Artwork by Céline Desrumaux.

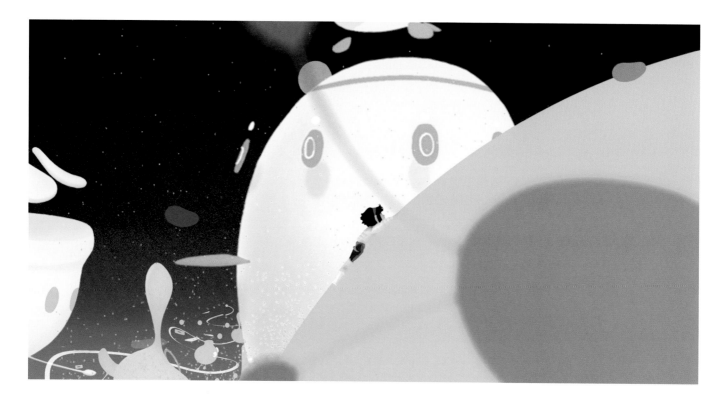

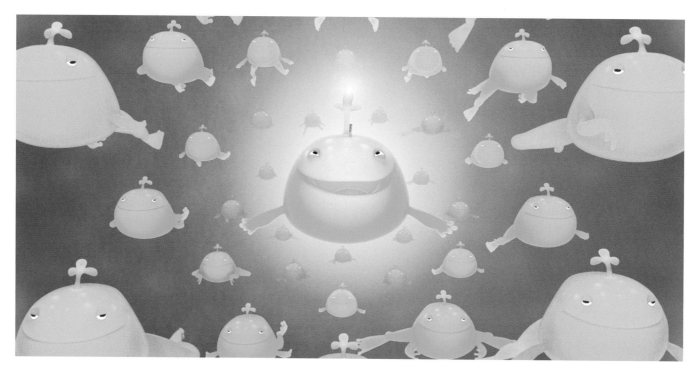

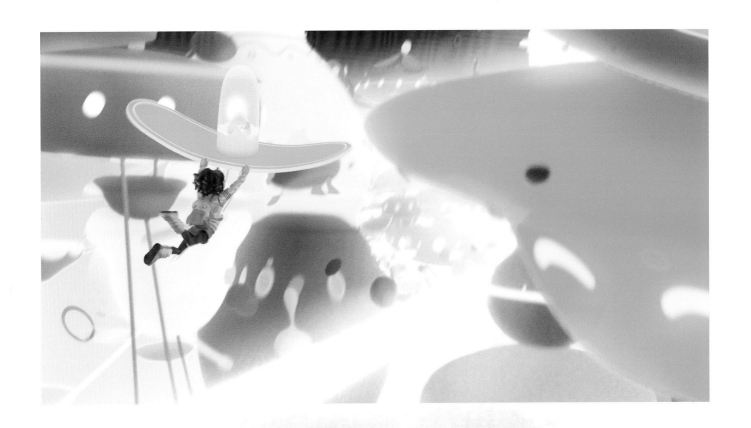

"IF YOU RELEASE THE PAST,
YOU'LL MOVE AHEAD AND
BLOOM AT LAST. THE HEART
GROWS AND IT KNOWS YOU CAN
GLOW—YOU'RE WONDERFUL."

GOBI

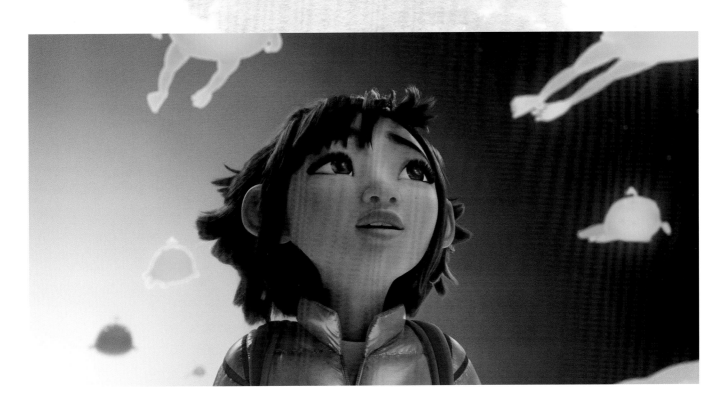

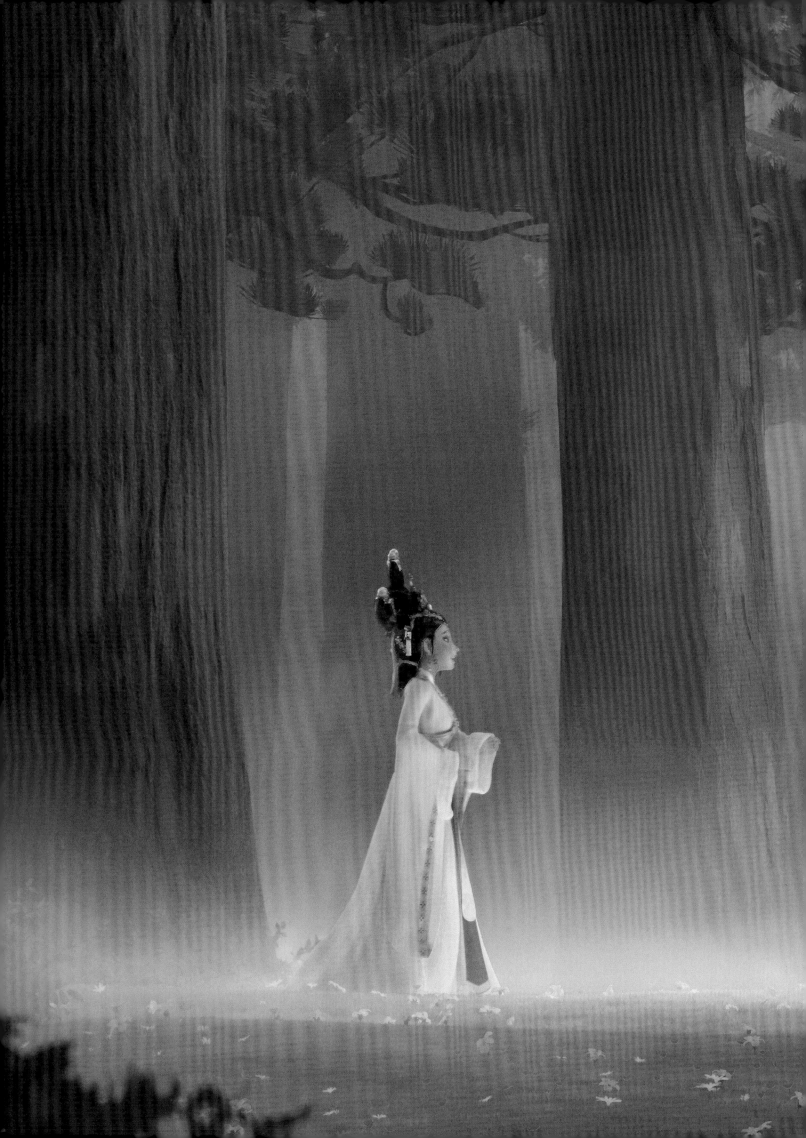

HOUYI
REUNION

JADE RABBIT

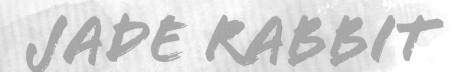

BELOW: Sketches of Jade by Jin Kim.

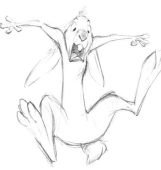

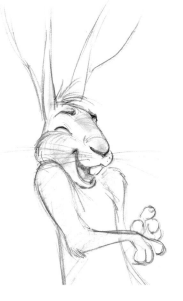

"FORTUNATELY, [CHANG'E] IS NOT ENTIRELY ALONE— SHE HAS A RABBIT COMPANION."

JANET YANG
EXECUTIVE PRODUCER

ABOVE: Designs for Jade by Alice Dieudonné.

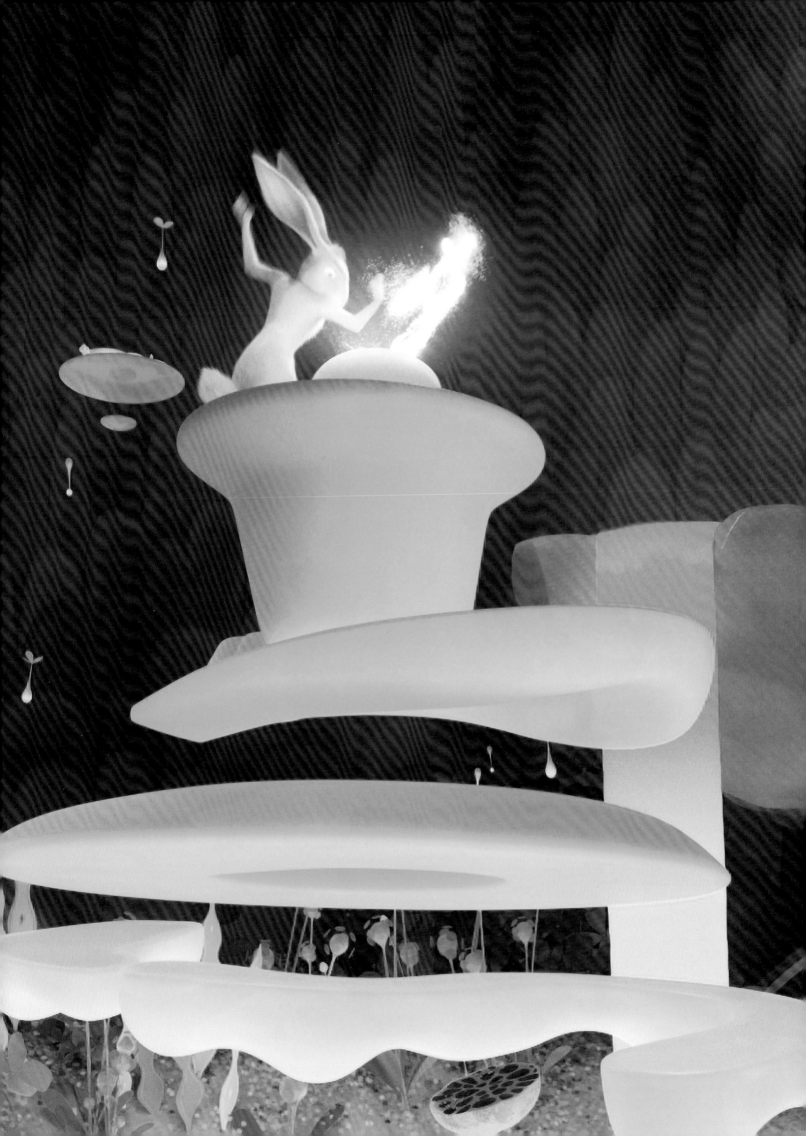

THE RABBITORY

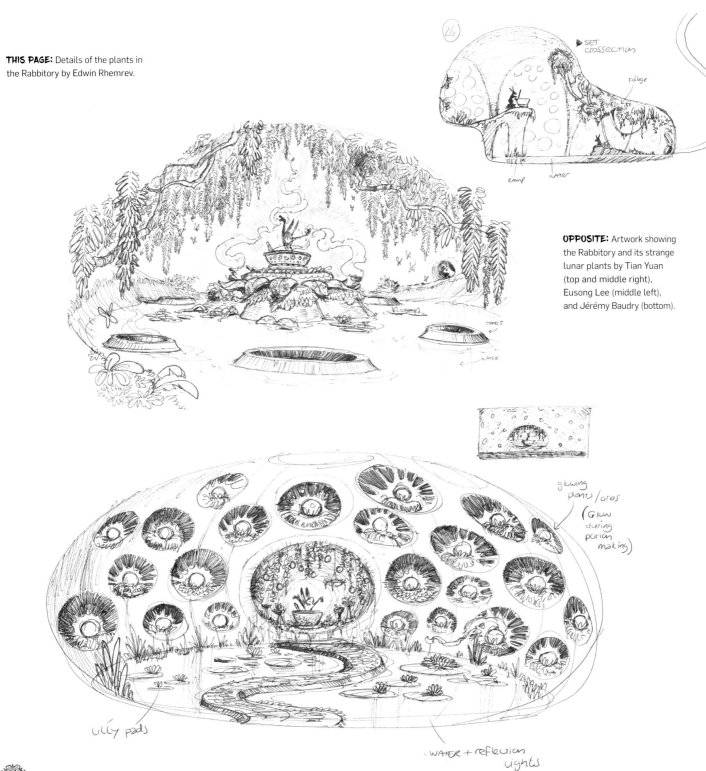

THIS PAGE: Details of the plants in the Rabbitory by Edwin Rhemrev.

SET crossection

Foilage

ramp

WATER

OPPOSITE: Artwork showing the Rabbitory and its strange lunar plants by Tian Yuan (top and middle right), Eusong Lee (middle left), and Jérémy Baudry (bottom).

glowing plants/orbs (Glow during potion making)

lilly pads

WATER + reflection lights

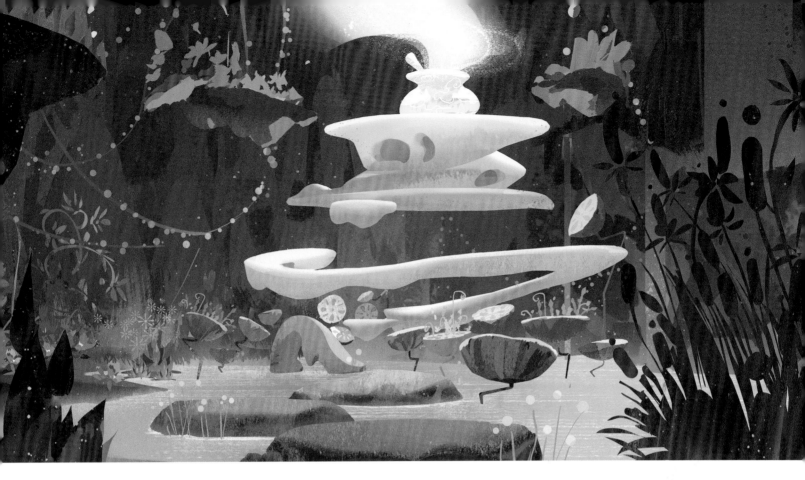

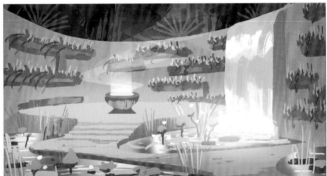

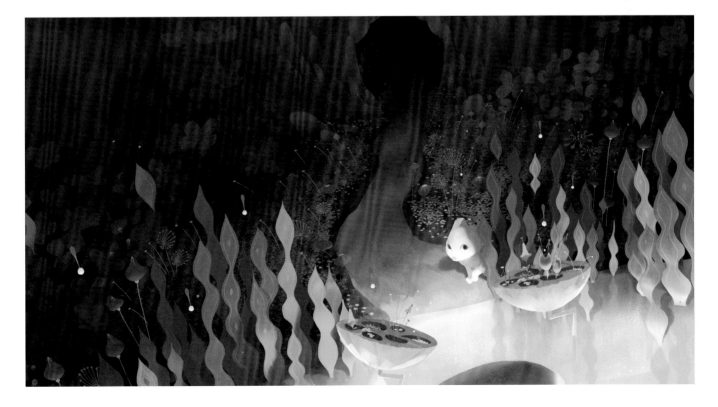

THE GIFT

LEFT: Close-up of the broken jade necklace. Artwork by Elle Shi.

"It gave us the idea of, *Hey what if there were no walls inside the palace?*" Céline Desrumaux says of the comic strip. "It was just this long corridor and because everything is linked to Chang'e, it means that even the colors are reacting to [her]. Because they are on the moon, all of the ideas are built on no gravity. Chang'e is the master of everything, so inside the palace, the columns are turning; they're constantly moving, linked to Chang'e's mood and behavior. Having no walls also got us to create this notion of black holes and portholes and create this infinite space that we needed for the Chamber of Exquisite Sadness."

Conceiving all of this is no small achievement, but executing Desrumaux's innovative ideas represented another mountain to climb. Replicating the surface of the moon was relatively simple: the production team relied on actual NASA photographs, but for CG supervisor Clara Chan, there was no precedent for visualizing Lunaria, only the concept art created by Desrumaux. The single biggest hurdle was illustrating a self-illuminating surface—populated by characters who are also self-illuminating. Even the buildings on Lunaria had to look unique and not like lanterns.

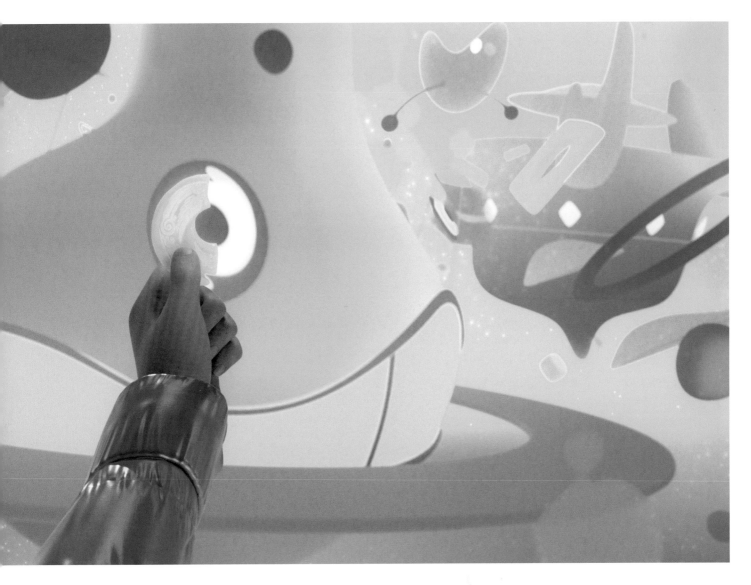

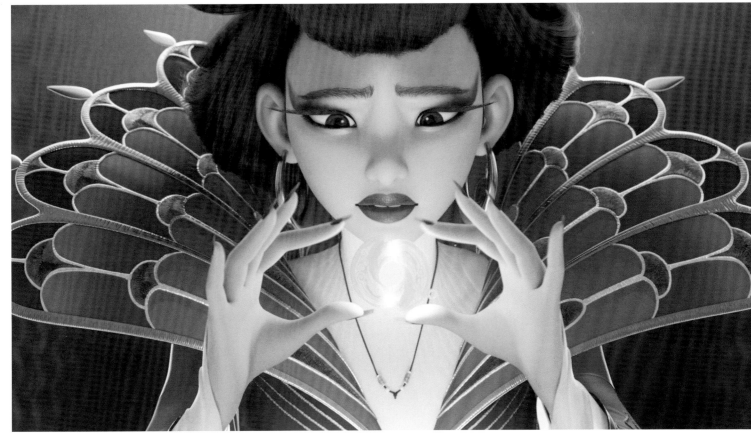

HOUYI

It is the loss of her love, Houyi, that drives Chang'e to live a life of heartbroken solitude on the moon. Together, she and Fei Fei must learn to live with their grief without letting it consume them.

THIS SPREAD: Sketches of Houyi by Jin Kim.

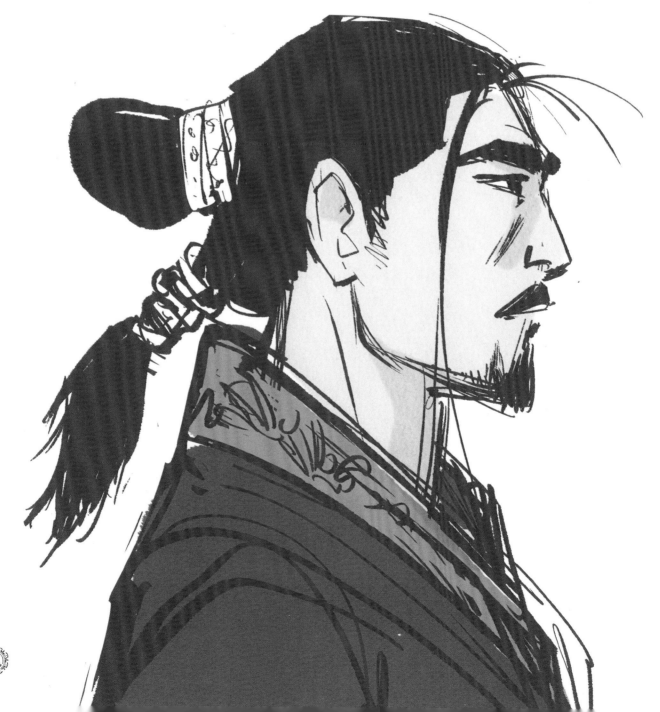

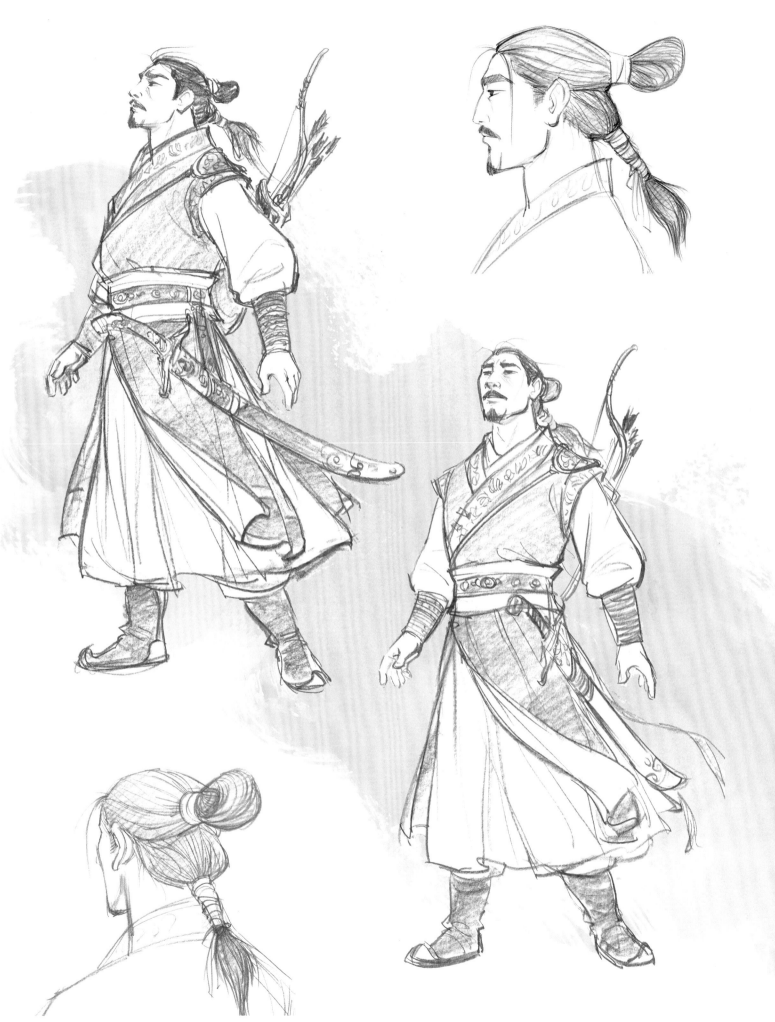

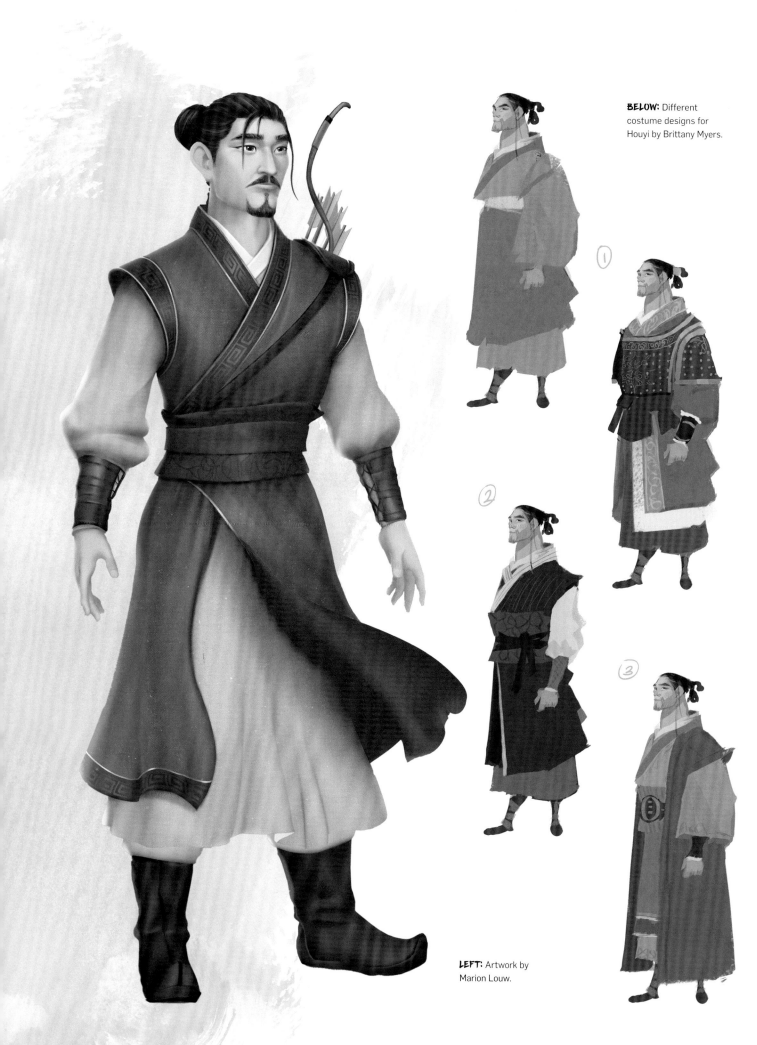

BELOW: Different costume designs for Houyi by Brittany Myers.

①

②

③

LEFT: Artwork by Marion Louw.

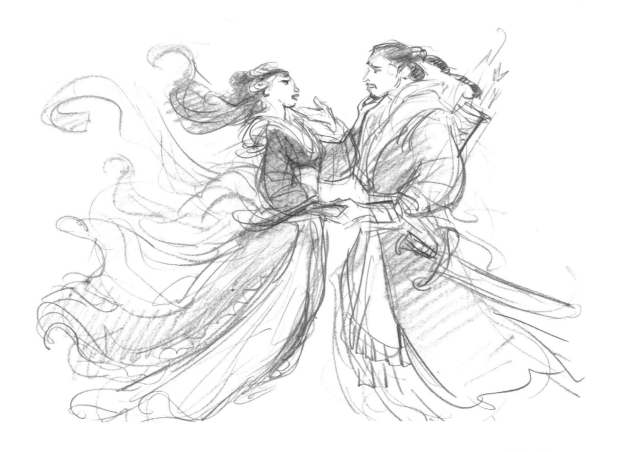

ABOVE & BELOW: Sketches of Houyi by Glen Keane.

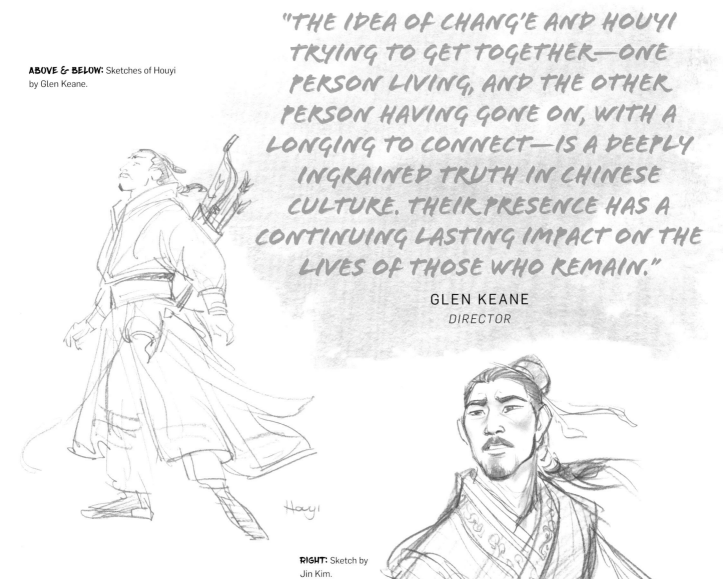

"THE IDEA OF CHANG'E AND HOUYI TRYING TO GET TOGETHER—ONE PERSON LIVING, AND THE OTHER PERSON HAVING GONE ON, WITH A LONGING TO CONNECT—IS A DEEPLY INGRAINED TRUTH IN CHINESE CULTURE. THEIR PRESENCE HAS A CONTINUING LASTING IMPACT ON THE LIVES OF THOSE WHO REMAIN."

GLEN KEANE
DIRECTOR

Houyi

RIGHT: Sketch by Jin Kim.

CHAMBER OF EXQUISITE SADNESS

■ Consumed by their grief, Chang'e and Fei Fei come together in the Chamber of Exquisite Sadness, where they realise, together, how to accept their loss and move forward.

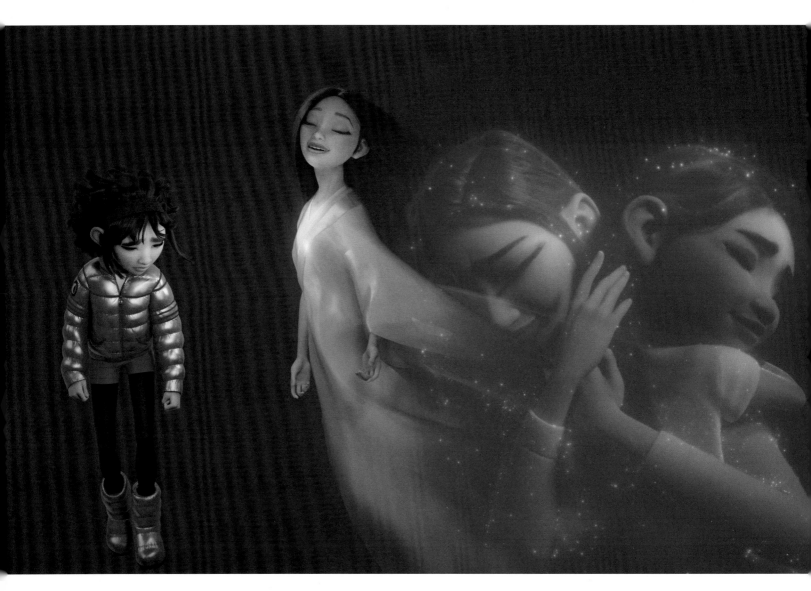

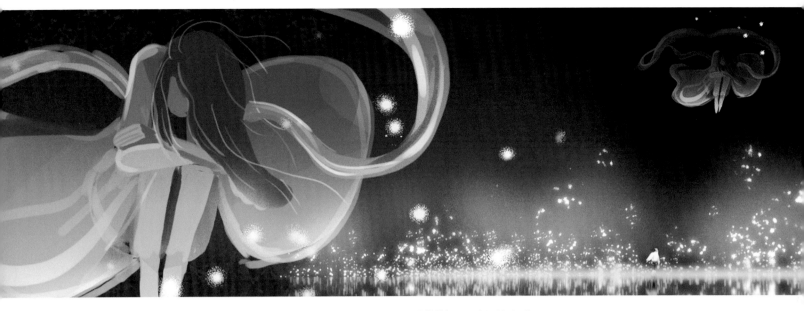

ABOVE: Artwork by Eusong Lee.

BELOW: Artwork by Marion Louw.

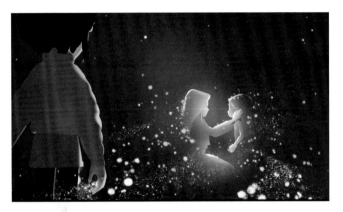

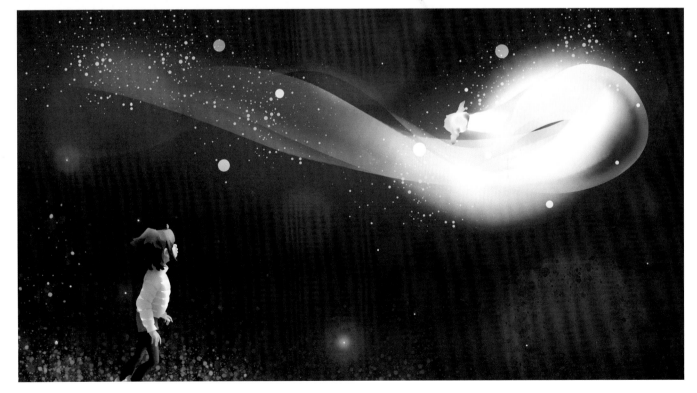

ABOVE: Artwork by Tian Yuan.

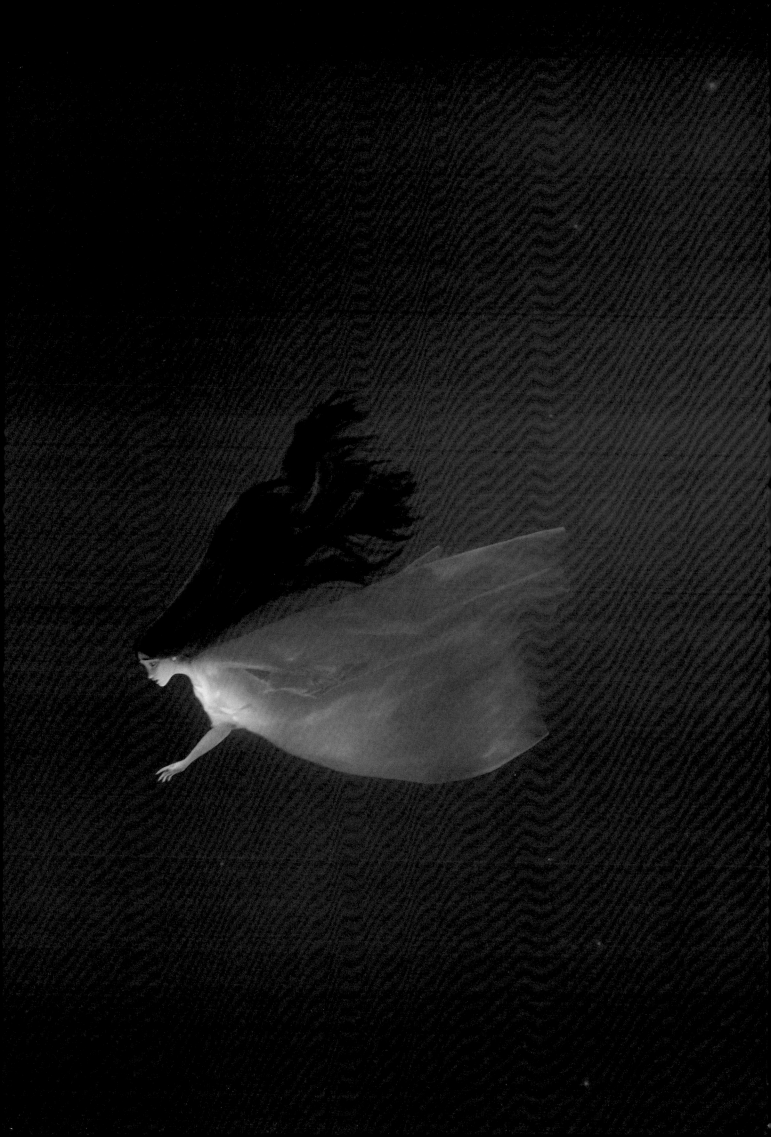

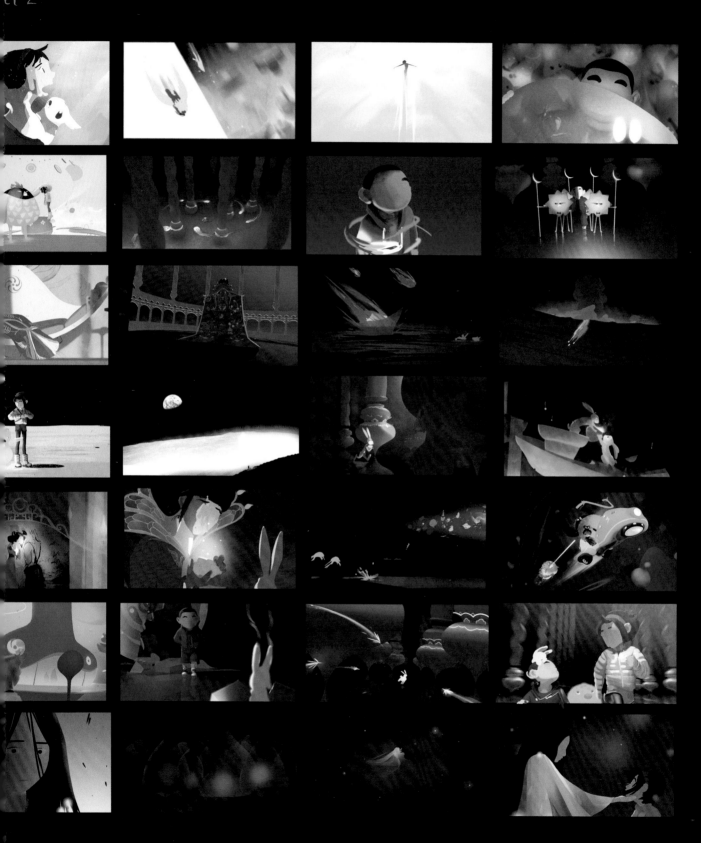

THIS SPREAD: Act 2 color script by
Céline Desrumaux.

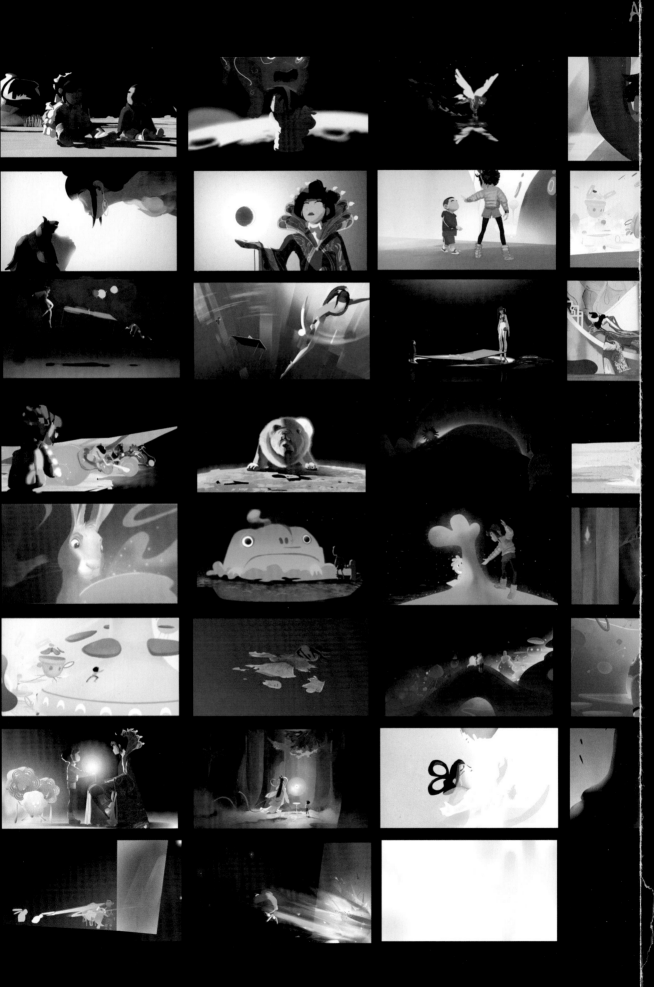

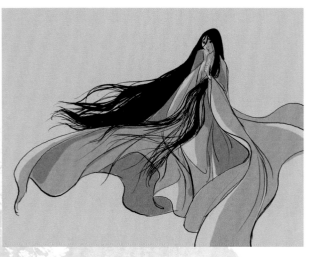
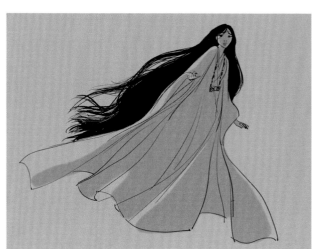

THIS PAGE: Sketches of a grieving Chang'e in the Chamber of Exquisite Sadness. Artwork by Jin Kim.

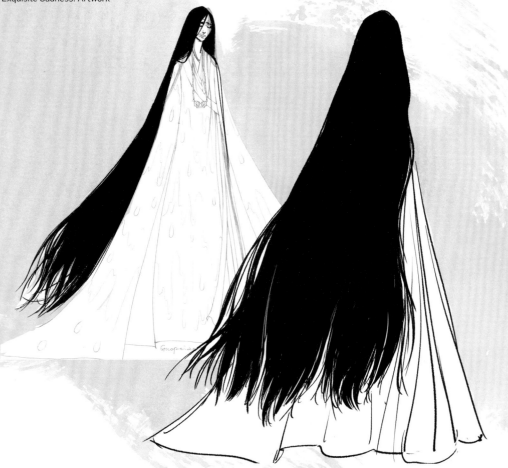

"HAVING NO WALLS ALSO GOT US TO CREATE THIS NOTION OF BLACK HOLES AND PORTHOLES AND CREATE THIS INFINITE SPACE THAT WE NEEDED FOR THE CHAMBER OF EXQUISITE SADNESS."

CÉLINE DESRUMAUX
PRODUCTION DESIGNER

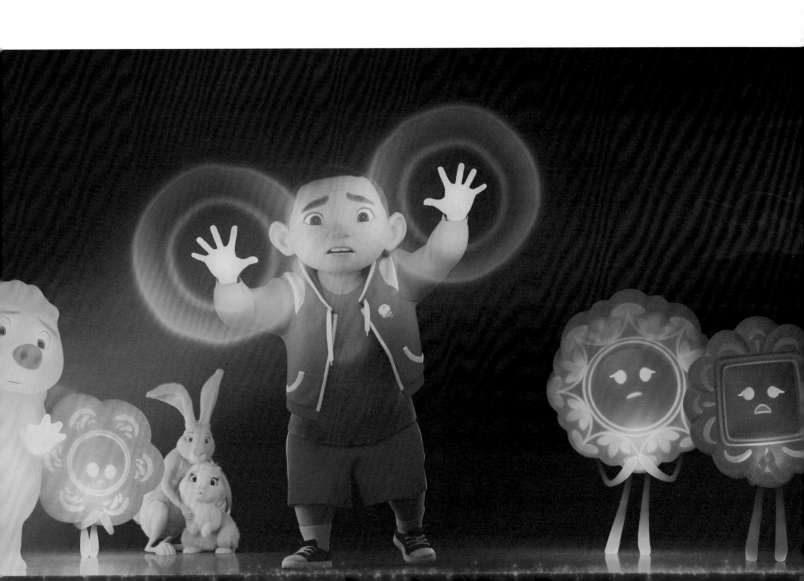

THE TRANSFORMATION

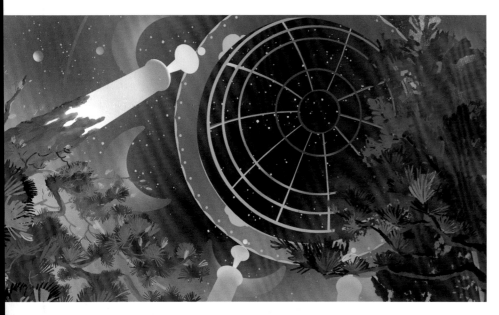

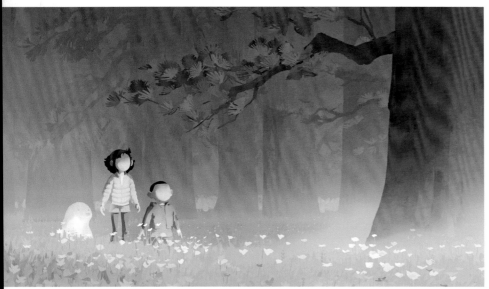

> "CHANG'E, I CANNOT STAY.
> YOU HAVE TO MOVE ON."
> HOUYI

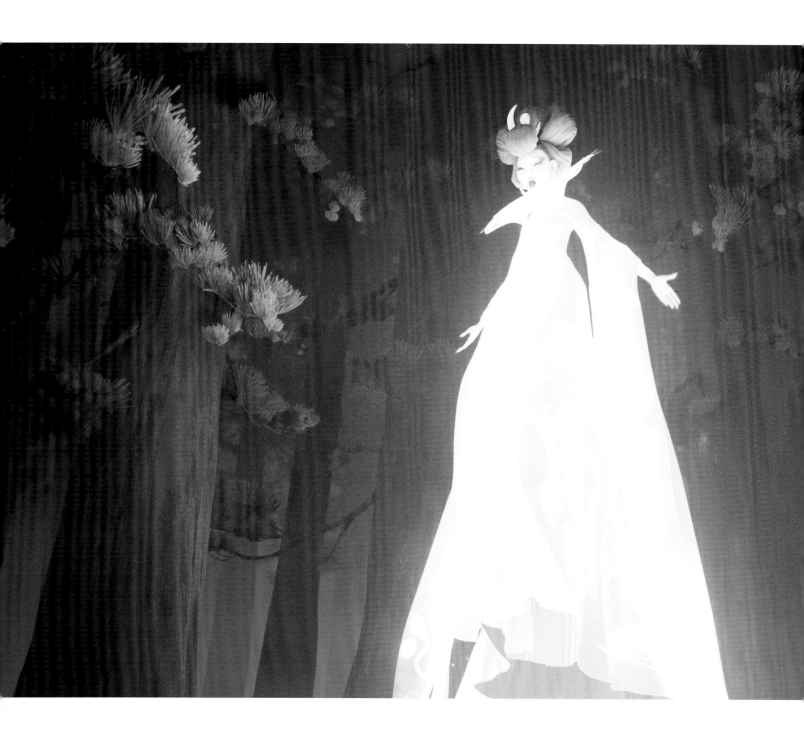

"Our software is calculated using actual math and how light bounces," Clara Chan explains. "We were able to modify it and create a different look than realistic lighting. It involved a lot of tests. There's pretty much no precedent that we could follow. [We were] trying to come up with a solution that can work on this scale of such a big movie. We have to be able to do this in every single shot so it cannot be something that takes a hundred hours to do. We have to both simplify it and create something that looks complex."

Having worked with the character of Electro on Marc Webb's *Amazing Spider-Man 2* (2014), VFX supervisor Dave Smith figured out how to adapt the software for Lunaria. "We have these things called mesh lights, which

we developed. That was the first use of those on this film because all of our characters were emissive. We took strong advantage of that mesh light tool, but the characters also needed to react to light when they were standing next to one another or going through the city, which is also emissive. We wanted them to be able to react to light. So our shading team had to rewrite that software so that it could both respond to light and give off light."

The icing on this elaborate cake was Chang'e herself, a goddess who is literally larger than life. Audrey Wells' screenplay had portrayed her as a fashionista, so the producers approached Guo Pei, the internationally renowned designer who created Rihanna's unforgettable

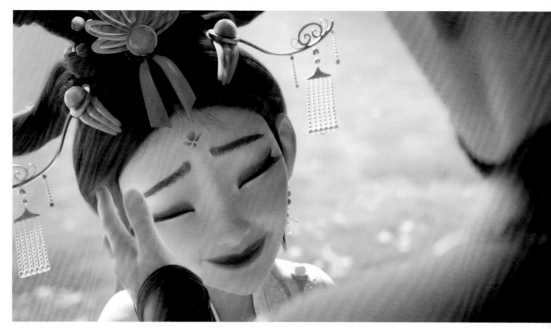

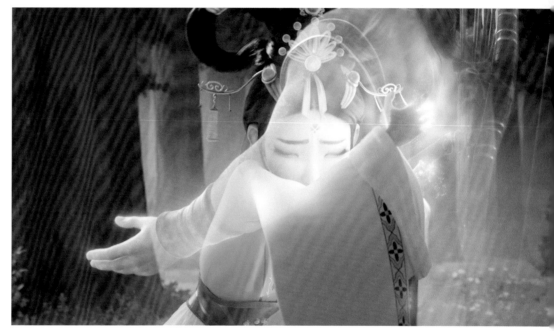

yellow gown for the 2015 Met Gala. (She was also named one of the world's 100 most influential people by *Time* magazine.)

Guo Pei had never worked in animation before but she relished the experience, especially after meeting Glen Keane. At their first face-to-face meeting, Pei's husband served as translator, but when he left the room for a spell, the two artists—who didn't speak each other's language—continued communicating by drawing. Peilin Chou says, "She would draw and he would draw and it was like the language of art—they didn't even need to talk to one another."

"We all liked this process and we want to make this a great opportunity, a great collaboration," Guo

Pei says (through a translator). "I like talking with him, communicating with him, it's a joy. He accepts all my thoughts: the crazy ones, the wild ones, I think it's really fun. He gave us infinite imagination."

She also appreciated the fact that she only had to draw those intricate and elaborate gowns for Chang'e and not manufacture them, which she says would have easily taken "thousands of hours."

Although Keane was the artistic leader of this enterprise—and made thousands of drawings along the winding path to completion—he has no problem sharing credit. He gave the all-important job of storyboarding several key songs to longtime colleague, Minkyu Lee.

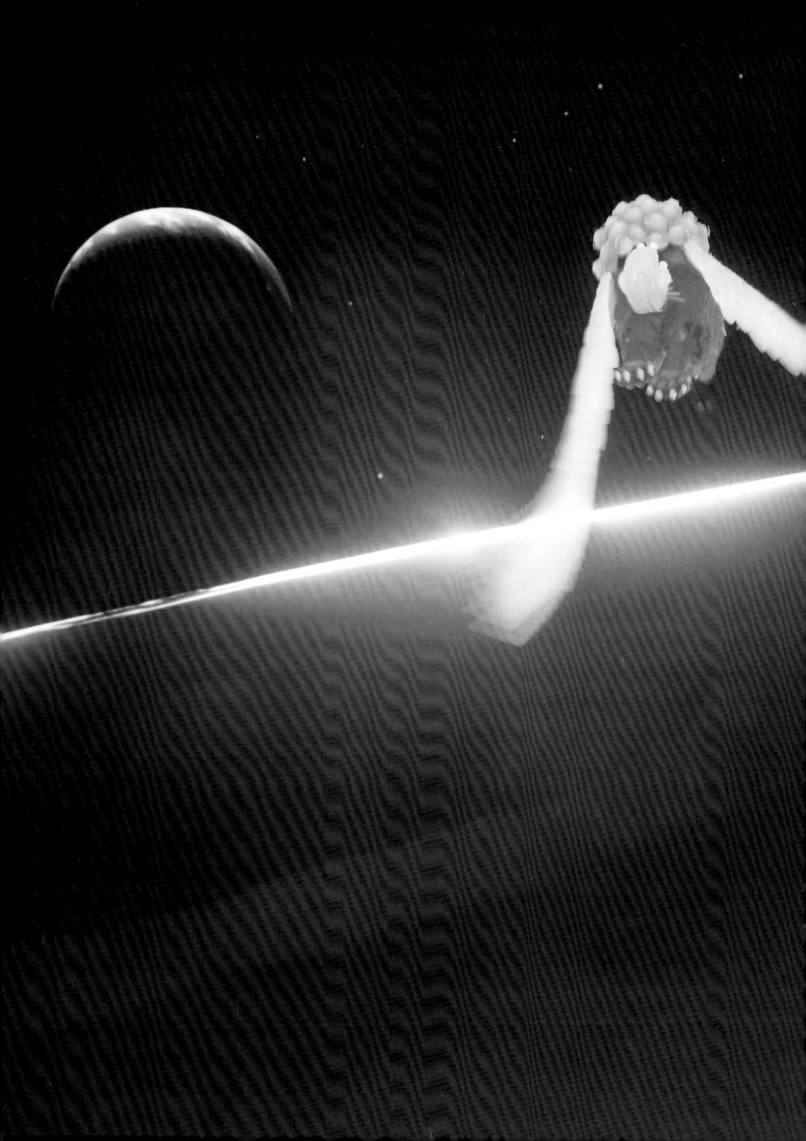

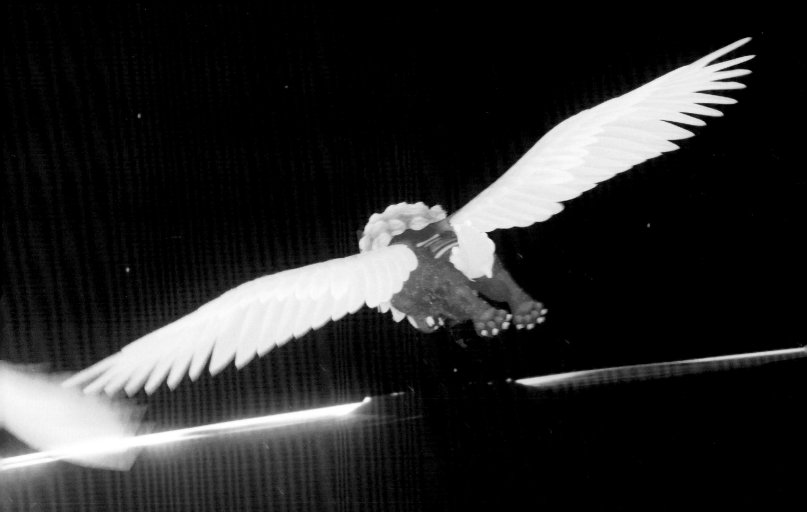

RE-ENTRY

动力下降段

圆形环月

近月制动

地月转移轨道

地球

发射!!

SPACE DOG

■ As they return to Earth, Fei Fei and Chin come face to face with another mythological creature from Fei Fei's mother's stories... the Space Dog.

BELOW: Arwork by Victoria Ying.
OPPOSITE: Artwork by Céline Desrumaux.

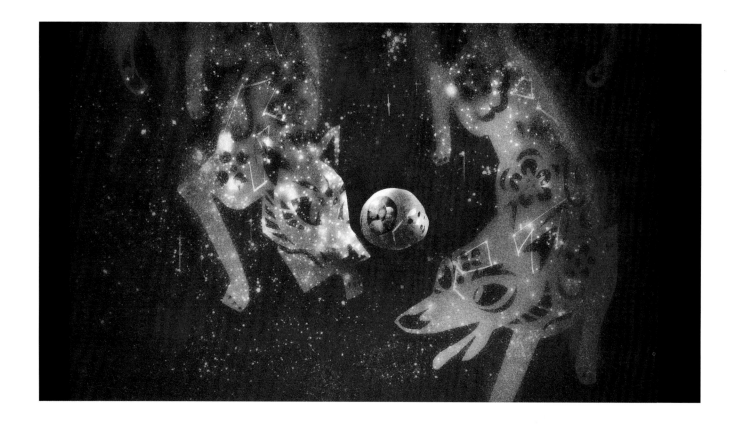

How does one begin to break down the visual representation of a song like 'Mooncakes?' Lee explains, "There's a lot of storytelling that's happening in the song. Crucial elements for the entire film are set up in that song such as the setting, but also Fei Fei's mother passing away. Also, Bungee entering her life and the beginning of her new life with her Dad. First I'm given the song, and we listen to it together in its workshop demo phase. With Glen and the story team, we go over what story beats do we need to clearly communicate? Also, what are the feelings that we need to feel in those moments? Like, how do we set up this moment so we really empathize with Fei Fe? We also see her life and how a mooncake is made. That's what her family does, so we really need to be invited into that home. Because it involves all these different contents that need to be communicated so clearly, I think the process was pretty far-reaching."

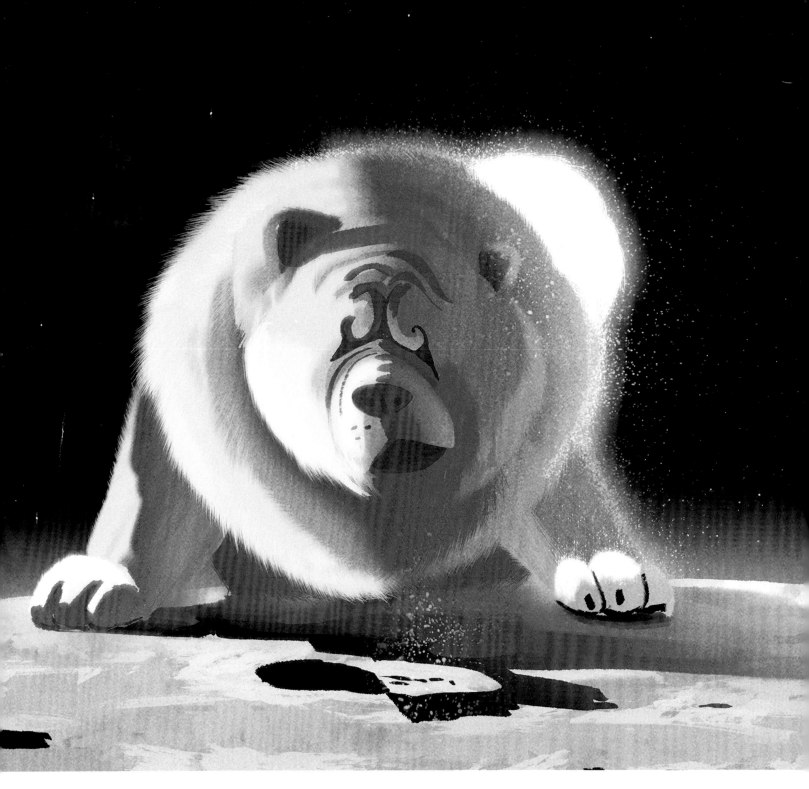

BELOW: Sketches of Fei Fei's "space" puppy by Glen Keane.

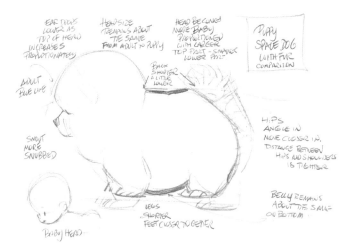

RIGHT: Artwork by Alice Dieudonné.

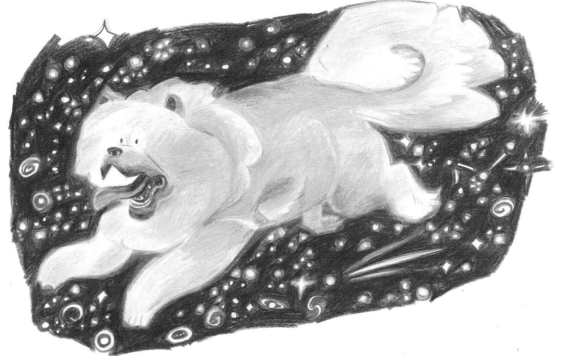

BELOW: Artwork by Céline Desrumaux.

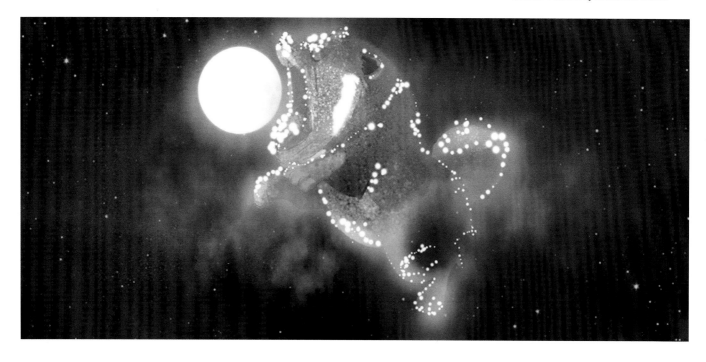

"AS FAR AS THE SPACE DOG'S CONCERNED, THE MOON IS JUST A BIG, TEMPTING BALL. AND ALMOST EVERY NIGHT, HE TAKES A BITE."

FEI FEI'S MOTHER

THIS PAGE: Sketches of the Space Dog by Jin Kim.

RETURN TO EARTH

■ Fei Fei's adventure ends with her returning to Earth with her step-brother, and we see her sitting around the table at the following year's Mid-Autumn Festival, surrounded by her family. This time though, Fei Fei joins in with the celebrations, having embraced her new step-family and learned how to move forward.

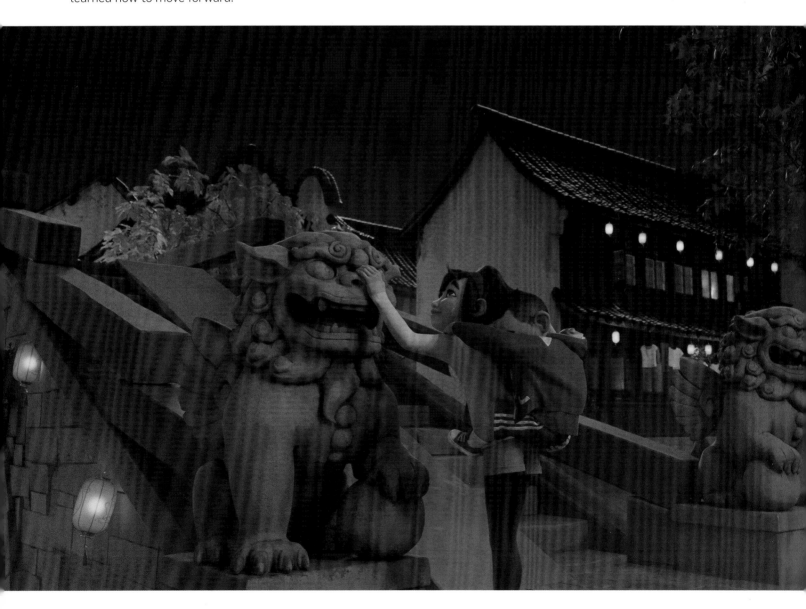

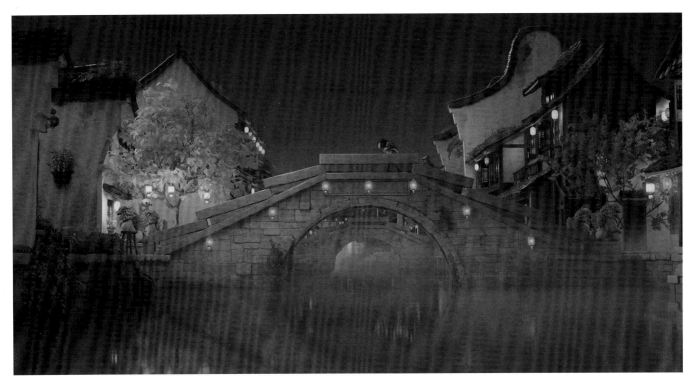

RIGHT: Artwork by
Céline Desrumaux.

BELOW: Storyboard
by Glen Keane.

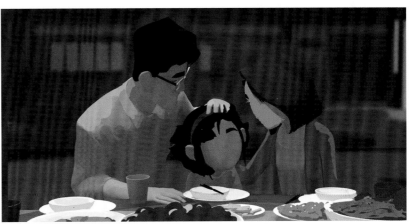

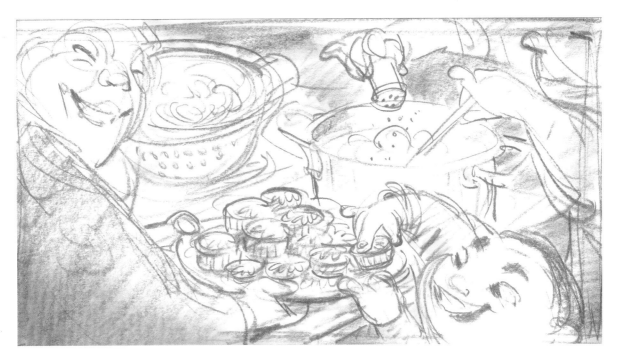

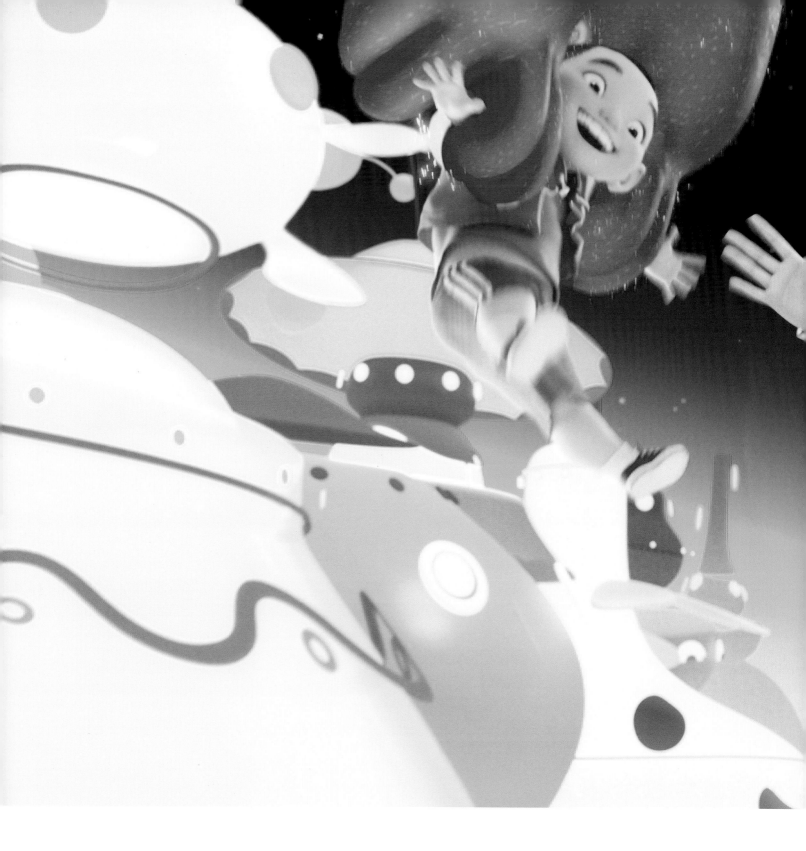

Lee is grateful for the opportunity Keane gave him and says, "It's such a blessing to be able to work with one of your all-time favorite artists. It's the blessing that is never lost on me. Every time I hear him talk, it's just a master class in animation."

His sentiments are echoed by Steve MacLeod, who served as head of story on *Over the Moon*. "On my last day of the project, I said to Glen, 'They say don't meet your heroes, but you not only met my expectations; you exceeded them.' I already knew he was talented, but [it was different] to be

around it and see how it comes to fruition and how hard he works. You know, we did some late nights, and Glen was always with us. Glen would stay late and he would draw with us, ask how he could help. It was amazing. I mean, they talk about, you know, being around greatness and I think Glen Keane and Gennie Rim, the producer, are like royalty."

From Keane's point of view, every facet of collaboration is a two-way street. "Sometimes," he says, "my problem is, I get so deep into the main character, that everything becomes too sacred, too special, too important. Steve

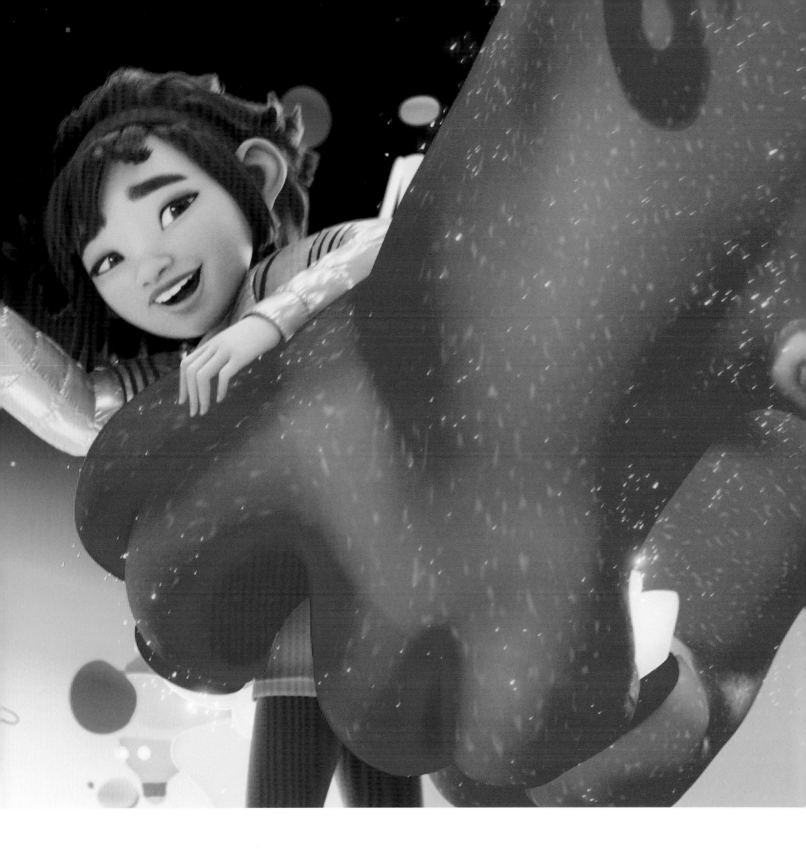

MacLeod was constantly this reminder to me to have fun with it, and to play lighter with it. Again and again and again through the whole movie, he gave us chances to lighten up and have fun."

Still, it's hard to avoid the constant pressure of deadlines and, of course, expectations. Gennie Rim speaks for Peilin Chou, Melissa Cobb, and Keane when she says, "We are all very deeply invested in this baby, making sure that it fulfills its potential of the type of storytelling that we set out to do, the level of quality that we wanted to achieve.

"We've gone out of our way to make sure that Audrey's words are leading us as well. There's a lot of phone calls, there's a lot of text messages all through the night. There's a lot of conversations about how we're all feeling collectively. Do we feel good about this? Do we agree, if it's a design point or if it's a story point or the music... We're all wanting to make sure that we all feel heard and that we're aligned, so when this movie comes out, it feels like it came from all of us."

FAMILY PHOTOS

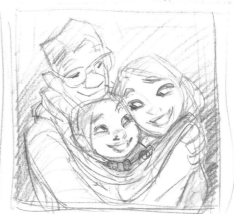

RIGHT: Sketch of Fei Fei with her parents by Glen Keane.

BELOW: Photos of a smiling Fei Fei with her new family, featuring Mrs Zhong and Chin.

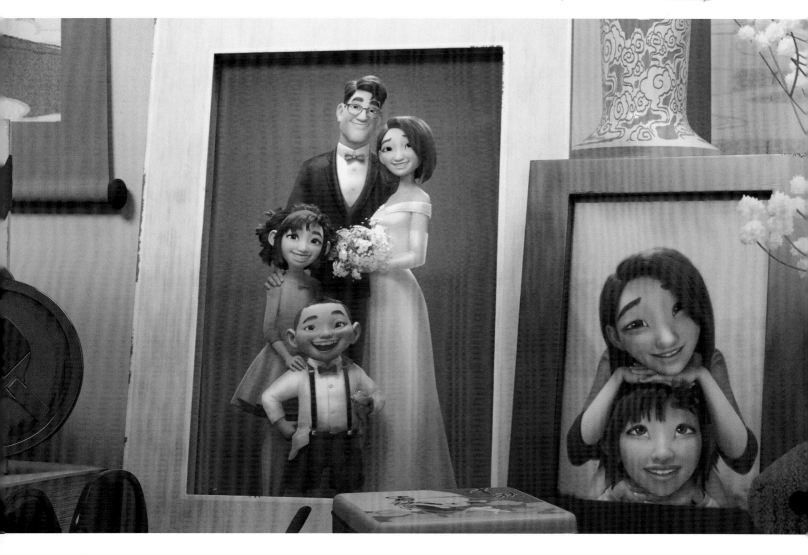

And while he has earned the respect of his peers and the applause of audiences worldwide, Keane drives himself as hard as he did when he was just starting out. His father told him, "I'm a cartoonist, but you are an artist." And his mother "was the most encouraging force. Going through animation, you're constantly being met with obstacles where you feel like you're failing," Keane says. "You're never going to figure this out. This is it, this is when everybody is going to know that you don't know what the heck you're doing. At moments like that, I always hear my Mom's voice in her wonderful Australian accent, saying,

'Glen, love, you're going to figure [it out], you're going to do wonderful things. You can do anything you want.'"

In addition to those memories, Keane has a tangible reminder of his early years. "When my folks died, I inherited a coffee table that was in our living room. All seven of us at Christmas would gather around that table and count all the pennies my mom had collected in the year and whoever guessed the total number in that jar would win. I thought, *Someday, I want to make a movie around that table.*"

And now he has.

BELOW: Different stages of Mrs Zhong and Fei Fei's father's wedding photo. On the left is early artwork by Elle Shi, and on the right is Glen Keane's sketch of the same with comments.

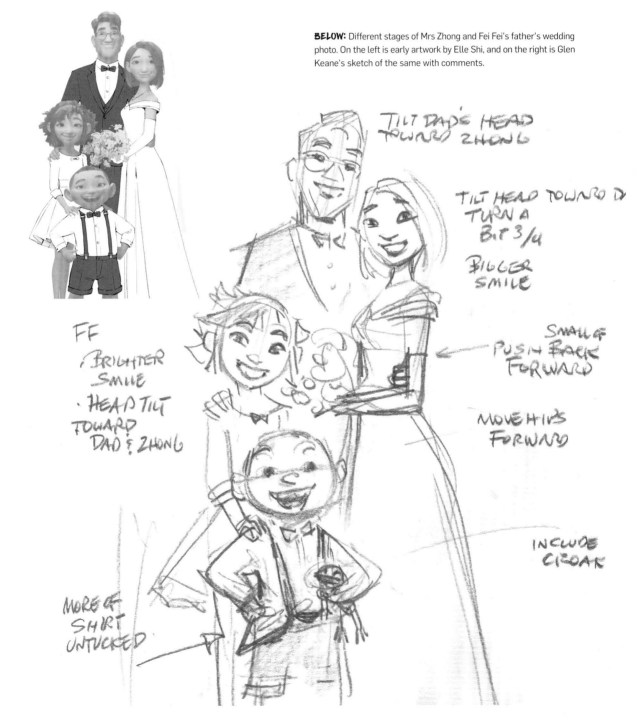

THE WHITE CRANE

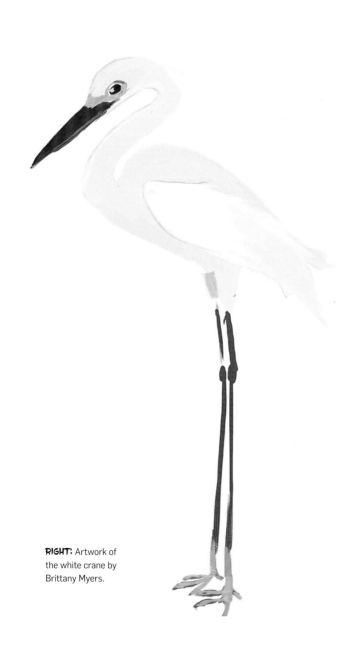

RIGHT: Artwork of
the white crane by
Brittany Myers.

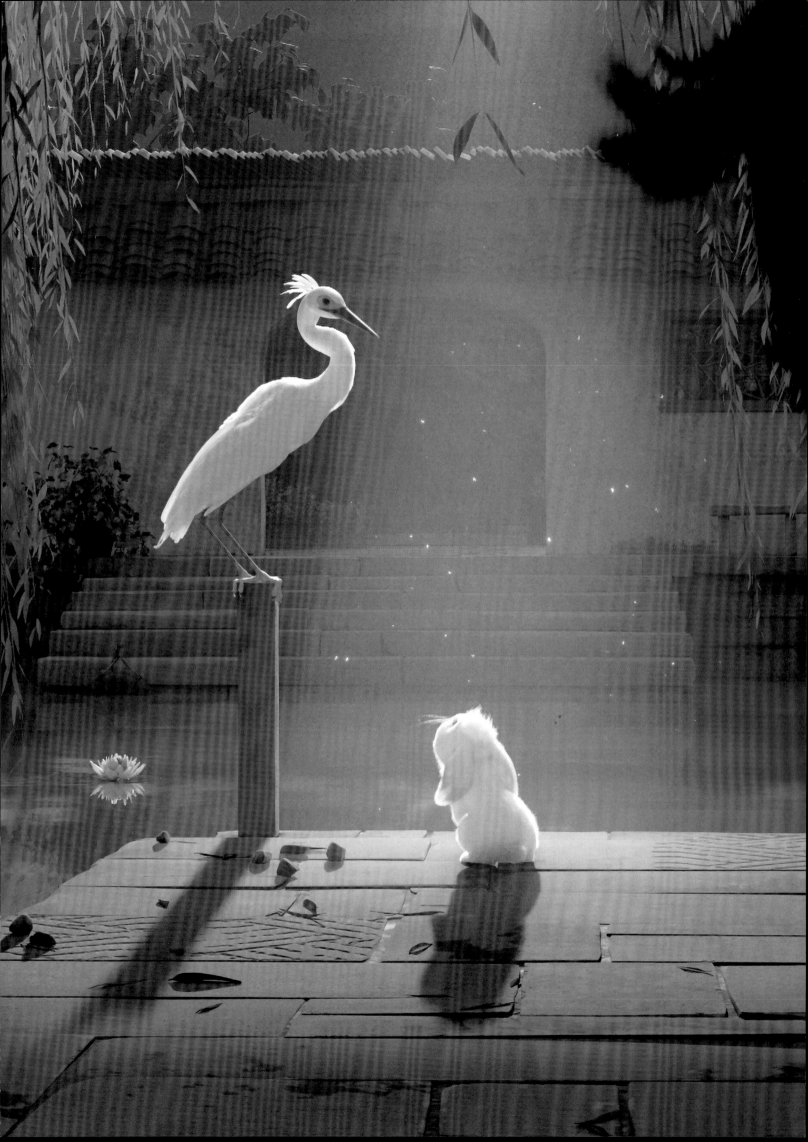

ABOVE: Sketches of the crane by Jin Kim.

BELOW & OPPOSITE: Fei Fei connects with the white crane before it flies away.

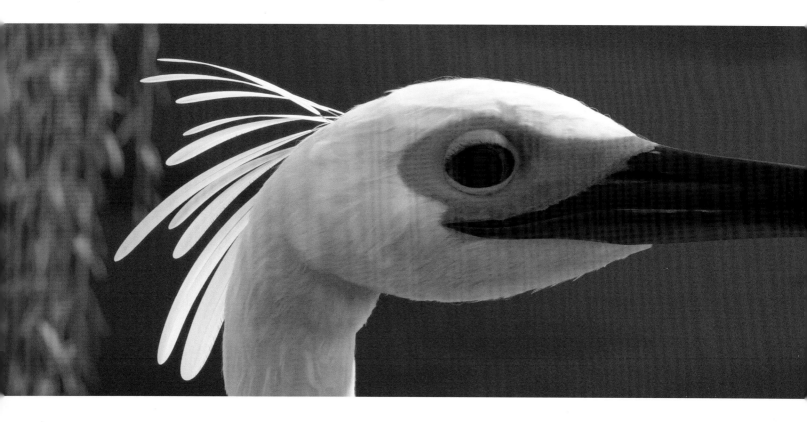

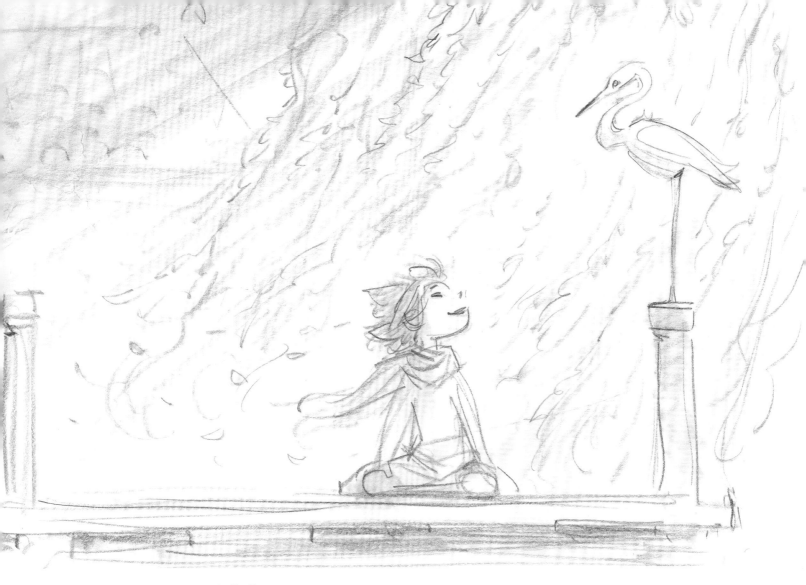

ABOVE: Sketch of Fei Fei and the crane by Glen Keane.

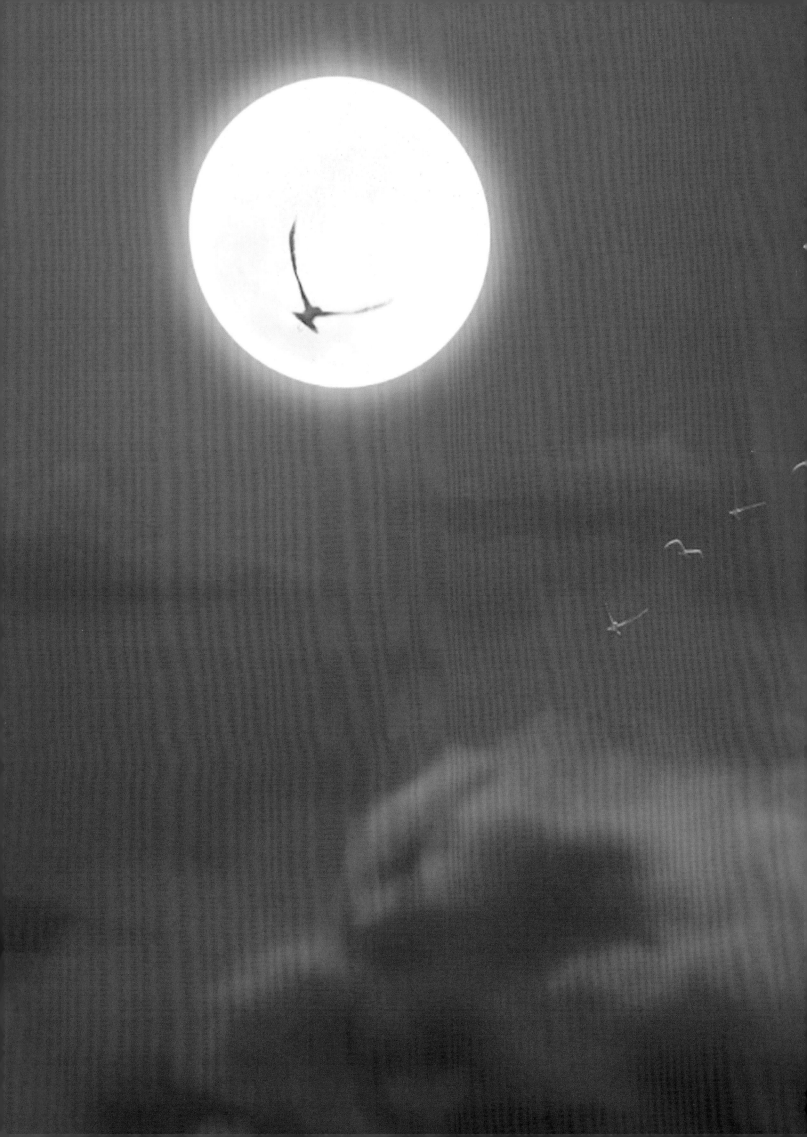

ACKNOWLEDGMENTS

We want to acknowledge the talents of so many who made this film and book possible.

Leonard Maltin, you took the amazing journey of our team and translated these experiences into a clear and beautiful artistic adventure.

Thank you Melissa Cobb, Gregg Taylor, and Netflix for your gentle guidance and firm support from start to finish.

Thank you to Frank Zhu and the Pearl Studio team for your partnership and belief in this film.

Thank you to our entire incredibly talented team who made this story come alive. Céline Desrumaux for her spectacular sense of color and lighting, Sacha Kapijimpanga for his animation leadership, Dave Smith for the unwavering partnership in delivering a beautiful film alongside the entire powerhouse team at Sony Pictures Imageworks.

To our Pearl Studio artists—Wang Rui, Elle Shi, Tian Yuan—along with Hank Abbott and Rachel Shu that lent their heart and passion in every detail of making this world.

To Edie Ichioka (editor), Steve Macleod (head of story), John Bermudes (head of layout), Jin Kim, Brittany Myers, Jérémy Baudry, Marion Louw and our entire outstanding team of artists. We are so grateful to each and every one of you for we could not have done this without your artistry and commitment to this film.

Guo Pei for her brilliant costume designs that brought our Chang'e to life.

Kyle Hanagami for the choreography fit for a Moon Goddess.

Our marvelous songwriting team—Christopher Curtis, Marjorie Duffield, and Helen Park.

Our composer Steven Price for his sensitive and soaring score.

Our indispensable and truly gifted production team—Lisa Poole, Trisha Vo, Maddie Lazer, Jue Cao, Carol Choi, Stasia Fong, Wancy Cho, Sabrina Lou, Kinga Vasicsek, Tiffany Chiu, Christina Foster, and Shelby Peake.

Janet Yang for igniting the initial spark that launched *Over The Moon*.

To our Netflix Publishing team and Titan Publishing crew, Chris Gonzalez, Lisa Bass, Susie Rae, Stephanie Hetherington, and Natalie Clay for creating a wonderful compilation of all the artistry and love that went into the making of this film.

And of course, Audrey Wells for her wit, soul, and passion in writing this script, the blueprint of this magical voyage, and for entrusting us with this love letter to Tatiana and Brian.

Our hearts will be forever grateful to have been able to share the story of Fei Fei in hopes that it inspires love and healing to families around the world.

With sincere thanks,
Glen, Gennie, Peilin & John

ABOUT THE AUTHOR

Leonard Maltin is one of the world's most respected film critics and historians. He is best known for his widely-used reference work *Leonard Maltin's Movie Guide* and its companion volume *Leonard Maltin's Classic Movie Guide*. His books include *The 151 Best Movies You've Never Seen*, *Of Mice and Magic: A History of American Animated Cartoons* and *The Art of the Cinematographer*. He teaches at the USC School of Cinematic Arts.